ISLAMIC ART AND ARCHAEOLOGY IN PALESTINE

*This book is dedicated
to my dear Dodik.*

Islamic Art *and* Archaeology *in* Palestine

MYRIAM ROSEN-AYALON

WALNUT CREEK, CALIFORNIA

LEFT COAST PRESS, INC.
1630 North Main Street, #400
Walnut Creek, CA 94596
www.LCoastPress.com

This is an English translation of *Art et archéologie islamiques en Palestine*, published in 2002 by Presses Universitaires de France.

Translated by E. Singer.

Library of Congress Cataloging-in-Publication Data

Rosen-Ayalon, Myriam.
[Art et archéologie islamiques en Palestine. English]
Islamic art and archaeology in Palestine /
Myriam Rosen-Ayalon ; translated by Esther Singer.
p. cm.
Includes bibliographical references and index.
ISBN-13: 978-1-59874-063-9 (hardback : alk. paper)
ISBN-10: 1-59874-063-6 (hardback : alk. paper)
ISBN-13: 978-1-59874-064-6 (pbk. : alk. paper)
ISBN-10: 1-59874-064-4 (pbk. : alk. paper)
1. Palestine—Antiquities. 2. Art, Islamic—Palestine. 3. Islamic antiquities—Palestine.
4. Archaeology—Palestine. I. Title.
DS111.1.R6713 2006 709.569409'02—dc22 2006014613

Printed in the United States of America

♾™ The paper used in this publication meets the minimum requirements of American National Standard for Information Sciences—Permanence of Paper for Printed Library Materials, ANSI/NISO Z39.48–1992.

06 07 08 09 10 5 4 3 2 1

Contents

List of Illustrations

Preface

ISLAMIC ARCHAEOLOGY is one of the newest branches in this field and has only recently received official recognition. This applies to the study of Palestine as well as the surrounding areas, and helps explain the care needed when presenting an overview of this subject.

The geographical region covered by this book corresponds to the area west of the Jordan River, which does not coincide with any historical political entity. The Islamic art and archaeology that developed in this region cannot be separated from its geographic and cultural context, and, as is the case everywhere, its defining characteristics did not emerge in a vacuum. The different phases of Islamic art resulted from shifts in centers of culture, and these influences had a great impact on Palestine, a true melting pot of political, cultural, and artistic energies. However strong these influences were, it would be a mistake to downplay local contributions to artistic production. The impact of these two forces—external and local—is what we will follow throughout this volume.

This book is designed to be a first step in this field. Its objective is to present, for the first time, an overview of finds from excavations and the main monuments in the region, in order to provide a summary of the subject. The classification used here will, I hope, be a starting point for more in-depth studies, both in terms of phenomenological interpretation and for the study of its characteristics.

The complexity of the subject matter and the wealth of topics covered here for the first time call for some introduction. The artistic and archaeological material brought together in this book reveal a genuine local identity, and at this stage I will not enter into the controversies and debates that the chapters in this volume could spark. It is clear that in the future special comparative studies will be required, linking artistic expression in Palestine to art forms existing during the same time periods in other Islamic regions.

A great deal of thought went into the structure of this book. Studies of art and archaeology all differ as a function of the civilizations or the specific topic they cover. Certain authors elect to describe specific archaeological sites over different periods of time, such as a survey over time of Hama or Abu Gosh. Others prefer a thematic approach, for instance, the finds at Samarra, Qasr el-Qadim, or Nishapur. Still others base themselves primarily on chronology, as is the case for archaeology textbooks by W. P. Albright, A. Mazar, or T. Levy.

I believe this latter choice is the best suited for the material presented in this book. I thus discuss art forms and archaeological finds in the light of history, but without maintaining an overly rigid framework. In some cases I have used a thematic presentation—for instance, in the section on fortresses and the one dealing with the sugar industry. Nevertheless, I have carefully adhered to the chronological sequence of events.

I begin first of all by presenting the history and the archaeology of the country during the Jahiliya, the pre-Islamic period, although limited to the years immediately preceding this new epoch. As the Umayyads came to Palestine, heralding the first great era of Islamic civilization, a new wave of artistic expression was emerging in Damascus, the capital of the caliphate, one that was highly influenced by the legacy of the classical world.

During the next era, the Islamic entity took root and Egypt was the prime mover behind endeavors carried out in Palestine. Toward the end of the Middle Ages, Muslim art was subject to both Western and Eurasian influences. The enormous artistic activity of this period highlights the role of Palestine's location between Syria and Egypt. However, when the country fell into the hands of the Ottoman Empire, there was a significant change, and the style of the court of Istanbul influenced the arts produced in Palestine.

The study of Islamic archaeology deserves several preliminary comments. In contrast to traditional or "noble" forms of archaeology, which deal with

ancient civilizations, the archaeology of the Middle Ages is the most recent chapter in the field of archaeology. This trend is not specific to Palestine but rather reflects the field in general. The first archaeological excavations conducted by Western scholars in the mid-19th century focused on biblical topics or their associated traditions. Yet once the colonial period was over, the various Muslim countries maintained a similar archaeological policy for several decades. There was a race to discover ancient civilizations: the Egypt of the Pharaohs, Hittite Turkey, Achaemenid Persia, as well as Sumer, Akkad, Babylonia, and Phoenicia. Rather than examining the Muslim Middle Age, from which their current identities directly derive, all these countries were oriented toward the search for past glory going back thousands of years. Palestine and its biblical past were no exception.

In addition, two unspoken factors weighed heavily in researchers' decisions to neglect the archaeological strata of the Middle Ages. On the one hand, there was the opportunity to unearth the treasure hoards of the ancient tombs of High Antiquity. On the other, the Islamic tradition held little promise of spectacular finds from the medieval strata in the form of jewelry or other precious objects. Because archaeology is a costly enterprise, the hesitation on the part of the authorities to devote the same attention and the same budgets to more recent levels as to the oldest levels is understandable—since they could expect to increase only scientific and historical knowledge. The study of recent levels would also mean delays in archaeological exploration of the lower strata that were so promising. This explains why the medieval layers were so often sacrificed.

Moreover, the dilemma of the study of the Islamic strata is relatively recent. For instance, such plans were made for the excavation at Hama in Syria and Ashkelon and Jerusalem in Israel, which were the bases for key research in Islamic archaeology. In fact, the problem of excavations of Islamic sites per se has had to wait for a change in scientific outlook. The case of Samarra, in Iraq, is in many respects a landmark, signaling the end of prejudices in this field. The same is true for Ramla, in Palestine, where excavations were conducted with the clear intention of finding the remains of a medieval past.

Given these realities, it is easy to grasp the enormous disparity between the archaeological knowledge of ancient times—dating, stratigraphy, material culture, pottery—and the knowledge of these same data for the Middle Ages.

Most archaeology textbooks, in fact, stop on the eve of the medieval period rather than risk entering into this terra incognita. The 1995 book edited by Thomas Levy is a pioneering effort in this field; it attempts to cover all the periods of the history of archaeology of Palestine. One cannot, however, help but be disappointed by the small number of pages devoted to the Middle Ages, compared to the hundreds of pages devoted to prehistory.

Some archaeologists are currently involved in developing a new approach to this issue in order to give the Islamic archaeology of Palestine its proper place in the great chapters of the archaeology of the country. Over the last few years, the Israel Antiquities Authority has worked feverishly; countless digs have been made possible on sites providing interesting perspectives on the Middle Ages. In contrast to digs of the past, the excavations have dealt with the upper layers and all the material removed has been subject to in-depth analyses.

Furthermore, a series of surveys have been conducted to collect material likely to provide information going beyond purely material finds. For instance, an in-depth study of shards has reached a truly historic dimension.

Thus, the many excavations, the wealth of discoveries—which in some cases were completely unexpected—the unearthing of sites, and the restoration of monuments have all led up to this book, which aims at being a preliminary overview. The need for this volume was expressed by the teaching community, as well as by students and by all those who take an interest in the study of the art and archaeology of Palestine.

Nevertheless, the essay format places several limitations on the text and the illustrations. Only the major issues are presented, without any attempt at exhaustiveness. The same is true for the examples. The idea of presenting complete lists had to be abandoned—this will, I hope, be the subject of a more comprehensive study for the future—and the book is restricted to a selection designed to illustrate the different topics.

Before turning to the subject matter itself, I would first like to thank all those who assisted me. First of all is Janine Sourdel, my mentor and long-standing friend, for her advice and encouragement. Her great perspicacity and understanding of the subject convinced me of the need for this book, and I am particularly grateful to her for allotting this task to me.

I would also like to express my gratitude to all my students: Their intellectual curiosity, their pioneering work, their interest in their studies often made

difficult by the lack of interest from professional milieus, their acumen, and their devotion made this work possible.

I would also like to thank the numerous friends and colleagues who were willing to grant me some of their valuable time and enable me to benefit from their experience and wisdom.

This book is dedicated to David, my steadfast companion, now sorely missed. He gave me his constant attention and precious support; he was always ready to help me overcome the obstacles I was facing. It is thanks to him that I was able to successfully complete an often difficult enterprise. May this book be a humble tribute to his memory.

Introduction

Before delving into the subject matter proper of this book, its framework requires definition, since the natural boundaries of the region known as "Palestine" are far from being unanimously agreed upon, and have shifted many times, over many years, due to the vicissitudes of political and historical events.[1]

As a geographical entity, the concept of Palestine is relatively modern, and it is somewhat difficult to find references to it in historical sources. The Muslim conquerors translated the Roman terms "Palestina prima" and "Palestina secunda" as "Jund Filastin" and "Jund al-Urdunn" to designate the two parallel strips of land that divided the country from north to south. They made Ramla the capital of Jund Filastin to replace Caesarea, and Tiberias the capital of Jund al-Urdunn to replace Baysan. The importance of each of these capitals varied as a function of the era.[2] The division adopted later by the Ottomans was more or less identical, although the two provinces were extended northward and were called "Wilaya of Sidon" and "Wilaya of Damascus," respectively.

These changes required me to find a coherent geographical zone for this book that covered these different areas, while also preserving their identity. The only geographical boundaries that fit these requirements are those used in the 20th century by the British Mandate, in terms of both cultural history and archaeology and local art forms. Due to the self-imposed restrictions of

this framework, this book excludes the extremely important contributions of Jordan, despite the proximity of sites that are often closely associated with the history of Palestine—in particular the Ayla excavations[3] and the ruins of certain Umayyad castles.[4]

Almost everything we know about the beginnings of Islamic art comes from a region far removed from the Arabian peninsula which was nevertheless the cradle of Islam. The true "heart" of Islamic art is located much more to the west—namely, in Palestine and in its immediate vicinity—in the center of a region that, at the start of the seventh century, was extremely advanced. This accounts for the major role of this region in the development of a new chapter in the history of civilizations.

Throughout its development and the shaping of its identity, Muslim art was influenced by ongoing exchanges with non-Muslim civilizations, which did not prevent it from integrating pre-Islamic influences as well. From the seventh to the 18th century, there was a real dialogue between the art forms of Palestine and those of the surrounding areas; art reflected political changes as well as the new aesthetic trends developed in Palestine under Islam. The first five chapters of this book present this extraordinary experience in chronological order, which serves to retrace the history and highlight the unique features of each of these developments.

The abundant finds from recent excavations in Israel greatly facilitate the study of the trajectory of Muslim art in the region, and make it easier to grasp certain subtleties in the transitions from one era to another. The numerous finds made during the course of these excavations—objects, coins, pottery, inscriptions, and even architectural complexes—help paint a more complete picture of the development of Muslim artistic expression in Palestine over a thousand years.

In each era, the trends that influenced artistic expression were a function of the center from which they originated. These different influences resulted in different styles, affinities, and specific interpretations. Chronologically, the influence of Damascus, Cairo, and Istanbul are presented. Nevertheless, despite these different trends, the Islamic art of Palestine in the final analysis forged its own identity.

For instance, the art of the Umayyad period can be placed under a general heading, but the more one studies, the more one is struck by the specifics of

what was happening during that time in Palestine. This was also true in the years to come; the art of each era was distinctive in Palestine. To take just one example, the Mamluk art of Jerusalem differs in several significant ways from the art forms that emerged at the same time in Cairo. If we head off on a journey of discovery of these highly unusual forms of Muslim art, we will see that the different Islamic eras, nourished by the pre-Islamic roots of the region, reflect in turn the influence of the different milieus in which they evolved.

Other factors also affected art in the region: The borders of Palestine in the Middle Ages were also those of the "Holy Land." For two centuries, the Crusaders were behind a conflict between east and west. The Crusades were also the impetus for the mutual discovery of these two worlds, and acted as a source of reciprocal influence and transmission of various traditions. We know that the Muslim world was, from its inception, in conflict with the Byzantine Empire, which desperately attempted to close its borders to the ever-advancing Arab forces. This was the first encounter between Islam and Eastern Christianity; the Crusader period was the second, and it was totally different. Despite the constant battles, a form of coexistence emerged during which the inhabitants and even the warring parties frequently crossed paths. On the official level, the sides apparently ignored each other; certain historians—both Muslim and Crusader—devote scant attention to the enemy in their writings. However, each camp was, albeit unbeknownst to it, influenced by the traditions and customs of its adversary.

The pilgrimage to the Holy Land was a key feature in promoting this type of osmosis. Palestine became a destination not only for Christians but also for pilgrims from the two other monotheistic faiths. Whereas Christians came primarily from the west and Jews came from Spain, North Africa, or from the Muslim countries of the east, Muslim pilgrims came from all the Islamic regions. Pilgrimages were so popular that in 1173 there were three travelogues written at exactly the same time by a Jew, a Muslim, and a Christian, each of whom visited Jerusalem and recorded his impressions.[5] Like migratory birds following a predefined itinerary, the pilgrims went from place to place, transmitting recollections and collecting relics. These often became the seeds of major art collections, even treasures, in the west. But they also visited the markets overflowing with oriental fabrics, unknown spices, and other precious goods that were easy to carry. The pilgrims' progress, incorporating goods and

memories, contributed to the forming of a mobile universe imbued with piety, subjected to the vagaries of history, but tightly linked to Palestine.

Thus, the study of the Islamic art of Palestine involves overlapping topics, an accumulation of issues, and myriad perspectives that change over the course of Muslim history.

This book could have taken many different approaches to achieving its goal of presenting an introduction to this extremely vast subject. I have chosen the most didactic, which is based on chronology and introduces the different topics as they emerge in time, attempting to provide a response to, if not a possible answer for, the various questions that emerge at each stage. This way we can trace, step by step, the events of the history of the Islamic world and take into account their impact on phases in the development of Palestine. By examining the distinctiveness of Palestinian art and archaeology in light of these events and the different axes of influence, we can gain a better understanding of the way they fit into the broader perspective of changes in the Islamic world as a whole.

This approach results in an unequal division of the chapters in this book, but, like a stream that has both rapids and its calm waters, history follows a highly irregular course. This is true as well for this history of Palestinian art and archaeology.

Chapter One

The Pre-Islamic Period and the Beginnings of Islamic Occupation

ARAB PENETRATION AND INFILTRATIONS

Ancient sources indicate that the presence of "Arabs" in the region of "Palestine" can be dated to the first millennium BCE.[1] Without going that far back, there is evidence that Arab Bedouin tribes played a considerable role in the southern part of the country, in the Negev and the Sinai, several centuries before the Muslim occupation. These Bedouins were also known as "Ishmaelite Arabs."[2] They are described as early as the fourth century CE, and continue to be mentioned in later centuries primarily because of their raids on sedentary villages throughout the country, and as far away as Syria.[3] This harassment of civilian populations, especially in the south, was often accompanied by lengthy incursions that constituted a forerunner to the future great waves of Arab penetration.

These warlike incursions did not prevent new or existing trade routes between Arabia and Palestine from enabling the circulation of spices, textiles, and other goods. Countless caravans journeyed through the Arabian Peninsula from Mecca, and Gaza was one of their main destinations.[4] This major marketplace apparently experienced a period of great prosperity, even benefiting the family of Mohammed, the prophet of Islam. Having already been subjected to Persian occupation, Gaza surrendered to the Arab invaders without a fight. The inhabitants of Ayla, a city on the tip of the Red Sea, aligned themselves

with the Muslims as of 630, thus opening to Islam the southeast route and the road to Palestine, and indeed the new armies would penetrate the country from the south.

THE NEGEV

Since the 1980s a series of studies have focused on the south of the country, and the central Negev in particular.[5] Although the published findings are still not complete, the reports nevertheless provide key information about Islamic archaeology. Not surprisingly, researchers have not drawn unanimous conclusions about these finds, but nevertheless a certain consensus emerges as to the period and certain features of the discoveries.

The terrain shows numerous traces of ancient agricultural settlement. More specifically, there are areas surrounded by low stone walls containing openings; some researchers argue that these are the vestiges of houses, whereas others believe they are simply enclosures. In several cases the walls are found in groups, sometimes connected by a common wall with no openings. When they are attached to each other, these constructions sometimes form long rows. Many of these have a platform, which is generally raised and circular—in Hebrew, *bima* (pl. *bimot*). At numerous sites, stelae have been found upright, leaning, or lying down, sometimes as part of the entrances. Some researchers claim that they are related to a betyl[6] cult, whose roots are found in pre-Islamic tradition.

The terraces are especially interesting in terms of the objects, particularly the pottery, found there. This is because pottery is characteristic of the beginning of the Islamic era, that is, the seventh and eighth centuries. Complete oil lamps or fragments with molded decorations, often bearing inscriptions in Arabic or even Greek, as found elsewhere, have been discovered.[7]

Another remarkable archaeological find is the presence of several hundred examples of graffiti engraved on the rocks of the region.[8] Although inscriptions like these have been found at other sites in Palestine, their presence in the Negev is particularly striking.[9] Despite the existence of several dates, these graffiti raise numerous questions about chronology and paleography. They often include animate motifs, such as small human figures and horsemen or camels. The images are not necessarily integrated into the inscriptions, most

of which are written in Arabic, although some are Thamudean or Safaitic. Are these the reflection of an art form of a few nomadic tribes? Unfortunately, current research cannot provide a satisfactory answer. However, it is likely that they are a local art form from the pre-Islamic period, which the Arabs call Jahiliya, or the "period of ignorance."

THE SASSANID OCCUPATION

The period preceding the Muslim occupation coincides with the decline of the Byzantine era in Palestine, at a time of instability stemming from various causes. The first was a series of earthquakes in Palestine that took place in 551, 633, and 659 and which doubtless resulted in turmoil.[10]

The second was the plague. Sources tell us that this deadly disease struck the region of Syria between 542 and 749, in seven-year cycles.[11] Obviously Palestine was not spared, and mention is made of an epidemic that affected Emmaus shortly after the beginning of the Muslim occupation.[12]

But the greatest calamity to befall Palestine on the eve of the Muslim occupation was clearly the Sassanid invasion. At that time Palestine was experiencing such disorder and lawlessness that anarchy is the only term that applies.[13] Riots and bloody events were the backdrop for the arrival of the Persians in 614. They conquered Jerusalem and carried off the Holy Cross as booty. The wave of destruction that followed in their wake laid the groundwork for another invasion that took place 20 years later—the Islamic invasion.

Several sources provide information on the 14 years of Persian occupation in the region, from 614 to 628. All concur in describing the widespread destruction of churches and the massacre of the Christian population. Nevertheless, it is surprising that there are almost no archaeological remains of the Sassanid presence in seventh-century Palestine, despite all the excavations conducted in the country and in Jerusalem. A few "tidbits" can perhaps be associated with this period, but they may also be the result of migrations or exchanges along the trade routes.[14]

The Sassanid destruction left many churches in ruins, and these remained so at the time of the Muslim conquest. An exception is the Holy Sepulchre, which was restored by Modest, the archbishop of Jerusalem.[15]

Although the Muslim conquest was not accompanied by such devastation, the new Islamic era was built upon a country in ruins. Despite earthquakes, epidemics, military unrest, nomadic infiltrations, and the Sassanid occupation, there is a certain archaeological continuity between the end of the Byzantine era and the beginning of the Muslim period. One can nevertheless imagine the suffering of the population and the breakdown of the social system during these troubled times. It was a bloodied, inert country that witnessed the arrival of the Arab troops.

THE MUSLIM CONQUEST

It thus comes as no surprise that the sources report no bloody battles, and no resistance on the part of the population or its leaders. Certain revisionist historians have used this to suggest that the Muslim occupation did not take place at the generally accepted dates, and that it was the result of a slow, peaceful process.[16] What is accurate is that there is no "layer of destruction" between the Byzantine archaeological layer and those associated with the Arabic period.

Here we need to go back several centuries, and take into account an ancient layer considered to be the oldest Arab layer in Palestine, predating the infiltrations of nomadic tribes and the massive arrival of Islamic troops;[17] namely, that of the Nabatean kingdom,[18] that extraordinary political entity whose days were ended by the Romans in the year 106. Certain ancient Nabatean cities, such as Kurnub (Memphis), Oboda, and Nessana continued to play a major role in the south of the country after the Byzantine era, and their history extends up to the Muslim era. But they are few in number and their history dies out completely in the Umayyad era. Nevertheless, proof of the existence of this sequence provides us with the factors that influenced the Muslim heritage and certain artistic traditions linking the Nabateans to the Umayyad period.[19] Thus, it demonstrates that the new presence meshed with a process that had begun long ago.

Rather than entering into the controversy on the origins of the new faith of Islam,[20] I will focus on the development of Islam in Palestine. The notion of continuity mentioned above can also be found in other areas linked to the beginnings of Islamic civilization.[21] The results of excavations and surveys con-

ducted in the south suggest that there was a certain phase of Jahiliya specific to the country. Thus, there was a manifestation of the pre-Islamic period that extended beyond the official date of the Muslim conquest of the country.

In the Negev, Arab nomads were free to move about wherever they pleased. These tribes had no major settlements and what archaeologists have found are probably their enclosures.[22] It is difficult to view these enclosures as sedentary buildings. By contrast, large-scale farming was a hallmark of certain Nabatean cities, which continued to exist after the Muslim conquest.

The graffiti discovered on the rocks in this region are most likely associated with this period. These probably date back to the Arab infiltrations in the south on the eve of the Muslim conquest, and continued long after. Written primarily in Arabic, but also in Thamudic, these graffiti, some of which are dated, provide further indications of a continuity that lasted several centuries.[23]

Finally, the upright stelae, which are most likely associated with a pagan cult, appear to have survived beyond the year 638, at which date the Muslims completed their conquest of Palestine. This is a local manifestation of continuing Jahiliya. This feature is mentioned here once again to stress the prolongation of an Arab pre-Islamic chapter that extended beyond the phase that gave rise to Islam. It was, however, a period that can also be termed "Arab": Both the cultural and the artistic production were still closely tied to demographic features and cultural expression drawing on pre-Islamic Arab roots. Later, when a stratified political system was set up, and in particular the Umayyad dynasty, it is more accurate to begin to refer to a "Muslim" period.

THE NESSANA PAPYRI

From 1935 to 1937, the British School of Archaeology in Jerusalem conducted major excavations in the northern church of Nessana. These yielded a wealth of nearly 200 documents, some intact and some fragmentary. This trove of information shed new light on the end of the Byzantine period between 512 and 789, but contained an unfortunate gap for the years 608 to 674.

Written in Arabic and in Greek, the Nessana documents confirmed the use of Greek well after the Muslim conquest. The finds include literary and religious texts, and in addition to interesting details on the agricultural life of the

southern communities, there is valuable information on daily life in the Negev from the sixth to the seventh centuries.[24] Given the lack of written material for this period, these documents are crucial to reconstructing the beginnings of the Islamic occupation of Palestine and provide a new perspective on the transitional years between the Byzantine period and the Islamic period.

The documents include instructions from the Muslim governors' headquarters in Gaza to their agents in the Negev. There are also tax receipts, deeds of sale, and even records of harvests. Other official documents are for ownership of goods or farmlands. We learn about the crops grown at the time, the different types of farming, existing access roads, and even the use of boundary stones marking the borders of properties. In short, the documents present an extraordinary picture of life at that time in the Negev region.

Chapter Two

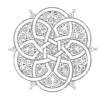

The Umayyad Period:
Identity and Grandeur

THE UMAYYAD era was the crucible in which Muslim art was forged. This chapter does not deal with theories of its emergence under the Umayyads[1] but rather focuses on the more specific features of artistic creation in Palestine at that time.

The Muslim armies completed their conquest of Palestine in 638. However, the Umayyad dynasty only appeared in 661. The intervening years were something of a continuation of the pre-Islamic Arab strata—the traces of infiltrations and raids, as well as the Nabatean legacy. It was what can be termed a transitional period on the brink of the unfolding of the new Muslim civilization. Coins, for instance, were still minted in the Byzantine tradition, and the inscription found at Hammat Gader (discussed below) and dating to Caliph Mu'awiya is still written in Greek. The al-Aqsa Mosque, the first mosque built in Jerusalem, was not yet a Muslim work of art.[2]

However, the coming of the Umayyad dynasty heralded a decisive turning point in artistic ingenuity. Significantly, the major artworks of this formative period were produced far from Arabia, the cradle of Islam, and were primarily associated with Palestine, where its monuments had a crucial impact on the development of Muslim art as a whole. It is also noteworthy that these artistic innovations followed upon one another within a relatively short period of time. The Umayyad dynasty lasted just 89 years (661–750), and this

period was even shorter in terms of artistic output. The term "Muslim art" only really becomes appropriate with the building of the Dome of the Rock in 72/691–692. Thus, only half a century was needed to lay the foundation for this new art and civilization.

Under the Umayyads, Islam expanded to become an immense empire, challenging Byzantium and stretching from the Atlantic in the west to India and China in the east. From its capital, Damascus, it exercised a direct influence on Palestine. The caliphate took a close interest in the country and, in turn, the historical and artistic heritage of Palestine contributed greatly to the development of Muslim art. Aside from Byzantine and classical influences, Palestine was also shaped by the Hellenic East[3] and by the Sassanids, the heirs of Oriental antiquity, not only during the Sassanian period but through a powerful artistic dynamic whose impact continued to be felt upon the region for centuries. In addition to these trends, which have been identified since the beginnings of the study of Muslim art roughly 100 years ago,[4] there is a consensus today that the local contribution of Coptic art and the Nabateans must also be taken into account.

In any case, the Umayyad period was the impetus for a new range of artistic creation—namely, that of a Muslim art influenced primarily by the second branch of the dynasty, the Marwanids, beginning with the caliphate of 'Abd al-Malik. (The Sufyanid branch that preceded the Marwanids to the throne left almost no artistic legacy.)

Forged in Palestine, Umayyad art can be seen as a continuation of the pre-Islamic art of the region, but with a fresh interpretation, as we will see in particular for the Dome of the Rock. This was no imitation of existing forms: We are witnessing the birth of a new art.

THE NEGEV AFTER THE MUSLIM CONQUEST

Our body of knowledge for this area is only just beginning to take shape. One of the first contributions comes from investigations at the Eilat-Ayalot site.[5] Estimated to date as far back as the ninth century, the site has only preserved a series of square structures. In them, stone fragments and pottery sherds have been found, some of which are glazed, which makes it possible to date them to about the eighth and ninth centuries. However, some remains provide data on

topics that have yet to be classified or analyzed for the Islamic period, namely the fauna[6] and fish[7] in the environment at that time.

Eilat-Ayalot is located at the southern tip of the Negev, at one end of the Red Sea. The archaeological remains of a farmstead dating back to the beginnings of the Islamic era (seventh to eighth centuries) have been found in the northern Wadi 'Arabah, near Nahal Mitnan.[8] In addition to pottery sherds, coins and other metal artifacts have been found.

HAMMAT GADER

The hot springs of Hammat Gader, located roughly seven kilometers southeast of the Sea of Galilee,[9] are replete with history. The Romans built architecturally superb baths in the second century CE. Excavations at the springs have resulted in discoveries of a wide variety of objects belonging to two significant phases of the Islamic Middle Age.

The first of these phases coincides with the beginning of the Umayyad dynasty and is characterized by numerous pieces of pottery,[10] objects made of glass, coins, and a remarkable item, an inscription that is discussed more fully below. The pottery includes several pieces known as "hand grenades"[11] and the molded oil lamps that were typical of this time.[12] As for glass, whole objects and pieces found on the site confirm the key role of medieval Palestine in glass manufacturing. An impressive series of centers have been identified, including Tiberias, Bet Shean, and Yokneam. At Hammat Gader, a variety of glass cups, bowls, lamps, bottles, and jugs have been found.[13] The coins belong primarily to the Umayyad period, and a few have double strikings.[14] A few fragments of inscriptions have also been found on the site, along with graffiti associated with the same period.[15]

However, the outstanding find is an inscription described in a publication some decades ago.[16] It consists of a marble slab containing nine lines in Greek, dated year 42 of the Hegira, or 661 CE. It mentions the name of Mu'awiya, the first Umayyad caliph, with his Arabic titles 'abd Allah, "servant of God," and amir al'hu'minin, "prince of the believers," and mentions the repair of the baths[17] (fig. 1). The inscription also mentions 'Abdallah ibn Abu (sic) Hashim, or 'Abdallah ibn Abi 'Asim, who carried out the renovations. The slab shows that Greek was still used for official inscriptions at the start of the Umayyad

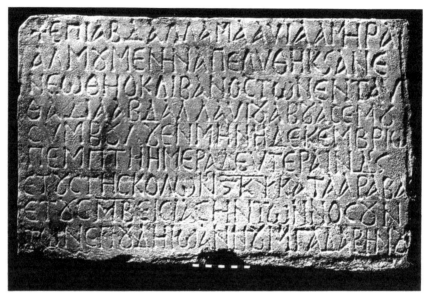

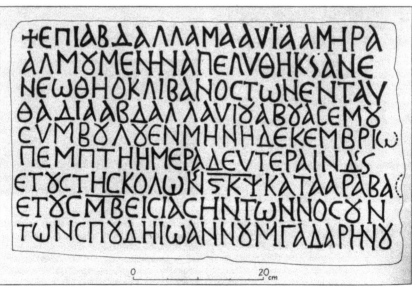

Fig. 1. Inscription from Hammat Gader; the stone and its transcription.
After Y. Hirschfeld.

period. The date of the inscription is consistent with archaeological finds at a site that was in use from the time of the renovation of the baths in 661 until the earthquake in 749 that destroyed them.

More recent objects found on the site include some ceramic fragments and shards of glazed pottery, but these cannot be dated accurately.[18]

JERUSALEM

The Dome of the Rock

Although it is unquestionably the most famous monument of Palestine—as well as the oldest existing Muslim monument—not enough is known about the Dome of the Rock (plate 1). We do not know who the architects were, but we do know that it was built during the reign of the Umayyad caliph 'Abd al-Malik in the year 72 of the Hegira, or 691–692 CE. This renowned building has not undergone any major transformations, a rare feature for the Middle Ages and for Palestine. Despite a series of renovations, its original plan and proportions have been preserved. Its harmony as an architectural masterpiece is enhanced by ornamentation that uses a wide variety of materials, including mosaics, marble polychrome panel overlays, and champlevé (hammered and then painted sheet-metal panels). It should be pointed out that although it is called the "Mosque of Omar," the Dome of the Rock is not a mosque, and it cannot in any way be attributed to the caliph Omar, or rather 'Umar (634–644), who was the second caliph after Mohammed at the head of the oldest Muslim community.

The Dome of the Rock, or *qubbat al-Sakhra* in Arabic, is of key importance to all Muslim art and is located on the upper level of the Temple Mount of Jerusalem, known today as *al-Haram al-Sharif*, or Noble Sanctuary, further discussed below. It gets its name from the rock around and above which its dome was built, and is in fact a shrine reflecting the pre-Islamic tradition of central-plan buildings. The numerous studies devoted to the Dome of the Rock all emphasize its octagonal structure, covered by a dome. The inner space is divided into a double concentric ambulatory, leaving room for a central area reserved for the rock. The first arcade, parallel to the outside walls, is made of eight angular pillars with two marble columns supporting three arches, between each pair of piers. (These polychrome columns and their capitals are

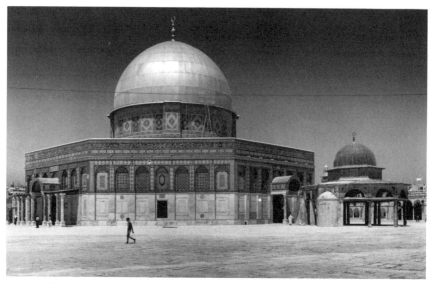

Plate 1. The Dome of the Rock. To the right, the Dome of the Chain.
Photo, Z. Radovan.

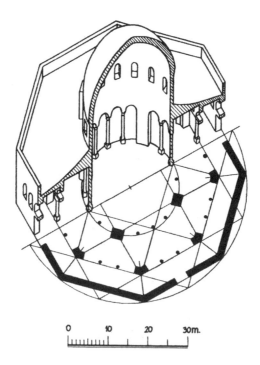

0 10 20 30m.

Fig. 2. The Dome of the Rock, plan and cross section.

all reused pieces.) The arches are all a full 180 degrees, as was the custom for arches in the Umayyad period. Inside the middle octagon, the second arcade is made up of four angular pillars, each separated by three columns. This last arcade supports the drum, crowned by the famous dome that is discussed in detail below.

The exquisite harmony of this architectural composition stems primarily from the fact that the length of each of the eight sides is identical to the diameter of the dome, or about 20.4 meters. Another key feature is that the dome is perfectly designed: Its diameter is equal to its height (fig. 2). Equally remarkable proportions can be found, with striking similarity, in a pre-Islamic monument that was also built nearby in Jerusalem: the Rotunda of the Holy Sepulchre, which predates the Dome of the Rock by about a century.

Numerous theological, political, and architectural interpretations have been put forward to account for such architectural perfection. Clearly, inspiration from the Holy Sepulchre, in addition to the cultural and artistic legacy of pre-Islamic styles and techniques, played a major role in the architecture of this first Islamic monument. For the nascent Muslim power, building the Dome of the Rock on the esplanade where the Temple of Jerusalem once stood was a political statement. The new domination affirmed the Muslim presence and took the place of the former faith that once ruled the site. In terms of both the topography of Jerusalem and the Islamic faith, the building of the monument gave the city a new identity. This religious proclamation was the signal for the creation of the future Haram al-Sharif.

On the outside, the monument has four doors located at the four cardinal points. Each side of the octagon has seven bays. The five central ones have windows, and the two outside bays on each side are blind niches. Historical accounts, confirmed by archaeology, indicate that at the time of its construction, the entire façade was covered with mosaics. They were made up of tiny tinted glass cubes, and had been repaired several times, in particular twice during the Mamluk era. The historian Mujir al-din, who lived in Jerusalem at the end of the 15th century, mentions that the mosaics were in disrepair at the end of the Middle Ages. When the Ottomans captured Jerusalem at the beginning of the 16th century, they followed the trends of the time in Istanbul. Thus, under Suleiman the Magnificent, polychrome glazed ceramic tiles replaced the Umayyad mosaics on all the outside walls.

However, the delicacy of Umayyad art has survived in the decorations on the inside walls. The drum has been restored several times, so the decorations on the walls of the middle octagon are preserved best. The motifs of these mosaics are extremely complex, and their richness stems from the encrustation of mother-of-pearl associated with glass and gold. The ornamental effect is further enhanced by the use of polychrome marble, decorated in certain places in champlevé, all of which is decorated with colors that harmonize with the mosaics.[19]

The Al-Aqsa Mosque

The first mosque built in Jerusalem was the al-Aqsa Mosque (plate 2), which is mentioned as existing shortly after the Muslim conquest of Jerusalem, but with no precise dates. The southern wall of the Temple Mount was doubtless used very early as a *qibla* wall—that is, the back wall in a mosque indicating the correct direction for prayer toward Mecca. A mosque of this type was described by Arculf, a pilgrim, between 679 and 688; it was a rudimentary building that had been constructed from material found at the site and taken from the ruins of the Herodian buildings.

Later, when Caliph 'Abd al-Malik built the Dome of the Rock, between 685 and 691, he must have been troubled by the lack of architectural harmony between the al-Aqsa Mosque and the splendid edifice that he had erected on the upper platform. A source as reliable as the 10th-century geographer al-Muqaddasi stated that the al-Aqsa Mosque was rebuilt so that the two buildings would be aligned on the same axis.[20]

There is no consensus as to who was behind this initiative. Analysis of literary sources suggests that 'Abd al-Malik was probably the originator of the project, which was completed by his son al-Walid the First. It was apparently an impressive building, decorated with sculpted wood, mosaics, and marble, and capable of complementing the Dome of the Rock on all counts, unlike the earlier mosque described by Arculf. The building itself has not survived, and it was long believed that this first monumental Umayyad mosque had arcades perpendicular to its rear wall, thus prefiguring the Abbasid building that replaced it. In fact, recent research supports the idea that the plan actually contained three long arcades parallel to the qibla wall. The building thus exemplified a new type of Syro-Palestinian mosque, with three rows of parallel

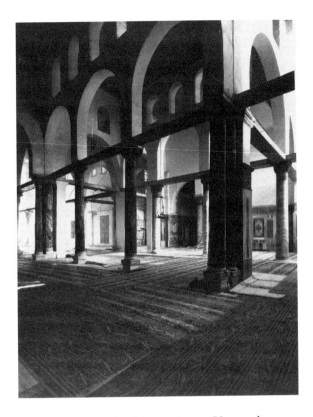

Plate 2. Interior of the al-Aqsa Mosque, Umayyad part.
Photo, Israel Antiquities Authority.

columns, first erected in Jerusalem and later integrated into the design of the Great Mosque built by al-Walid the First in Damascus.[21]

Unfortunately, the al-Aqsa Mosque was built on the southern area of Haram al-Sharif, the part added in the first century, in Herodian times, in order to build the royal basilica and its colonnade, the stoa. This part of the esplanade was supported by a series of pillars, forming an underground area commonly known in the Middle Ages as Solomon's Stables. These large underground spaces were particularly susceptible to earthquakes, and the al-Aqsa mosque was subjected to a series of tremors, resulting in recurrent damage. This explains why it was rebuilt half a dozen times,[22] unlike the Dome of the Rock, which was built on bedrock and which has held firm over the centuries (fig. 3, I–IV).

Fig. 3. Plans of the al-Aqsa Mosque.

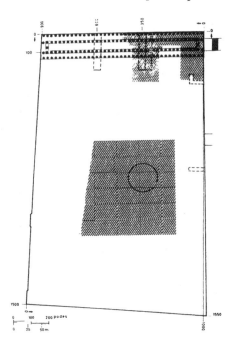

Fig. 3-I. First stage. *After M. Rosen-Ayalon.*

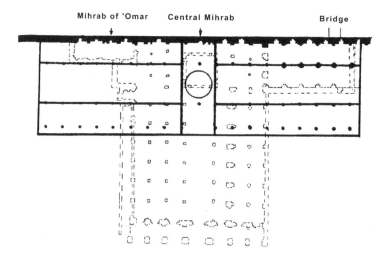

Fig. 3-II. Umayyad period. *After M. Rosen-Ayalon.*

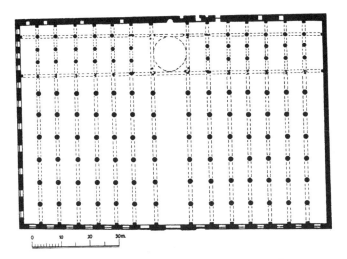

Fig. 3-III. Abbasid period. *After M. Rosen-Ayalon.*

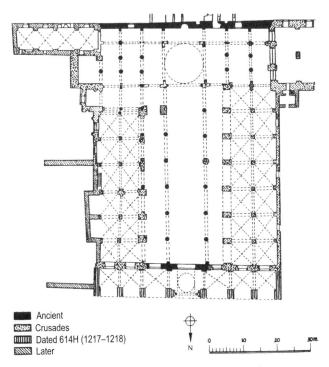

■■ Ancient
▓▓ Crusades
▥▥ Dated 614H (1217–1218)
▧▧ Later

Fig. 3-IV. Current state. *After R. W. Hamilton.*

Based initially on a Herodian structure shaped like a classic Roman basilica, the al-Aqsa Mosque was completely remodeled when it was rebuilt by the Abbasid caliph al-Mahdi in 780. It was given a central nave with seven arcades on either side, with a dome in front of the central prayer niche, the *mihrab*. The fairly detailed descriptions we possess refer to a building whose surface area was more than double its size today.[23] The building has lost most of its original architectural ornamentation, except for an extraordinary set of sculpted wooden panels that adorned the supporting ends of the roof beams.

These panels provide a rare illustration of Umayyad woodwork, since the motifs in the sculpture show numerous parallels with the wall mosaics in the Dome of the Rock. The dynamics, power, and naturalism of the floral decorations are comparable to the stone sculptures of the Umayyad palace of Mshatta in Jordan. Because wood is perishable, few archaeological remnants have survived. However, in Palestine, in addition to these panels, a remnant of a wood-carving was excavated at Khirbat al-Mafjar containing motifs that are similar to those at al-Aqsa and will be discussed later.[24] The mosque itself underwent further transformations, which will also be described later, but despite its smaller size, it remains today the Great Mosque of Jerusalem.

The Haram al-Sharif and Its Other Monuments

On the eve of the Muslim conquest, the Temple Mount had been deserted. Its dimensions were identical to those Herod had given at the start of the first millennium, during the construction of the royal stoa and the rebuilding of the Temple Mount. The ruins of this stoa were used as building materials for the first al-Aqsa Mosque, as mentioned earlier. This monument and the Dome of the Rock, built slightly earlier in 691–692, formed the key components of what was to become the Haram al-Sharif, the Noble Sanctuary (fig. 4). The Haram al-Sharif really only took on its significance after these two edifices were built; they were the impetus for a new architectural reality.

Over the centuries, the Haram was filled with monuments—religious or commemorative buildings marking historical or religious events—in addition to fountains, wells, arcades, and gates.[25] Today, despite these additions and the changes they symbolize, the Haram al-Sharif is defined architecturally as being of the second half of the seventh century, with the al-Aqsa Mosque to

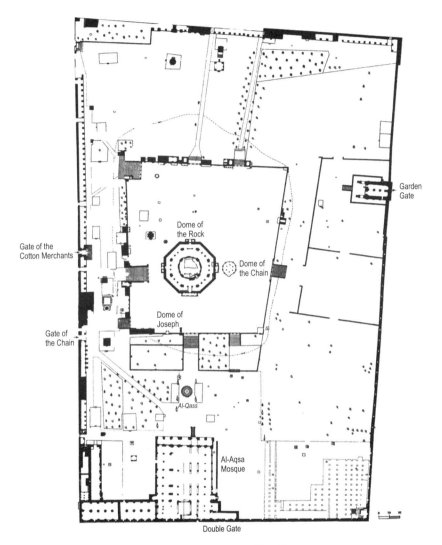

Fig. 4. Haram al-Sharif.

the south and, more to the north, an elevated platform crowned by the Dome of the Rock.

The Mawazin

Today, eight stairways (*mawazin*) lead to the upper platform. For reasons that escape us today, they are divided unequally among the four sides. These stairs were built in different eras and have been repaired many times. Their height is unequal because of the differences in topographic level, but so is their width. A discontinuous set of arcades forms the common denominator and delineates access to the upper esplanade.

Four of these stairways, each located at the cardinal points, help highlight the four entrances to the Dome of the Rock. They may be the oldest and could date back to the Umayyad period.[26]

The Dome of the Chain

This small monument, made of two sets of columns topped by a dome, is located near the eastern entrance to the Dome of the Rock; its purpose remains unclear. A medieval source suggests that it could have been the model for the Dome of the Rock, but the two buildings are completely different from each other. The Dome of the Chain, *qubbat al-Silsila* in Arabic, is not an octagon and originally did not have enclosing walls. Nevertheless, there is a certain architectural similarity between the two buildings because of their use of Umayyad full 180-degree arches and polychromatic marble columns; also, both reuse pre-Islamic capitals.[27]

Today, the Dome of the Chain is covered with Ottoman ceramic tiles, dating from the restoration of the Dome of the Rock. Note that the history of these two buildings is comparable in many respects. Both are cited in different literary sources, which describe the different stages of renovation. Additionally, remains of wall mosaics have been found when the Ottoman tiles have fallen off, confirming that this was the original Umayyad decoration here as well. Several corroborating historical sources also enable us to attribute the building of the Dome of the Chain to 'Abd al-Malik.[28]

The mihrab of this monument, facing south, must have been built somewhat later, but before the 10th century, when it is first mentioned in the sources. It was renovated at different periods, in particular during the Mamluk and the Otto-

man eras; its ornamentation still shows signs of these two phases. The decorative marble intarsia panels are particularly interesting, because they form a link in the chain of Muslim art that starts in Seljuk Anatolia and extends up to Jerusalem, both here and in the Tankiziya *madrasa*, as we will see later.

One feature that greatly enhances the symbolic significance of the Dome of the Chain is that it is located precisely at the center of the Haram al-Sharif, thus forming its focal point, or omphalos. It is also located in the axis of the mihrab known as the Mosque of Omar, which today is located inside the al-Aqsa Mosque—and perhaps played this role in the early mosque mentioned by Arculf. The location of this mihrab coincides exactly with the middle of the southern wall of the Temple Mount. In addition, two stairways leading to the upper platform in the north and south are also located along the axis of the Dome of the Chain and are part of this perfectly calculated overall plan.

The Double Gate and the Golden Gate

The Double Gate, set in the southern wall below the al-Aqsa Mosque, and the Golden Gate, which is part of the eastern wall, also play a key role in the history of the Haram al-Sharif. They are associated with Umayyad architecture and raise a number of archaeological issues, further complicating the problems of assessment of the artistic output of this era. These two gates share numerous features, concerning both their respective plans and their ornamentation. In addition, they have Herodian origins, and hence are pre-Islamic.

The Golden Gate, also known as the Gate of Mercy (in Arabic, *bab al-Rahma*) is one of the gates in the eastern wall of Jerusalem. It is the only one that leads directly to the Temple Mount from outside the city. The Double Gate is located below the al-Aqsa Mosque in the southern wall of the Haram al-Sharif.

Each of these units is made up of a double entrance covered by two semicircular domes supported by columns. In the Double Gate, a central pillar is the starting point for four pendentives that support the shallow domes. In the Golden Gate, two columns separate two pillars located at the two ends of the space created by the twin entrance, making it possible to cover the space with six semicircular domes. In both cases, because of the slope from the Haram, this space turns into an underground passage leading to the Haram al-Sharif. For the

Golden Gate, a series of steps lead to the platform level. The Double Gate opens onto what was at the time the Umayyad street (described later) parallel to the southern wall of the enclosure; this covered entrance ends on the platform via a ramp and stairs, just in front of the entrance to the al-Asqa Mosque.

The dating of these two gates has been the subject of heated debate; consensus reigns only as to the parallel in their architectural history. The same floral decoration, made up of rosettes and friezes, is found, even though the arrangement is not the same for both gates.

Roughly a quarter-century ago, the remains of an ancient arch were found by chance, buried some two and a half meters below the current level of the Golden Gate. Because the finds were the remains of an ancient, most likely Herodian, gate, they confirmed a recurrent feature in the Islamic period of integrating older traditions while remaining faithful to them. In the Herodian period, the Double Gate was one of the main entrances to the Temple, and its architecture dating back to that time has been partially preserved.

These gates were long believed to date back either to the Byzantine period or to the time of Justinian or Heraclius.[29] However, it has been made abundantly clear that the Temple Mount was deserted at that time, and would remain abandoned until the Islamic conquest. A sufficient number of narratives[30] describe the piles of refuse in this area of the city for us to exclude a Byzantine date. Monneret de Villard was the first to suggest an Islamic date for the Double Gate[31] and the Golden Gate. A careful study of their decoration, with their highly individualized style, makes it possible to state that they come from a Syro-Palestinian school.[32]

Although during the Umayyad period both gates enabled the public to reach the Haram al-Sharif, they only did so for a short period. The earthquake of 747 that destroyed all the administrative buildings on the southwest Haram (I return to these later) also eliminated the need for the Double Gate. It ceased being used toward the middle of the eighth century. The Golden Gate was also sealed, but at a later date that has yet to be firmly established. It has given rise to a whole series of legends and eschatological beliefs concerning its opening on Judgment Day.

These buildings were all part of the overall plan designed for the Haram during the Umayyad era. The initiator is believed to have been 'Abd al-Malik, whose son al-Walid the First was responsible for carrying out the vision. It is not

surprising that the Double Gate is located on an imaginary north-south axis that bisects the Dome of the Rock and the al-Aqsa Mosque. The pre-Islamic roots of this gate provide proof of the tradition of assimilation in Islamic civilization. As for the other gates that went from the city to the Haram al-Sharif, it is currently impossible to specify their exact location, or know their actual names.

Umayyad Monuments Outside Haram al-Sharif

In the 1970s, during excavations conducted in Jerusalem by B. Mazar, a set of monuments were discovered outside the Haram al-Sharif, in the south-western area (fig. 5). Although they are similar to the Umayyad "rural" castles (described in detail later), the monuments discovered in Jerusalem are more akin to what we might call "urban palaces."

Before Mazar's excavations, the major obstacle in the study of the Umayyad era was the absence of contemporary historical sources. For lack of something better, later sources were used—which, aside from their age, could not replace genuine testimony, and, worse, since these dated from the Abbasid period, they could be reasonably suspected of an attitude hostile to the representatives of the preceding caliph's dynasty. Mazar's excavations thus led to a revolution in this field and opened up uncharted perspectives on Umayyad civil architecture at the beginning of the Islamic history of Jerusalem. It is obviously impossible to determine the exact date of the building of this large complex, but everything appears to suggest that it was the end of the seventh or the beginning of the eighth century—that is, the era of Caliph 'Abd al-Malik (685–705) or his son al-Walid the First (705–715).

This architectural complex is composed of half a dozen buildings, some preserved better than others. All are square or rectangular, and their rooms are set around an open-air courtyard. These palaces are reminiscent of the Umayyad castles that will be studied later. Three buildings are aligned along the southern wall of the Haram al-Sharif, separated from it by an Umayyad street that covers the Herodian street that predates it by seven centuries. Aside from architectural similarities with other Umayyad monuments, there is also considerable stylistic kinship with the latter, in particular as regards ornamentation.

The central palace is particularly eye-catching, with its frescoes, sculpted stonework, and a beautiful pavement of stone slabs over the entire central courtyard. A series of vaulted spaces provide the supports for the palace, made

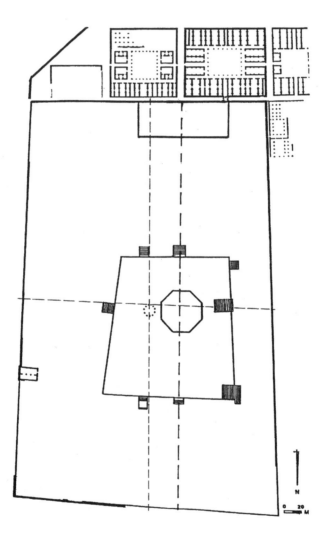

Fig. 5. The Umayyad complex in Jerusalem. *After M. Rosen-Ayalon.*

necessary by the slope of the southern part of the city. It is likely that they were used as warehouses.

A highly curious detail is worth noting: Analysis of certain elements found during excavation work suggests that the building had an upper floor, and the "stump" of an arch indicates that a bridge connected it to the southern wall—the qibla wall of the al-Aqsa Mosque. This custom of connecting the palace to the mosque dates back to the first century of Islam, and guaranteed the ruler a safe passage from his residence to the mosque.[33] The palace can thus be identified as the governor's residence (the *dar al-Imara*) and as forming the central component of what can rightly be considered the administrative compound.

This palace differs from the other Umayyad castles in Syria and in Jordan—and even in Palestine, as we will see later—by the lack of corner towers and semicircular towers. It is part of a well-defined architectural program, each of the buildings located along the same axis and the main building lining up with the wall of Haram al-Sharif. The western wall is aligned with the western wall of the Haram, whereas the northern walls extend along the southern wall of the Haram. The entrances of each of the three palaces are located in the eastern and western walls and face each other.

An interesting detail concerning the urban topography of Jerusalem at the time of the Umayyads also comes into play. One part of the Ottoman wall of the old city—in the south, where these palaces were found during excavations by B. Mazar—rests directly on the foundations of these ancient structures. It can be deduced that Umayyad Jerusalem extended, in this sector at least, beyond the limits set down in the 16th century by Suleiman the Magnificent. I will return to this issue later.

THE UMAYYAD CASTLES

These castles raise fairly complex issues. From the romantic *badiya* (rural/hunting castles) interpretations to the modern (and other) archaeological theories put forward by Jean Sauvaget—who considered these structures to be no more than farmsteads[34]—any number of purposes have been attributed to these Umayyad castles.[35] Most Umayyad castles are located in the Syrian and Jordanian deserts. In Palestine, aside from the palaces in Jerusalem mentioned earlier, there are two classic examples that are clearly

demonstrative of the vitality and diversity of the Umayyad era. The first dates to the beginning of this period, and the second to its end.

Khirbat al-Minya

One of the first Umayyad castles, and one of the most classic, is Khirbat al-Minya (fig. 6), located northwest of the Sea of Galilee. Several archaeological excavations have been conducted there. A German team worked in the 1930s up to the start of World War II, followed by an international team made up of French, American, and Israeli specialists who discovered additional pieces to the puzzle in 1959.[36] The site, however, has never been fully cleared.

The remains vary considerably in their state of preservation; some walls are still standing and can be four meters high in some places. The building is a square structure measuring about 70 meters on each side. The rectangular enclosure has a round tower in each of the four corners, and a semicircular interval tower in the middle of each side. The western one was opened out for use as a latrine. The main gate is located in the center of the eastern side.

Despite the many studies devoted to Umayyad castles, none of these buildings can be accurately dated. One inscription, which is not in situ, as well as a gold coin found nearby, make it possible to date Khirbat al-Minya to the beginning of the eighth century, during the time of the Caliph al-Walid the First, who reigned from 705 to 715. It provides a capsule view of all the features of other monuments of its kind.[37]

After entering by the arch of the main gate, a corridor leads to the central courtyard, surrounded by a colonnade. Several bases still remain. The rooms are laid out around this courtyard, and the function of some of them has been identified. For instance, at the southeastern corner is a small mosque in the Syro-Palestinian style, containing three rows of columns parallel to the qibla wall, of which only the bases remain. The only additional entrance to the castle is also found in the eastern wall of the mosque, enabling the faithful to come in from the fields to pray without having to use the main gate. Continuing along the southern wall, there is a large basilica hall, most probably the reception hall, followed by the residential quarters, where the room layout clearly adheres to the classic *bayt* plan. There is a central room with two small rooms on either side of it. Four mosaics (there were originally five) can still be seen on the floors. They are in more or less good condition, and of excellent workman-

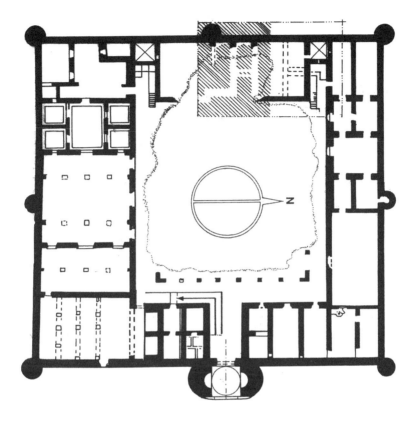

Fig. 6. Khirbat al-Minya, plan. *After O. Grabar, J. Perrot, B. Ravani, and M. Rosen.*

ship, as were all the mosaics in the Byzantine tradition in Palestine. They look like real carpets, with geometric themes surrounded by borders. One mosaic contains a lotus motif blending in with the geometric design.

The ornamentation in the palace appears to have been fairly sober. The flanking entrance portals still show a relief with floral motifs; there are the remains of plinths and doorjambs with geometric motifs. The walls in the large basilica hall must have been covered with marble panels, as is confirmed by several fragments still in position and the numerous holes used to attach these panels. This is a tradition characteristic of Umayyad construction, a legacy from Byzantine architecture. Along the western wall, twin staircases

lead to an upper level. Currently it is impossible to determine whether this level was the second floor or a flat roof in the Mediterranean tradition. Overall, the stone is beautiful, carefully cut and laid out. The whole building is set on a lower course of black basalt blocks, typical of local architectural style.

Not far away was a *khan*, or caravansary, which today has vanished. Given that Khirbat al-Minya is located in a particularly fertile area, one of the explanations suggested for building the castle and others like it was that it was not only a place of residence and festivity, but also a center for overseeing the surrounding agricultural land.

Khirbat al-Mafjar

This castle, located near Jericho, is thought to have been built about 740—in other words, toward the end of the Umayyad era (fig. 7). To a certain extent, it can be seen as a "baroque" variant on buildings of this type.

Popularly known as *Qasr Hisham*, or Hisham's Palace, it was commissioned by Caliph al-Walid the Second, as R. W. Hamilton has shown.[38] In contrast

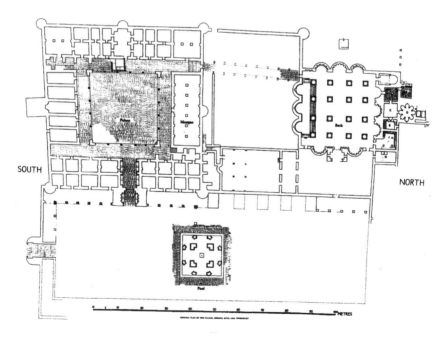

Fig. 7. Khirbat al-Mafjar, plan. *After Hamilton.*

to Khirbat al-Minya, whose plan is a simple square, Khirbat al-Mafjar is composed of at least four buildings, some of which are interconnected. Excavations were carried out by the British Mandate archaeological service between 1930 and 1940, but the whole site could not be fully unearthed. One of the conclusions drawn by the researchers was that this complex had never been finished. In contrast, all the existing buildings were probably destroyed in the earthquake of 749, which corresponds to the end of the Umayyad era.[39]

It is believed that the castle had an outer enclosure wall, but only part of it has been found to the south and to the east. The main gateway in the outer enclosure is located to the south and leads to a large courtyard, which must be traversed to reach the castle itself. The plan of the palace itself is somewhat reminiscent of Khirbat al-Minya, but in a more flamboyant style. It is a square measuring 65 meters on each side, with round towers at the four corners and semicircular towers in the west and the north. The gateway to the castle is located in the east and is much more monumental than at Khirbat al-Minya. In the middle of the southern wall, a concave niche within a square exedra faces the half-tower in the northern wall; I return to this feature later.

The rooms are laid out around an open-air courtyard, framed by a colonnade. There is, however, an unusual colonnade that leads to the main gateway, to the east. The columns are arranged by fours on a square base. The two rows of rooms on this side each have a bay opening out either onto the façade or to the courtyard, unlike the two rows of rooms on the western side. In the main area, facing the gateway, is the central room, re-creating the bayt plan as at Khirbat al-Minya. The rooms located along the southern wall form a single row. The central room has a niche, making it possible to identify it as having been the prayer room. (Syro-Palestinian mosques are oriented south, toward Mecca.) It could have been a small princely chapel, which would not have replaced the large mosque, itself fairly small, that was built to the north, between the castle and the front vestibule of the baths. The existence of a square base that extends to the outside, behind the mihrab of the small sanctuary is hard to account for. R. W. Hamilton attempted to explain it as the base of a minaret, like the Syro-Palestinian minarets of the Umayyad era, examples of which can be seen in Ramla, Damascus, and even, in its Western incarnation, in Córdoba.

Almost at the same spot as at Khirbat al-Minya (that is, in the southwest) are staircases leading to the upper level. But here again we are unable

to determine what was located there, whereas excavations have been able to reconstitute almost the entire upper floor of the eastern façade, both outside and on the courtyard side.

Facing the central room, in the middle of the west colonnade, is a very special architectural feature, the *sirdab*. This is a cellar that is accessed by a stone staircase. The sirdab, another of which is known to exist in Kufa, in Mesopotamia, is extremely luxurious here. A large, three-sided stone bench provides seating facing the mosaic-covered floor. Behind this bench, on the back wall, is an opening for a permanent stream of water to flow—governed by a hydraulic system—into a basin. The room was thus cooled by this advanced form of air-conditioning, dating back to the eighth century.

In the northwest corner of the building, a series of broad steps lead to a gateway under the arcades whose bases have been preserved, and end at a second building, itself of exceptional interest. This was the second complex, made up of a large square room (described below), to the north of which was another smaller room that archaeologists call the *divan*. In addition, to the north is a complex of Roman-style baths.

The gateway in the center of the wall is a smaller copy of the castle's main gateway. This immense room is divided by 16 enormous cruciform piers, which are even more imposing than those of the castle's façade. They are flanked on all four sides by columns on a square base. These pillars supported barrel-vaulted exedrae topped by a central dome. Each of the four walls of the main hall had three niches that varied somewhat from wall to wall. Several years after the palace was built, the base of the three niches of the southern wall was sealed watertight to turn this part of the room into a pool, which was reached by a series of stairs.

The divan was a small rectangular room, ornamented with a stone bench at each side and ending in the north with an elevated apse. It included, according to the classic layout, a cool room, a warm room, and a hot room set on a hypocaust. Outside there was a spacious latrine area.

Before dealing with the architectural ornamentation of Khirbat al-Mafjar, it should be stressed that, because of its richness and variety, it constitutes an unparalleled example of Islamic art of that time. In general, the architecture is highly comparable to Khirbat al-Minya. The stone blocks are beautiful, and the entire complex is well dressed. This is one of the main features of Islamic architecture in Palestine, reflecting secular regional stone architecture, differ-

ing from the eastern regions, such as Iraq and Iran, where the use of brick predominated.

One highly unusual feature is worth mentioning in this respect. Although the decoration of stone architecture is traditionally stone or marble, virtually all the architectural surfaces of Khirbat al-Mafjar—its walls, its vaults, and arches—are covered in stucco, which is the classic overlay for brick construction. This is an astonishing combination of artistic traditions from the Sassanid east and the Byzantine west. Although there are a few examples of stone sculpture, in particular in the niches of the monumental door and the balustrades on the second floor, they are the exceptions (fig. 8).

The themes and motifs of this stucco decoration are fascinating. The variety is amazing, and there are geometric motifs as well as floral representations,

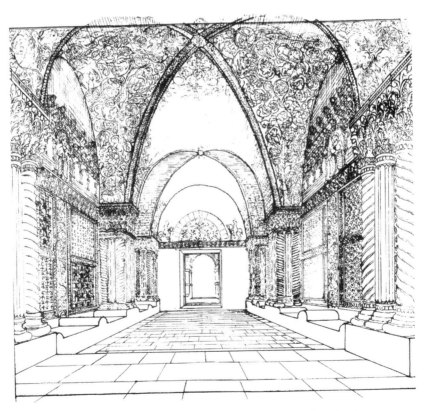

Fig. 8. Khirbat al-Mafjar, interior of the entrance. *After Hamilton.*

animals, birds of all kinds, and a whole range of human figures. The geometric patterns and the illustrations of the plant kingdom show a fusion of classic, Western influences with Eastern tradition, where the Sassanid influence predominates. Umayyad art is a remarkable illustration of the encounter of these two aesthetics, and Khirbat al-Mafjar provides us with an outstanding example.

The naturalism of the representations of human and animal figures is striking. The male Atlantis figures supporting the dome of the divan are true three-dimensional sculptures, although they were made of stucco. Both in the forecourt to the castle and under the bath hall porch, the visitor is welcomed by almost life-sized bare-breasted women (plate 3). They have been compared to the female figures on many Sassanid silver objects. There are also some influences of Coptic art.[40] A large statue of a man, nicknamed the "Caliph" when it was discovered, dominates the porch and the bath area, and was interpreted as a figural representation of the master of the house.

Methodological investigation of ornamental features confirms the archaeological observations that the bath area predates the rest of the construction by several years. A remarkable stucco rosette adorns the dome of the divan, composed of a bouquet thick with acanthus leaves, with six alternating male and female heads.

In an entirely different realm of artistic creation, Khirbat al-Mafjar can be proud of its extraordinary collection of floor mosaics. The immense square room of the bath area is completely covered with a series of mosaic carpets, which, amazingly, have come down to us intact. These extremely high-quality artistic masterpieces cleverly combine geometric and floral motifs. Their layout appears to reflect the architectural program of the building: a circle below the dome, half-circles under the half-domes, and rectangles under the vaulted spaces.

The decorative composition of the central niche of the western wall, which differs from the other niches, has given rise to various interpretations. Some believe it is a charade—a riddle—whereas others have expressed different theories.[41] But the most sumptuous mosaic of Khirbat al-Mafjar is unquestionably the one that decorates the niche of the divan. There are two gazelles on either side of a leafy tree laden with fruit. A lion is attacking one of the gazelles, sinking its claws into the gazelle's flanks. Drops of blood illustrate the ferocity of the attack. This strange imagery has prompted many interpretations.

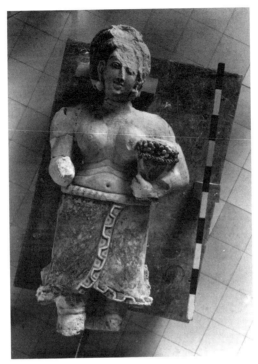

Plate 3. Sculpture from Khirbat al-Mafjar. *Photo, Israel Antiquities Authority.*

As for the large hall, some have argued that it was a meeting room where people undressed before going into the adjacent baths. This would be a purely Umayyad style that expands upon the classic Roman layout by adding the meeting area to it.[42] Others have thought it was the throne room.[43] Still others believe that the southern sector of this bath quarter, and more specifically the "pool," would have served for bacchic encounters and licentious frolics, as described in certain poems.[44]

There are two other architectural elements in this complex. One is the mosque. Exceptionally large, it served as a public place of prayer, in contrast to the small mosque in the castle, mentioned earlier, which was probably a private sanctuary. This large mosque is of the Syro-Palestinian type, as discussed in relation to Khirbat al-Minya, and is composed of two rows of columns whose bases have been preserved and which are parallel to the qibla wall. The mihrab is clearly visible in the southern wall. The other building is a small square

pavilion located in front of the castle and the mosque. Designed like a kiosk, it is made up of four pillars and eight pilasters. The very beautiful decoration of its balustrades and dome has been reconstructed. Its floor, which was given a protective layer that made it water-resistant, enabled a water adduction system to keep the building cool.

The whole architectural complex of Khirbat al-Mafjar—that is, the castle itself, the sirdab, the baths, the pavilion, and the vast system of water adduction and evacuation—provides proof of extraordinary skill, both on the technical level and in terms of the elaborateness and profusion of its ornamentation, all of which were devoted to incredible luxury.

It should also be noted that fragments of polychrome wall paintings have been found, but they were too damaged to fully restore. There is also a fragment of sculpted wood that was preserved at the time of the excavations.[45] Ignored up to now, this sample constitutes a rare testimony to a whole artistic tradition we might never have known. This wood fragment is similar in style to the wooden panels in the al-Aqsa Mosque and is reminiscent of the decoration of the Dome of the Rock. It testifies to the secular use of sculpted wood in Umayyad architectural ornamentation in Palestine.

The Founding of Ramla

In the second decade of the eighth century, the Umayyad Sulayman, son of 'Abd al-Malik and brother of al-Walid the First, was appointed governor of the Jund Filastin. One of his first moves was to found a new urban center, which he made into his capital and his place of residence. By doing so, he was following in the footsteps of other Muslim conquerors, whose territorial gains acquired during the Muslim armies' forward march evolved and gave rise to genuine cities. This was the case for Mesopotamian cities known as *misr* (pl. *amsar*)—the most famous being Kufa, Basra, and Wasit—as well as Fustat in Egypt and Kairouan in Ifriqya, which would later become Tunisia.

In Palestine, Ramla is the only example of a city founded after the Muslim conquest. (The founding of Beersheva by the Turks in the 19th century is a very different case.) An initial period of rapid growth was followed by a slower pace; today, after centuries of stagnation, Ramla has begun to flourish once again.

Sulayman's motivations for founding Ramla have never been fully under-
stood. It has been seen as a ruler's caprice to vaunt his personal glory. However,
economic and family interests could very well have been involved.[46] Whatever
the reason, Ramla is ideally located in the center of what was the Jund Filas-
tin province. In addition, the city is located at the crossroads of routes leading
north toward Syria, south toward Egypt, and east toward Jerusalem. Another
key feature may have played a role in its founding: the nearby presence of
the predominantly Christian city of Lydda (*Ludd*), the seat of a bishopric.
Sulayman's motivation may have been to dethrone this city, and it is true that
a number of texts describe a policy of "transfer" of the population of Lydda
by the new masters of the province. Sources stress the fact that there was no
earlier city on the site, and that Ramla was built on the dunes from which it
gets its name: *Raml* means sand in Arabic. As we will see later, archaeological
excavations confirm that the city was built on virgin soil.

The remains that can be dated to the beginnings of the city of Ramla are
few and far between, and thus it is difficult to identify the original city plan.
The city today covers most of the ancient quarters. In addition to the rare
remains, a small number of archaeological discoveries complement each other
to form a picture of this capital in the eighth century. In 1949, J. Kaplan began
to dig in the vicinity of the White Mosque—an Umayyad mosque mentioned
in the historical sources as dating back to the founding of the city. Kaplan's
finds helped draw up a plan of a typical Umayyad Palestinian mosque (fig. 9),
which can also be defined as Syro-Palestinian.[47]

The mosque is composed of a wide, open-air space, enclosed on three sides by
porticos. The fourth side, which also has a range of arcades, leads to a roofed hall
oriented toward Mecca. The qibla, the back wall of this roofed hall, is strikingly
long. Only a row of pillars divides the space. In the middle of the qibla wall, to
the south is the prayer niche—the mihrab—which has a polygonal portion jut-
ting out toward the exterior. Today this niche has lost all its decoration, but the
historical sources describe it as the most beautiful mihrab of all the mosques,
including Jerusalem and Damascus. The mosque and its minaret have both been
restored many times over the centuries, as discussed below.

In the open space of the mosque—often termed the "courtyard"—are three
underground cisterns, which are an archaeological curiosity. These cisterns are
divided into three areas of almost equal size by cruciform pillars. The arches,

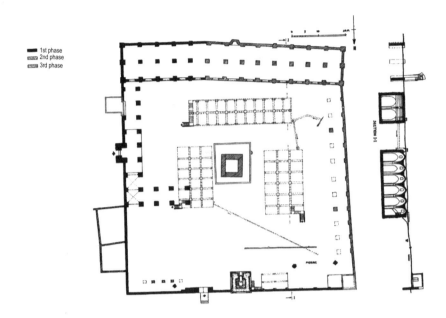

Fig. 9. The Umayyad mosque of Ramla, plan and cross section of cisterns. *After Kaplan.*

set in the four directions, are all pointed, which creates a sequence of interlaced vaults. The dating of the cisterns creates an interesting archaeological dilemma (plate 4).

More specifically, in terms of both the layout and architecture, these cisterns are very similar to the well-known cistern built in Ramla by the Abbasid caliph Harun al-Rashid in 172/789. However, the Abbasid cistern was considered to be the first to have systematically used pointed arches rather than the full 180-degree arches used under the Umayyads. The fact that the three cisterns in the White Mosque of Ramla, which are not dated, have identical architectural features means that either an earlier date must be assigned to the introduction of the pointed arch, and its systematic use acknowledged during the Umayyad era, or we must view the three cisterns of the White Mosque as having been built later, at the same time as the cistern of Harun al-Rashid. This archaeological enigma remains unresolved.

An excavation was conducted in 1965 in an area located to the southwest of the mosque, and was followed by a series of control digs. An impressive

Plate 4. Ramla cistern. *Photo, Israel Antiquities Authority.*

collection of pottery was quickly found, illustrating the range of ceramic production in the early Islamic period in Palestine. Hundreds of undamaged pieces were found, as well as an enormous quantity of sherds indicative of great homogeneity.[48] All this pottery was found on practically virgin soil, confirming the existence of sand dunes at the time of the founding of the city. Comparison of the results of several control digs in the vicinity of the mosque, mentioned by different sources as having been the point of departure for the development of this new urban center, all coincide with the eighth century and early ninth century, as regards pottery. Note that the excavations found no traces of ceramics from the late Middle Ages.

The complete pieces—jugs, cups, bowls, and a variety of receptacles—form a fairly complete collection that is highly homogeneous in quality. The clay used is light, ochre, and usually unglazed. In fact, in Palestine in general and

in Ramla in particular, glazing of pottery and polychrome decoration only appears a little later, as we will see.

Some pieces, as well as the casts and the rejects, suggest that there was a local workshop, perhaps with a stall. The use of molds is associated in particular with the manufacture of oil lamps and jugs (plate 5).

The ornamentation is in low relief, often refined, and uses geometric and floral motifs as well as birds or small quadrupeds. Molded ceramics appear to have been widespread in Palestine in the eighth century. The ingenuity of the casting process—through which several parts of the same object could be decorated separately before being combined—enabled an infinite range of variations. Numerous examples of this technique have been found in Ramla, but there are also other sites where this type of ceramics has been found for the Umayyad period. The best pieces of this type have been discovered at Khirbat al-Mafjar[49] and in other less important sites.[50]

Finally, the accidental discovery of a group of three mosaics in the sector of old Ramla deserves particular attention, since this find can be linked to the beginnings of the history of the city. Two of these mosaic "carpets" were designed in the traditional fashion, in the style used during the Byzantine period. One has a series of intertwined diamond medallions, filled with different motifs, including a small animal. The other is symmetrically laid out from a

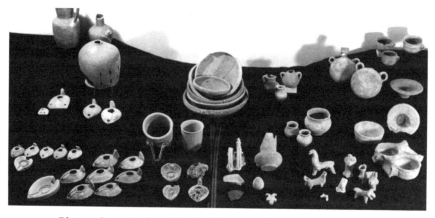

Plate 5. Ceramics from Ramla. *Photo, Israel Antiquities Authority.*

central motif. These two mosaics are complemented by a third, which is exceptional. Partially damaged at an unspecified date, today it has been separated from the first two but still preserves most of its decoration. An arch supported by two columns is clearly visible, along with the pedestals and capitals. The upper part of the arch contains a Koranic inscription in Kufic script with an injunction to prayer. There is no doubt that it is a mihrab, the only one in all of Muslim art to have been made in mosaics; the Koranic inscription is also the only one of its kind to appear on a floor mosaic (plate 6). In addition, the ceramic artifacts found on-site and the virgin soil on which the mosaics are laid confirms the dating to the eighth century.[51]

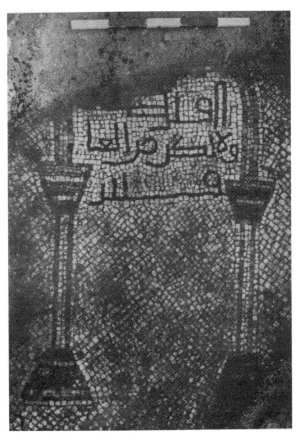

Plate 6. Ramla mosaic.

The White Mosque is unquestionably an Umayyad work, but the ceramics and the mosaics described above could belong either to the Umayyad era or to a period after the middle of the eighth century.[52] As for the Abbasid cistern, the other remarkable testimony to the history of Ramla, it belongs to the next chapter.

BET SHEAN (BAYSAN)

Recent excavations in Bet Shean have revealed a very impressive architectural complex. This city was part of the Decapolis and enjoyed continuous growth from the Roman era to the Byzantine period.[53] Activity in Bet Shean continued after the Byzantine conquest until the terrible earthquake of 749 that put an end to this flourishing urban center. This date is thus a cutoff point dividing the Umayyad period, with its wealth of monuments and potteries, glass, and coins, from the eras that followed up to the coming of the Mamluks, when the city was only a pale imitation of its former self.

One of the most interesting complexes discovered during these excavations is the Umayyad market, or *suq*. Among the impressive collection of items discovered from this time is a highly unusual mosaic inscription. Written in the stiff letters known as Kufic script, and dating to the period of the Caliph Hisham, who reigned from 724 to 743, this text is contemporary with the building of the market. The inscription is divided into two parts, one made up of six lines and the other containing a less well-preserved text. These two components were probably attached to either side of the main entrance and were made of gilded cubes, so the text stands out against the royal-blue background.[54] This is the only wall mosaic ever found in Bet Shean, and the only case of an Umayyad market that bore an inscription (plate 7). All the other ceramic and glass artifacts, and other remains found during the excavations, are presented in the chapters related to these different topics.

OPEN-AIR MOSQUES

Several remains of open-air mosques have been found in the Negev (fig. 10). These are fairly small rectangular spaces bordered by low walls. In the middle of the wall, oriented toward Mecca, is a niche forming the mihrab. This group

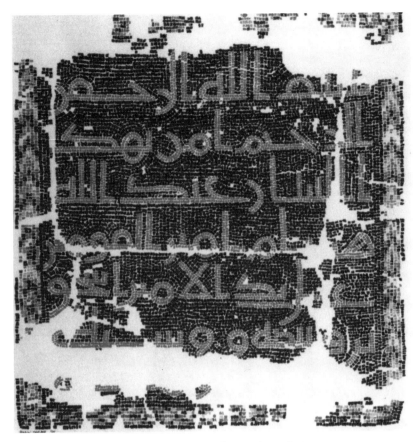

Plate 7. Mosaic from Bet Shean. *Photo, G. Foerster.*

of mosques is slightly later than the enclosures mentioned earlier, and it is generally believed that they date from the eighth and ninth centuries, a dating confirmed by sherds and coins found on-site.[55]

Similar examples have been reported in neighboring countries, and in particular in the Syrian desert.[56] The interpretations vary depending on the site. It has been suggested that the open-air mosques in Syria were forerunners of mosques. In Palestine, this highly regional architecture is thought to be a distant echo of a type of mosque that already existed at the time, but had not yet been adapted to the southern desert region. Even today one can still see walled-off spaces in the Bedouin encampments in the south of the country

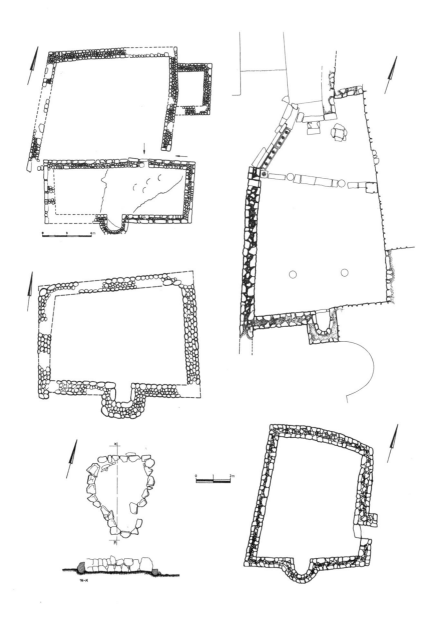

Fig. 10. Mosques in the Negev. *After G. Avni.*

which serve as mosques, and which are almost identical to those dating back to the start of the Islamic era. The artifacts collected during excavations help date these mosques to the eighth and ninth centuries.

Finally, a covered mosque built in the Nabatean city of Sbeita (Shivta)[57] should be mentioned. This mosque represents a type of construction that differs completely from the rudimentary mosques described above. However, Sbeita was originally a Byzantine city with churches and other buildings, whose ruins supplied a wealth of building materials. As for the open-air mosques "lost" in the desert, they do not appear to have been associated with large-scale architectural complexes.

MILESTONES

In many ways, the Umayyad era laid the groundwork for a civilization that was to develop in the centuries to come, and in many respects it established the basic institutions of the Muslim world. For instance, the *barid* system—operating the post office as well as the secret services—was set up in the era of Ma'awiya ibn Abi Sufyan, the founder of the dynasty.[58] The Umayyad caliphs who followed him continued to operate this institution, which naturally depended upon the existence and maintenance of a large network of roads. Confirmation of interest in this network by the Umayyad rulers can be found in remains of boundary markers or milestones.

Until recently, only four milestones were known. These were in the name of Caliph 'Abd al-Malik and indicated the distances from Jerusalem or Damascus.[59] They served to recall when the road was built and the date the milestones were erected. A new discovery of two other milestones, both in the name of this ruler, enriched this domain.[60] They were found in the southern Golan and reference the Damascus road. Archaeological studies in this area have shown that there was no road before the Islamic era. These two milestones thus provide proof of the construction of this road during the reign of 'Abd al-Malik.[61] It should be stressed, however, that from a paleographic standpoint, the inscriptions on these two milestones are of poorer quality than those on the four milestones inventoried in Jerusalem.

MISCELLANEOUS INSCRIPTIONS

A large number of inscriptions, singly or in groups, have been collected throughout the country, and it is of course impossible to list them all. They are from all the historical eras mentioned in this book but do not form a coherent set.

Several series of tombstones have been found in cemeteries and they can be studied on-site. The ones found in Jerusalem[62] are of great interest. A series of epitaphs can be seen in various museums in Israel, but not all have been published.[63] In this book, I will deal with inscriptions that are directly related to a historical, archaeological, or artistic context. A large number of these inscriptions found in Israel appear in the corpus of inscriptions now being drawn up by M. Sharon.[64]

The paleography of these various inscriptions, throughout the centuries of Muslim history in Palestine, has no unique characteristics of its own. From the standpoint of changes in scripts as well as their ornamentation, they are entirely consistent with the data from neighboring countries, and they do not differ significantly from what we know about the evolution of Arabic script during the eras in question.

NUMISMATICS

Although it is a key topic, making sense of the data from the coins of Palestine is so complicated that only a superficial discussion can be presented here. It is in fact impossible to chart a clear sequence of the different types of coins minted in the country after the Islamic conquest.

It is known that after having initially used Byzantine money the new rulers of the country began to mint "Arabo-Byzantine" coins—that is, Byzantine coins with a second strike in Arabic. The appearance of a new Muslim identity was followed by the use of the Arabic language alongside somewhat altered Byzantine motifs. In the next stage, professions of faith in the Muslim religion appeared on coins, coexisting with traditional motifs or even figurative representations dating from the pre-Islamic period.[65] Finally, in the Umayyad era, the Muslim identity was clearly established on coins. Mints were installed throughout the country and indicate "Filastin" or "Urdunn" as country of origin. These are generic terms, since the minting was done in Baysan, Ramla, Tiberias, or Iliya, which was the name used at that time for Jerusalem.

Umayyad-era coins were also produced by double-strike, as was shown at Hammat Gader. But in 97/696, Caliph 'Abd al-Malik introduced a sweeping reform: The new coins were all to be aniconic and exclusively epigraphic. This was obviously a measure that affected the Muslim empire as a whole. Palestine was no exception, but it is important to note a series of particularities.

For instance, during the Umayyad period after the monetary reform, coins have been found with the Muslim credo in Kufic script on one side, and various other themes on the other. Each coin had a different theme from the animal or plant kingdoms; there were also stars, crescents, lions, birds, and even scorpions. The floral motifs, such as palms or pomegranates, were apparently inspired by local pre-Islamic traditions. Some motifs appeared on ancient Jewish coins. A find has even been made of coins with one side depicting Islamic themes and the other side, a candelabra. It should be noted, however, that most of these candelabra only have five branches, and only a few rare ones have seven branches. These coins minted after the monetary reform are generally ascribed to the Jerusalem area and suggest inspiration from pre-Islamic Jewish motifs.[66] In subsequent eras, coins were minted according to rules handed down by authorities outside Palestine, and these local idiosyncrasies disappeared (plate 8).

Qanat Irrigation Systems

Remains of a system of hydraulic irrigation comparable to what was known to exist in Iran under the name of *qanat* have been found primarily in the Jordan valley and in the 'Araba region in the southern part of the country. The most interesting findings are located around Yotvata, and more than 20 drainage systems of this type have been studied.

The technique consisted of digging a series of wells about 10 meters apart, connected by an underground tunnel that sloped gently downward, making it possible to collect and draw water from below the water table. The longest tunnels were five kilometers long. Some of these qanats ended in a network of irrigation canals, which were covered with a layer of lime to make them watertight.

Remains of houses have been found near these canals, built presumably so that their inhabitants could take advantage of the water brought there.

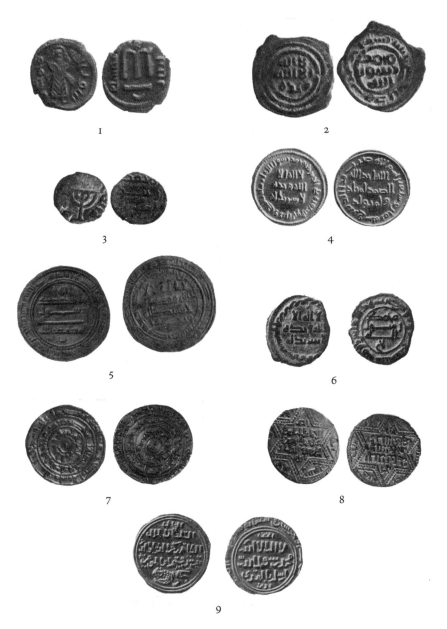

Plate 8. Coins from different periods. *Chart by Y. Meshorer.*

1. Umayyad—Byzanto-Arab; struck "Iliya Filastin"
2. Umayyad—Post-reform; struck "Iliya"
3. Umayyad—"candelabra" coin
4. Umayyad—gold dinar, 78H
5. Abbasid—silver dirham
6. Abbasid—bronze, struck at Ramla
7. Fatimid—gold dinar, 363H, struck in Egypt, found in Palestine
8. Ayyubid—silver dirham, 637H, struck at Aleppo, found in Palestine
9. Mamluk—gold, coin of Baybars

Numerous inscriptions in Kufic Arabic have been found that are paleographically similar to inscriptions from the first and second centuries of the Hegira found elsewhere.[67]

The pottery found in these houses is also characteristic of the beginnings of the Muslim era. There is a considerable quantity of cups, cooking pots, oil lamps, and other objects, manufactured in a homogeneous style and in general unglazed. Some pieces show the use of decorative techniques, in particular molded decoration. This pottery is highly similar to eighth-century pieces found in Ramla.

Other finds are worth mentioning, including ostraca, or sherds covered with inscriptions written in ink, in Arabic, which are thought to date to the eighth to ninth centuries, as well as coins, mostly Umayyad. Vestiges of farming activity, cooking remains, and tools found in situ confirm that this region was actively inhabited during the seventh and eighth centuries. The head of this excavation suggested that the system of qanats in Yotvata could not have been the work of local farmers or Bedouins, and that it was probably the remains of a state project, one role of which was to guarantee a supply of water to pilgrims going to the Hejaz.[68]

TEXTILES

Very recent archaeological finds have shed new light on the field of textiles, which remains one of the least well known. Because of climatic conditions—in particular the extreme dryness of regions like the Jordan Valley—at sites like Qasr al-Yahud, Nahal Soreq, Nahal Omar, the coastline of the Dead Sea (Karantal, Pella), and the Negev (Avdat and Coral Island), textile fragments have survived over the centuries, and in certain cases, even a thousand years.[69] These fragments enhance our knowledge of clothing and cloth-making techniques; they also provide information on the type of crops used to produce the raw materials.

The most significant find is that of cotton and linen; the latter could have been imported from Egypt or grown in the region. There are also indications of the use of wool and silk. All the fragments are from two separate periods: the beginning of the Islamic era (at Nahal Soreq, Nahal Omar, Pella) and the 9th, 13th, and 14th centuries, for the fragments found on the Karantal.

Several centers have already been cited as specializing in the manufacture or sale of textiles. Documents from the Geniza inform us as well that some silk fabrics made in Ramla were highly valued.[70] It is hence extremely interesting to have discovered, in the excavations at Ramla, the remains of a dye workshop and dyes.[71] The sources also mention the settling of dyers in Ramla, almost from its founding.[72] Some cloth fragments from excavations also show the use of printed decorations and decoration painted in indigo. A fragment of linen embroidered in silk has also been found.

This section would not be complete without a description of the superb reed mat now located in the Benaki museum.[73] Two lines or bands (*tiraz*) of inscriptions in Kufic script containing the words "*Fi tiraz al-khass bi-Tabariya*" ("Manufactured in the private workshop of Tabariya") indicate that this piece came from Tiberias and that it was made in a workshop that was active in the 10th century. Other fragments of mats have been found that use the same technique.[74]

Chapter Three

The Abbasid, Tulunid, and Fatimid Periods

ALTHOUGH the Umayyad era in Palestine was fairly short, lasting only from 661 to 750, it was uninterrupted, experiencing no invasions. The period that followed was different in many respects.

The rise of a new caliphate dynasty, the Abbasids, fomented the first split. Instead of Damascus, the seat of direct and quasi-Western influence in Palestine, the capital of the new Abbasid empire was first transferred to Kufa and then to Baghdad in Iraq in 761, and was then moved briefly to Samarra from 838 to 883. The shift in the center of gravity of the empire meant that the chiefs of state no longer took architectural initiatives in Palestine as they had in the past, and were not involved to the same extent in the life of the province. The "East" was the prime focus, and the part of the empire located to the west of Iraq no longer experienced the same vitality as it had under the Umayyads.

Let us pause for a moment to define historical periods for Palestine proper. The Abbasid era is usually said to have begun in 749–750, the date of the overthrow of the Umayyads by the new dynasty, and to have ended in 1258, with the capture of Baghdad by the Mongols. In Palestine, however, this lengthy stretch of time was broken in the middle of the ninth century when the governor of Egypt, Ibn Tulun, rebelled against Abbasid rule, proclaimed independence, and, to extend his influence, took Palestine under his control. For a period of several centuries, Palestine was no longer under the control of Iraq

but rather Egypt, well before the founding of Cairo under the Fatimids—who would play, as we will see, a crucial role in the history of Palestine. Without entering into the complex historical circumstances, it should be noted that between the Tulunid and Fatimid rules, there was a brief period of Ikhshidid rule from 935 to 969, which did not change relations between Palestine and Egypt, and which has left practically no trace except for a few coins scattered about archaeological sites. Two other intermediary periods, the Qarmats in Palestine from 969 to 1020 and the Seljuk conquest from 1070 to 1098, did not prevent the Fatimids from reconquering the country. The main traces of the brief period of Seljuk rule can primarily be found in a few epitaphs.

The influence of Egyptian rulers in Palestine was manifested in their vast projects, such as the building of the port of Acre under Ibn Tulun. This influence can also be seen in the very dense fabric of social, commercial, and cultural ties.[1] These relationships were so extensive that even the arrival of the Crusaders in 1099 was unable to sever or change them. This period is hence of utmost importance for constructing our overall picture of art and archaeology in Palestine.

RAMLA

The relatively small number of projects undertaken in Ramla during the Abbasid era contrasts sharply with the preceding Umayyad era. The most important monument associated with this period that can be dated to the beginning of the Abbasid period is the underground cistern mentioned earlier in relation to the White Mosque. Its architecture is reminiscent of the Byzantine cistern of Istanbul, which is supported by a series of colonnades that gave it its name: the Bin Bir Direk, the "cistern of a hundred columns."

The Ramla cistern is a true architectural masterpiece, built in one span of time, and the staircase leading to the lower level contains a beautiful inscription dating the construction to 789, the period of Caliph Harun al-Rashid.[2] It constitutes one of the most impressive examples of secular architecture. It is rectangular in shape, with an irregular perimeter measuring 24 meters by 20.5 meters, divided into square spaces by enormous cruciform pillars (fig. 11). The interior is characterized by the systematic use of pointed arches, and was, as we have seen in detail in this volume, the precursor for the new

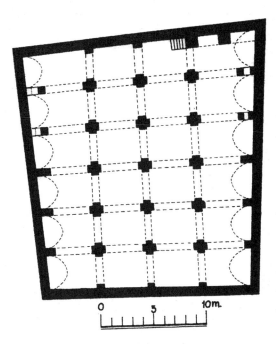

Fig. 11. The cistern of Ramla, plan. *After Creswell.*

type of arch that replaced the full 180-degree arch found in Umayyad archi-
tecture. However, both the plan and the style of this cistern suggest that it
was built at the same time as the cisterns of the White Mosque. To resolve
this problem, the historian must either attribute the cisterns of the White
Mosque to a later date, closer to the construction of the Abbasid cisterns, or
date the use of pointed arches to the Umayyad era.

Both sets of cisterns have openings in the vaults for purposes of drawing
water with buckets, and their walls are coated with a sealant to protect the
stones from humidity. The beautiful proportions of the Abbasid cistern create
a cathedral-like atmosphere, and it would seem that Ramla enjoyed a period of
great prosperity; numerous sources from that time praise the city's products.
However, no other monuments dating back to this period have survived.

Of note, however, is the Fatimid hoard found in Ramla containing many
different types of coins minted during this period.[3]

ABU GOSH

Abu Gosh is located about 12 kilometers from Jerusalem on the ancient road leading to Ramla and the coastal plain. Extensive clearance and excavation work began in 1941, and archaeological finds covering a period of a thousand years—from the Roman era to the Byzantine and up to the Muslim era have been found.[4] As regards Islam, Abu Gosh was important at two different periods: during the Abbasid era and then after the Crusader period, during a second Muslim phase, primarily under the Mamluks. For both periods, architectural and pottery finds have been made.

In architecture, a striking complex has been found that is very important in terms of its function and the historical role of this type of building. This building is a khan, or caravansary, which appears to be one of the oldest of its kind to have been found in Palestine. This caravansary, built at a time when this type of building was still in its infancy, already incorporates all the features that would be adopted later on, with clearly defined functions (fig. 12).

The khan has only one entrance, located to the north. This served to control who entered the building and guaranteed the safety of the travelers staying there. The entrance leads to a rectangular gallery that frames an open-air courtyard. In the center there was a pool, providing water for the visitors and a

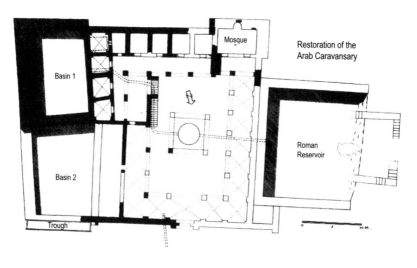

Fig. 12. Abu Gosh, plan of the khan. *After de Vaux and Stève.*

place for the worshippers to wash. It was filled by a system of pipes connected to an old reservoir, perhaps dating to Roman times, and to a basin. There is a series of chambers in the southeastern part of the gallery; this layout, which dates from the first centuries of Islam, was to continue until modern times. The chambers have only one entrance, and are not interconnected. A staircase leads to the upper level, but it is unclear whether this was a residential floor or a flat terrace roof. In the southeastern corner archaeologists have identified a small area with the traces of a niche in the southern wall; this may have been the mihrab of a small mosque, as was frequently found in khans.[5]

The architecture, along with a number of epigraphic sources, all concur that the Abu Gosh khan should be dated to the ninth century. Pottery found in situ, which I return to later, confirms this date. During the era of the Crusader kingdom of Jerusalem, the site was taken over by the Hospitaliers Knights, who called it *Castellum Emmaüs*. At this time the Franks built a large church in Abu Gosh, where valuable data for the study of architecture during the Crusader period can be found.[6]

Given that the khan dates to the ninth century, it may seem surprising that scholars have found pottery there they assign to the 10th or 11th centuries, and which is consistent with pottery found in other ninth-century sites. In fact this pottery, of great value to archaeologists, was found not in the stratification layers of the excavation, but rather in a cesspool built where a cistern had once been located.

The pottery can be classified into two groups: glazed and unglazed. The latter group is more prevalent and helps provide the earlier date since, as already pointed out concerning pottery found in Ramla, glazed pottery began to flourish in the ninth century (although there are a few examples from the eighth century). This trend was fairly general in the Muslim world but was particularly clear in Palestine.

Unglazed ware generally is only adorned with a few incisions or "combed" motifs. A group of hemispheric plates with rounded bases and fairly deep incisions was found. They are similar to a type of early Islamic pottery, as discovered in Jerusalem and at Khirbat al-Mafjar. Other plates are similar to those found in Ramla, and have been dated to the eighth and ninth centuries.

Similar to the Ramla ware, the clay is whitish and often covered with white slip. The walls are thin, the shapes are well balanced, and the finish is carefully

executed. These pieces are characterized by flat bases and tapered, stream-lined bodies with the neck flaring out from the shoulder. A long handle often goes from the rim to the shoulder, at times with a projecting knob on the top of the handle. All these features are similar to ware found in Ramla, but the differences in proportions of some jugs appear to suggest a slightly later date. This is also true for a series of 9th- and 10th-century plates found in Tiberias, Caesarea, and Yokneam, as we will see later. These similarities go beyond the borders of Palestine: Pottery with these traits can be found throughout the Muslim world of the time, in particular in regions of Mesopotamia, such as Samarra, and even as far away as Susa.

Along with this buff-colored pottery, there are intact specimens and sherds of red pottery, which were probably cooking vessels such as pots, pans, and lids. Other sherds, also in red clay, are from large, ovoid receptacles that "curve out toward the bottom to culminate in rounded bases"[7] with slight differences due to incised strips or an outlined coiled/threaded neck. These receptacles are similar to ones found in Palestine during the Byzantine era, whose style continued in the Umayyad pottery. The style of all this locally made unglazed pottery is entirely consistent with the Islamic pottery of Palestine in the 9th and 10th centuries, up to the beginning of the 11th century.

Only a few glazed pottery sherds were found, some of which are from imported objects. Some sherds, although damaged, can be identified as pieces of metallic lusterware from Mesopotamia. Almost all the other fragments had wide-lipped or rounded goblets with disk-shaped bases, and can be classified in the group of polychrome pottery, splashed or painted under a transparent glaze. Some sherds came from locally made cups. This polychrome pottery began to spread in Palestine around the ninth century and was made up primarily of cups, which were generally decorated on the inside.

The clay is white, fine, and comparable to unglazed pottery. The decoration uses rudimentary geometric patterns: scrolls, triangles, series of dots, or splashes of color—green or manganese on a cream-colored background enlivened with brown, green, or purple dots. The design is simple, covering the entire surface, and in some cases is complemented by floral motifs. The dividing line between this type of pottery (dating from the 9th century to the beginning of the 11th) and that of the subsequent periods (first the Crusaders, then

the Mamluk era, which saw the revival of the Abu Gosh khan) is extremely clear-cut, as we will see later.

The Port of Acre

This port appeared on Roman coins dating to the Ptolemaic era. However, the building of a new port in the ninth century was the initiative of the governor of Egypt, Ibn Tulun, who annexed Palestine as a whole. We possess a description of the port by al-Muqaddasi, a highly reliable 10th-century geographer.[8] What makes the description even more interesting is that al-Muqaddasi's own uncle was in charge of the project. This explains why his book includes a detailed description of the construction of the port: We learn how beams used to contour the port were anchored, and how they were inserted into a combination of stones and mortar before being sunk into the bay. After a year, the port was ready for use; the entrance had an arch with a chain across it to prevent boats from passing. This system was similar to that found in many other ports in the eastern Mediterranean, such as Tyre and Constantinople. Acre is probably the only port built in Palestine during the Islamic era whose construction has been described in detail.

The port of Acre remained active for several centuries, but it was destroyed in 1291 during the fall of the Crusader kingdom. Before that time, it is likely that the city prospered, but nothing remains of this Islamic city except a pottery workshop with its kiln, uncovered during recent excavations. Among the sherds, both glazed and unglazed pottery were found, as well as the stilts confirming local manufacture.[9]

Caesarea

A number of archaeological expeditions were conducted in Caesarea during the second half of the 20th century, and helped shed new light on the history of this city after the Muslim conquest of 640.

The most important excavations were carried out by the University of Haifa, starting in 1975. These were primarily devoted to a study of the harbor and the seabed, to which I return later. Starting in 1992, and for six consecutive years, research dealt with the old city.[10] The southern part of an entire

sector of Fatimid-era Caesarea was uncovered. This included a network of paved streets, with many subterranean storage bins near the southern wall of the city.[11] A mosque mentioned in the 10th century by al-Muqaddasi was even found.

On the basis of the artifacts—pottery, glass, metal—the standard of living in the Fatimid city must have been very high. These finds can be positively identified as dating from the 10th and 11th centuries, since the Crusader occupation did not begin before May 17, 1101. Urban planning in Fatimid Caesarea was very sophisticated, as is shown by the well-planned streets, sewer system, wells, reservoirs, and many water pipes.

The many storehouses that were unearthed were part of private homes and clearly demonstrate intense commercial activity, which was obviously related to the major maritime routes that terminated in the Caesarea harbor. Military conflict led to a period of considerable neglect in the 11th century, and the drop in the city's economic status caused a concomitant weakening of the social fabric. The economic revival in the second half of the 11th century did not enable the city to recover the splendor of the early Fatimid era. Nevertheless, the excavations have revealed the wealth and beauty that characterized Muslim cities in Palestine during the first centuries of Islam.

Pottery, the faithful representative of history, is poorly represented for the start of the Islamic era. A much broader range of Fatimid-era artifacts (both glazed and unglazed ware) have been found, although no unusual pieces were uncovered. The most typical form of unglazed pottery is the pear-shaped jug with an everted neck that bulges toward the spout, with a long, straight handle that stretches upwards from the rim and forms an angle before joining the shoulder. The top of the handle generally has a thumb rest. This pottery continues the trend already observed in Ramla and Abu Gosh. The clay is reddish and thin, with a "smoothed" finish. The decoration is extremely rudimentary, generally based on fine incisions. These shapes, typical of the first centuries of Islam in Palestine, at Khirbat al-Mafjar, Ramla, and other sites, would elongate and become thinner over the course of the 10th and 11th centuries. A series of artifacts characteristic of this period were found in Caesarea, including "grenades," oil lamps, and large containers of the "Pitoy" type. As for cooking vessels and pots made of brown clay, all are covered, on the inside, by a colorless glaze.

The glazed pottery provides examples of different families of Muslim pottery. There is underglazed painted ware, in relatively simple shapes, but with attractive designs. More elaborate ware has been identified as "Coptic glazed," and is often decorated with subjects, particularly birds.

The color-splashed dishes are covered with a transparent, almost always colorless glaze; they are similar to ware found throughout the country, and in particular in Yokneam, Abu Gosh, and Ashkelon. The excavations have also uncovered several examples of lusterware. This fairly complete, although somewhat irregular, collection of different families of pottery creates a problem that is not specific to Caesarea: Namely, there is no way of proving that these artifacts were exclusively produced locally. It can be assumed that some of the finds are remains of imported ware from neighboring countries.

At that time, most imported pottery came from Egypt, but there could have been imports from Iran or Mesopotamia, especially for small series. This was the case in particular for highly elaborate items, such as the metallic lusterware, which should not be confused with Egyptian pottery with painted luster decoration. Obviously, it is unlikely that the unglazed pottery was imported at great expense from distant countries, given its low value. Furthermore, there is well-documented evidence for the local manufacture of unglazed pottery.

The glass found in Caesarea during excavations of the Islamic period raises a similar question, since there is no proof of local production. However, the number of intact items, reflecting a very high variety of glasswork, is impressive. There are examples of blown glass, in general colorless and unadorned, but in a very wide variety of shapes, recalling identical items of the same era found in Mesopotamia or in Iran.

This rich collection includes a whole set of lamps of all types, vessels for medical or cosmetic use, and daily ware—bowls, dishes, jugs—and game pieces. One of the most remarkable items is a container that can hold 18 liters. The decorative techniques span all those known elsewhere in the early Islamic period. For instance, there are objects decorated with applied glass trims—threads or lozenges—engraved, cut, and blown glass; and mold-blown, stamped, and pincered decoration. There are also several items made of colored glass paste in turquoise or cobalt blue. All these techniques were known in the different glass production centers, and nothing here is specific to Caesarea.

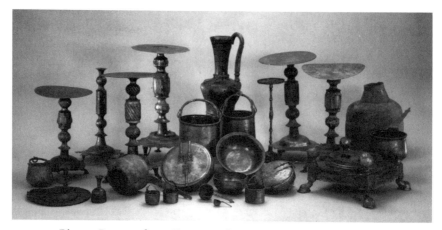

Plate 9. Bronzes from Caesarea. *Photo, Israel Antiquities Authority.*

Regardless of the value of the numerous pieces of pottery and glass found in Caesarea, the accidental discovery of a hoard of metal objects was the most striking find.[12] Hidden in the bottom of a recess that could only be reached by a well, this treasure of bronze and copper objects includes a spectacular assortment of objects for daily use. There are candelabra, candlesticks, boxes, braziers, ladles, buckets, as well as a variety of fragments, all providing a fascinating glimpse into daily life in the Fatimid period (plate 9).

These artifacts were often decorated with typical patterns, in terms of both style and choice of motif. In some cases, the decoration is accompanied by inscriptions in highly stylized, undulating Kufic script, often with letters having bifid ends. Most of these inscriptions are dedications, blessings, or good wishes. The set of candelabra are particularly interesting. Some are 60 centimeters tall; almost all are cast, and the largest are made up of soldered parts. The consensus is to date them to the 11th century.[13]

During an earlier excavation, about 40 years ago, the archaeologist A. Negev was lucky enough to find a hoard of jewelry buried in a small, transparent, green-glazed vase. The jewelry included different types of beads—carnelian, glass paste, tiny pearls, rock crystal—but above all a superb necklace of gold beads and several silver amulets (plate 10). The necklace, clearly the prize piece in the hoard due to its beauty and originality, captures all the features of the Fatimid art of jewelry making. Some of the large gold balls are decorated

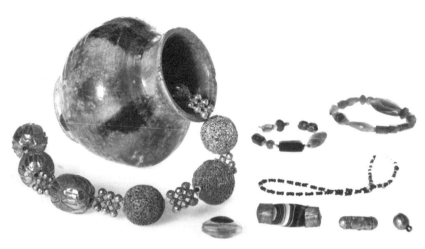

Plate 10. Jewelry from Caesarea. *Photo, Israel Antiquities Authority.*

with patterns created by exquisite granulation, while other balls and a central diamond-shaped bead were executed in filigree surrounded by granulation. The style of the necklace harmonizes perfectly with the other jewelry of the same period found during excavations in Ashkelon, which are described later.

But the Caesarea hoard raises an archaeological problem. The hoard contains silver amulets, two of which are shaped like a case and the other like a plaque. All three are decorated with a *niellé* design with inscriptions. Whereas the cases have simple blessings, the plaque is completely covered with verses from the Koran[14] written in a script known as *naskhi*. However, this script is generally dated to the Ayyubid period[15] (the time of the conquest of Caesarea by the Crusaders), and thus this hoard, made up primarily of Fatimid jewelry—as is shown from the style and comparison with artifacts found in Ashkelon—was only buried in the Ayyubid period.

Another Fatimid treasure found in Caesarea is less spectacular but nevertheless of interest. This is a set of silver bracelets, all of the same type but which differ in certain decorative details. The bracelets are hollow, rounded, and resoldered; some were filled with bitumen to prevent the fine silver leaf from being crushed. The decoration was hammered, and blends animal and bird motifs with geometrical bands. Again, the style here is perfectly consistent with other finds dating to the same era.[16]

Finally, other excavations carried out recently in Caesarea have found the contours of gardens dating to the first centuries of Islam, located on the outskirts of the city, so as to form a green belt.[17] As for the fortifications, scholars believe they have found the Islamic foundations, earlier than the Crusader walls.

TIBERIAS

After the Muslim conquest in 635, Tiberias became the capital of the Jund al-Urdunn. The city enjoyed a period of expansion, despite several earthquakes that caused considerable damage. The strong Byzantine wall continued to protect Tiberias, and in 1099, even resisted the first attacks by the Crusaders, who later reinforced it. As will be discussed later, archaeological excavations have been carried out in various sectors. Nevertheless, despite important finds, no significant monument from the Muslim period has been identified. On the other hand, a church dating to the eighth century (perhaps contemporary with the Abbasid era) and several residential buildings without notable archaeological value have been found. The important monuments of Tiberias are those dating to the Roman and Byzantine periods.

The numerous excavations begun by scholars attracted to the city's rich history have uncovered collections of pottery, glass, coins, and other objects to be discussed later. However, we should begin with an unusual object that was discovered accidentally several decades ago, during city construction work. It is a cylindrical piece of metal, open at both ends, and which may have been a stand. What is striking about this object is that its decoration is painted on metal, providing a unique example of the art of metalwork in the Islamic era. It is thought to date to the 10th or 11th century.[18]

The first excavations to make important finds for the Islamic period occurred in the 1960s. E. Oren cleared a whole sector, making a prime discovery in pottery.[19] What was most likely a pottery workshop was uncovered, as were numerous items related to pottery production. Remnants of glazes, rejects, and even lumps of ingredients used to make glazes were found. Aside from the kilns themselves, Oren found more or less unbroken objects, making it possible to reconstruct a fairly complete range of goods produced from the end of the 9th century to the start of the 11th century, confirming that there

had been local production of monochrome and polychrome glazed pottery, at times using molded decoration. The site also contained small quantities of unglazed pottery quite similar to items found in Abu Gosh, which argues in favor of the date suggested above—the 9th to the 11th centuries. It is also noteworthy that so many pottery fragments were found.

Numerous excavations conducted in recent decades have produced an impressive number of finds. A systematic study could form the basis for a categorization into families of pottery in Tiberias from the first centuries of the Islamic era up to the Crusader period,[20] most of which have been described above. In addition, less than one kilometer to the south of the workshop discovered by E. Oren, a potter's kiln dating from the 9th to the 11th centuries[21] was recently uncovered, confirming once again the existence of a local pottery industry.

However, Tiberias's greatest wealth was its glassware. An impressive number of unbroken artifacts, in addition to a multitude of fragments, is proof of the extremely high standard of living of the society that used them—including both engraved and cut glass or objects decorated with highly sophisticated methods. There is no doubt that they were made between the 9th and 11th centuries. The style corresponds to what has been found on other sites in the Islamic world at the same time, and nothing would suggest that Tiberias was an exception. On the contrary, all the glass discovered on the site coincides with the vast output of Fustat in Egypt, al-Mina in Syria, Samarra in Mesopotamia, and Susa and Nishapur in Iran.

The one outstanding object found in Tiberias comes from an excavation by G. Foerster and consists of glass fragments with luster decoration, which confirms the very advanced level of civilization of the time. This glass probably came from Egypt and provides additional proof of the relationships between Egypt and Palestine during the Fatimid era. A number of fragments with luster decoration that were part of a goblet were also found. This discovery, made at Tzur Nathan, not far from Tiberias, was associated with eighth-century glass. Unfortunately, it does not come from a stratified layer.[22] No other remains of glass manufacture have been found in Tiberias.

On the other hand, excavations in the autumn of 1998 revealed a large collection of Islamic bronzes. This treasure constitutes the largest archaeological find ever made in this domain. More than one thousand objects of all sorts,

stuffed into three large ceramic jars, were unearthed.[23] The jars were discovered at the foot of Berenice Hill, to the northwest of the city, and provide additional proof of the vitality of this Muslim city (plate 11). The collection includes numerous unbroken objects as well as hundreds of fragments, testifying to the fact that a workshop must have been located nearby. The find of a whole series of tools confirmed this hypothesis. Two of the jars also contained some 80 coins, among which were a series of Byzantine coins, known as "Anonymous Folles," which are fairly rare in this region. All the indications, both architectural as well as numismatic and archaeological, confirm a Fatimid dating, between 969 and 1099—before the arrival of the Crusaders.

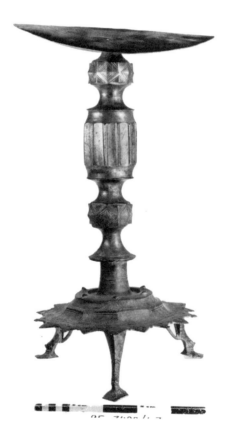

Plate 11. Bronze from Tiberias. *Photo, Israel Antiquities Authority.*

This hoard is valuable primarily for its artistic quality. Many of the objects are decorated, primarily by incisions.[24] The motifs are mostly floral, but there are also numerous epigraphic motifs, in general different blessings. The paleography of the latter is typically Fatimid, making it possible to date these bronzes to the 10th to 11th centuries. Their shapes are comparable to the treasure of Caesarea discussed earlier.

All this suggests that the Fatimid period in Palestine was one of great prosperity, shown convincingly by the Tiberias treasure. In addition to these finds, a small hoard containing jewelry and coins was found during a dig in the city center in 1989.[25] One of the most striking features about this jewelry is that it was placed in two clay vessels, one of which held the gold jewelry and the other the silver objects. This confirms the accuracy of S. D. Goiten's hypothesis as to the custom of separating gold and silver, both for jewelry and for coins.[26]

Although small in terms of quantity, the jewelry is broad in range—including earrings, rings, beads, and bracelets—but they are much less sumptuous than the Fatimid treasures found in Caesarea or in Ashkelon, as we will see.[27] Their authenticity provides a glimpse of the lifestyle of the less wealthy classes. There are only nine gold dinars, but one of them is stamped "Filastin," rare proof of the existence of minting in Palestine during the Fatimid era.[28] The silver coins are significant largely because they are much less commonly found in Fatimid-era excavations than gold coins are. They also have the particularity of having two holes drilled in each of them,[29] suggesting they were destined to be used as jewelry.[30] This impressive list of finds confirms that Fatimid Tiberias was a city of prime importance.

ASHKELON

This ancient city,[31] known in Arabic as 'Asqalan, grew rapidly during the Islamic era. Its port on the Mediterranean enabled it not only to trade with the Aegean world, but also to have close ties with Fatimid Egypt, as documents from the Geniza[32] have shown.

Aside from the Fatimid walls, to be discussed later, for many years nothing was known about the medieval city. Thus, great expectation surrounded the outcome of excavations begun in 1985 under the direction of L. Stager from Harvard University. They indeed proved to be of great interest and led to

discovering the remains of the Fatimid sections of the city. The pottery sherds and the gold coins unearthed were shown to have come from a period preceding the destruction of the city in 1191.

A study of the pottery from these excavations will be published shortly, but the major find is in the field of jewelry. It consists of a unique set of four pieces of Fatimid jewelry. These pieces, examples of the highest craftsmanship, are based on two techniques that were characteristic of this era: granulation and filigree.[33] Some of the pieces have more than half a dozen gold beads of various sizes. The twisted gold wires are soldered together on the back by fine flat gold bands, while on the front the wires are covered with tiny gold grains concealing these bands. The goldsmith used the art of filigree with an impressive level of virtuosity by creating circular motifs in which he inserted gold beads, creating almonds or small heart-shaped designs. The designs are all identical and destined to be inserted into a well-defined composition. The artist produced elements of equal length that could be joined to each other, as was probably the case. Unfortunately, only four elements of this marvelous set have survived (plate 12). It might be assumed that this high-quality object was imported, probably from Cairo, the Fatimid capital. However, studies of pre-Islamic Ashkelon, in particular during the Byzantine period, have pointed to the existence, already well established in the fourth century, of traditional goldsmiths, and the high status of artists who worked in this city of art and jewelry.[34] These superb Fatimid pieces discovered during excavations may just possibly have been made in local workshops.

Another object of great interest from 1993 excavations in Ashkelon is a tombstone containing 22 lines of text in a clearly Fatimid script, with its characteristic wavy ends. This stone was reused in Crusader times, following the Fatimid era, and it is covered over by a Latin inscription dotted with heraldic emblems.[35]

The pottery found here is similar to the Fatimid pottery of the time, such as was found in Tiberias, Caesarea, and in other sites; there were no exceptional finds.

Finally, the numismatic evidence is fairly irregular for a port city. Despite the expansion of Ashkelon during the early Islamic era, and in particular under the Fatimids, minting was apparently restricted to two short historical periods: from 700 to 750 and from 1109 to 1126. Whereas Umayyad coins

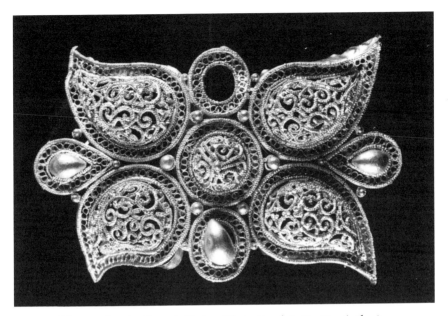

Plate 12. Jewelry from Ashkelon. *Photo, Israel Antiquities Authority.*

were made of bronze, the Fatimid coins were all gold dinars. These were the last coins minted in Ashkelon.[36]

Although the city had been under Islamic rule from its conquest in the seventh century until its capture by the Crusaders in 1153, this long period was not a peaceful one. Struggles internal to Islam opposing the Qarmats, the Ikhshidid, the Fatimids, and the Seljuks had disastrous effects on its prosperity. Later, Ashkelon's status as the last Muslim stronghold in Palestine before falling into the hands of the Crusaders endowed it with some degree of independence, and its Jewish community was given the title of "Madinat 'Asqalan." It continued to maintain ties with Cairo, as is shown by documents from the Geniza; these relationships, fruitful on an economic level, continued while the Crusaders occupied many parts of Palestine. They seized the city in 1153, and were routed in 1187 by Saladin's troops, who then began a policy of systematic destruction[37] from which Ashkelon never recovered.

In Ashkelon there are also records of a *mashhad*, or sanctuary, which according to tradition housed the relic of the head of al-Husayn. It is known that this

monument often underwent reconstructions, but its importance at the time was stressed by the presence of a superb Fatimid *minbar*, which, although commissioned especially to decorate this sanctuary, was finally transferred to Hebron, where it can still be found today.

JERUSALEM

We now turn to the discoveries from excavations carried out in the *qal'a*, or citadel, of Jerusalem. Several teams of archaeologists worked for more than half a century on this highly prized location (fig. 13).

Today, the citadel is an architectural mixture of Frankish, Mamluk, and Ottoman buildings, which we will look at more closely later. The excavations, concentrated in the courtyard, unearthed treasures covering several centuries; but in terms of the first centuries of Islamic conquest, they opened up a totally unexpected perspective. In the southern part of the courtyard, the investigators discovered a round tower about 10 meters in diameter.[38] A wall connects it to an earlier tower built during the Byzantine era. The walls were four meters thick, clearly showing that it was a military structure built in the early Islamic era. The pottery found in the excavations is typical of the eighth and ninth centuries, and includes unglazed as well as polychrome "splashed" or "dotted" painted ware. Fluted jugs with trumpetlike necks and molded oil lamps typical of the ninth century were also found. A gold coin dated 819–820 matches the dates of the other artifacts.

This first Islamic citadel is small, and much more unassuming than the ones that would later be built on the same spot. The plan, as determined by the excavations, is extremely complex and cannot be compared to any other known Islamic citadel.[39]

Archaeologists have suggested that the fort was built under the Umayyads and that it survived up to the Fatimid period (10th–11th centuries). At the time of the Kingdom of Jerusalem, it was replaced by a much bigger citadel that extended both north and south.

Other indications of the Fatimid period are provided by inscriptions found on the walls of the Dome of the Rock and the al-Aqsa Mosque. They testify to the importance of Jerusalem and its monuments in the eyes of the Muslim rulers, as well as attempts by the authorities to preserve them.[40] Aside from

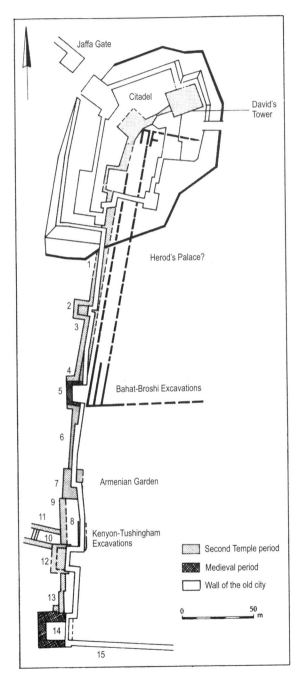

Fig. 13. Jerusalem, the citadel, and M. Broshi's excavations. *After H. Geva.*

the inscriptions in situ, other texts have been found on the Temple Mount[41] and in other parts of the city.[42] Most of these inscriptions are characterized by beautiful Kufic calligraphy with floral embellishments. The Fatimid craftsmen used not only stone but also wall mosaics (with glass cubes) or, in the case of the most spectacular inscription, wood.[43] The superb minbar in the mosque was unfortunately destroyed by fire about 30 years ago (plate 13).

THE SUGAR INDUSTRY

Archaeological explorations have revealed important information about the lesser-known activity of sugar manufacturing. As excavations proceed, archaeologists have been able to reconstruct a whole series of sites identified as having been used to refine sugarcane. Intact objects as well as sherds help confirm the existence of this industry.

Sugar manufacturing, which probably began at the start of the Islamic period, expanded considerably under the Crusaders, in particular in Acre,[44] and then under the Ayyubids and the Mamluks.[45] The containers used to refine cane sugar are similar to those used throughout the Middle East and even as far as Susa.[46] These were conical unglazed jars with wide rims and holes in the bottom. Unglazed receptacles were placed over the jars where the sugar crystallized. This industry also existed in countries neighboring Palestine, such as Jordan, in the cities of Kerak and Shaubak, for instance.[47]

In Palestine, more than 40 sites containing the remains of the sugar industry have been found.[48] However, after the final defeat of the Kingdom of Jerusalem with the capture of Acre in 1291, the Franks took this industry with them, traces of which have been found in Cyprus, Crete, and Rhodes. This was indeed an industry whose roots must be sought in Palestine.[49]

BONE ARTWORK

Excavations have also unearthed bone artifacts, for daily usage or artistic purposes, that date over a period of more than a millennium. Some of these artifacts are similar to finds made in Egypt and in Iran. In particular, there are bones transformed into little dolls decorated with engraved circles each with a dot. However, in Ramla and in Khirbat al-Minya, different "dolls" were also

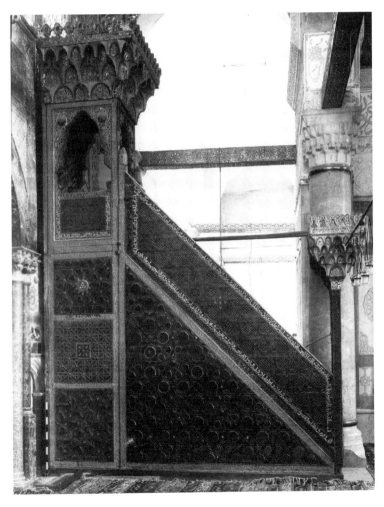

Plate 13. Minbar of al-Aqsa. *Photo, Israel Antiquities Authority.*

found where the bone was used as is, and engraved in the round. These are artifacts from a later period, most likely Mamluk.

In Ashkelon, several dozen fragments of bone plaques have also been found. The material was completely crafted in openwork, so that the end product looks like lace made out of bone. These were probably used as decorative pieces for objects or furniture (plate 14). They are associated with the period preceding the arrival of the Crusaders and are part of the rich heritage of craftsmanship of the first centuries of Islam. A few items, identical in style and quality, were also found during excavations conducted in Caesarea. Bones were also used to make small containers, similar in shape to those already known to belong to the same period, but made of glass or metal.[50]

The Fortifications

Even in antiquity, various cities in Palestine were surrounded by walls. However, during the Islamic era some cities were fortified and others were not.

For instance, there are no sources indicating that fortifications were built at the same time as the city of Ramla. Nevertheless, walls were apparently built in the eighth century—although strangely enough, the historical sources do not mention them. It was only in the 11th century, when Nasir-i Khusraw visited the city, that there was mention of the destruction of the walls of Ramla after a severe earthquake. These fortifications are concordant with the Umayyad building tradition, as seen in Ayla,[51] Ayn Dyarr,[52] and Qasr al-Khayr,[53] to mention only the best known.

The historian Mujir al-din, writing at the end of the 15th century, mentions that the area of the city of Ramla was smaller, as were probably its walls. Although we have no specific evidence concerning these walls, it can be presumed that, like other cities in the region for which fortifications are attested, they were shaped like a quadrilateral with the main gates at the cardinal points. Two perpendicular axes, made up of colonnaded streets that housed shops, divided the inside of the city, in the Roman tradition of the cardo and the decumanus.

The history of the walls of Jerusalem creates a specific problem: There is a historical gap in our information that is difficult to close. Although we know that there were walls in biblical times, it is impossible to retrace their existence

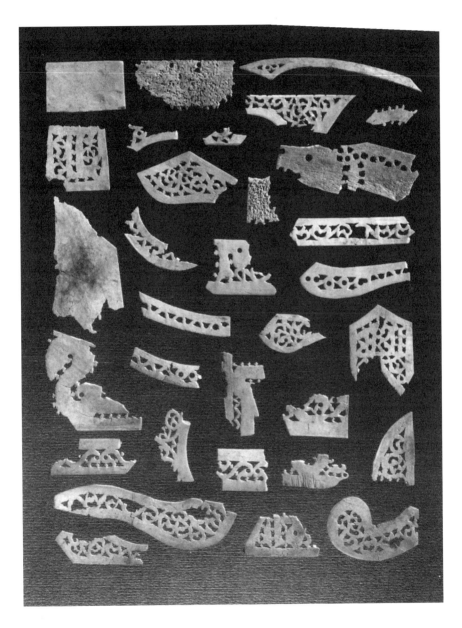

Plate 14. Bones from Ashkelon. *Photo, Israel Antiquities Authority.*

during the Middle Ages in a continuous fashion. It is known that the city was fortified during the first centuries of the Muslim conquest, but it is likely that during the entire Mamluk period Jerusalem was an "open city" and only partially walled. There is only partial documentation for the Fatimid period, and this information only concerns the extent of damage caused by the earthquake in 1033, in particular the destruction of part of the al-Aqsa Mosque. By contrast, it is known that the walls were reinforced at the end of the 11th century in response to the Seljuk threat.[54]

Under the Crusaders, Jerusalem was a fortified city, as attested to by a pilgrim who visited the city toward the end of this era. He states that the city was surrounded by three walls—which should probably be interpreted as three different sections of wall in several parts of the city, rather than three concentric walls.[55] In addition, all the illustrations of medieval Jerusalem show it to be surrounded by a wall.[56]

Another example that apparently has not been investigated is the walls of Ashkelon. On the eastern edge of the archaeological park in Ashkelon are enormous sections of felled walls. Although no in-depth study has been made of them, they are believed to date to Crusader times.[57] However, there is no evidence for the construction of Frankish fortifications in Ashkelon,[58] so we are forced to revert to the hypothesis that the building took place during the Fatimid period. As with Ramla and Jerusalem, the Fatimids rebuilt Ashkelon's defenses after it was damaged by the earthquake of 1033. The enormous stumps of walls of Ashkelon remain as silent testimony to Saladin's fierce destructive fury of the coastal cities at the end of the 12th century,[59] an initiative that was copied by the Ayyubids in Jerusalem.

The Fatimid period did not result in intense building in Palestine, and the rulers initiated few projects. For this reason it is noteworthy that precisely when the country was of little interest to the rulers, enterprises as impressive as the rebuilding of the walls of Ramla, Jerusalem, and Ashkelon took place. It should be kept in mind that the impressive walls of Cairo, the capital of the kingdom, were constructed during the Fatimid period. This influence was likely related to the wave of similar construction in Palestine at the time. Not until the Ottoman period did buildings associated with military architecture appear, first in Jerusalem and then in Acre, with the exception of Crusader edifices, which are not discussed in this book.

In addition to these large-scale projects, the country was dotted with small forts that can be divided into two main categories. On the one hand, there was a series of fortified buildings along the coastal region acting as military and religious forts, which corresponds to the Arabic term *ribat*. Almost all of these forts have disappeared, and only a few vestiges remain that can be used to reconstruct the plans at Ashdod Yam, Aphek, or Arsuf. Recently, a small fortress at Habonim, south of Haifa, was discovered—a genuine Umayyad ribat of classic proportions—in the shape of a quadrilateral with four circular angle towers and an entrance guarded by rounded half-towers.

On the other hand, a number of military forts are found throughout the country. Only a few rare vestiges, such as those of a fort found to the west of Jerusalem,[60] make it possible to trace their role. They were designed to form a line of defense, following a line dictated by the geography of the region.

Chapter Four

The Ayyubid and Mamluk Periods

THE CRUSADER ENCLAVE

History, art history, and archaeology of the Islamic period starting from the 12th century were all shaped by this exceptional period—the era of the Crusaders in the Holy Land.[1]

From the conquest of Jerusalem in 1099 until the fall of Acre (St. Jean d'Acre), the last stronghold abandoned in 1291, the Christian kingdom in Palestine experienced such vicissitudes as to make it an extraordinary topic of study. With respect to Islamic art and archaeology, this Western enclave acted as a catalyst in two ways. On the one hand, Western influence increased, although it varied, as we shall see, as a function of place of origin. On the other, when the Crusaders returned to Europe, they brought back their own impressions from their journeys in the Holy Land. Thus, the Crusader occupation of Palestine not only had an impact on Frankish art but also gave rise to the transfer and export of Oriental and clearly Islamic ideas, which were then disseminated in the West. These cultural and artistic exchanges were manifest on all levels, and can be found both in major art forms such as architecture,[2] as well as in the manufacture of the most humble materials, in particular ceramics.[3]

Before they embarked on the building of new edifices that would bear their own distinctive mark, the Crusaders began by appropriating existing

monuments that responded to their needs, and imparting to them a new symbolism. In Jerusalem, this was the case for the city's two major monuments. The Dome of the Rock and the al-Aqsa Mosque were both transformed into churches; the former became the *Templum Domini* and the latter the *Templum Salomonis*. Later, a cross was placed atop the former and various Latin inscriptions were added.[4]

Al-Harawi, a Muslim pilgrim and ascetic who visited Jerusalem in 1173, just a few years before Saladin reconquered the city, states that these two buildings were intact and that the Crusaders had scarcely damaged any of the existing structures.[5] He even provides a detailed list of the inscriptions in Arabic, which he copied in full. Unfortunately, the inscriptions themselves have not come down to us, with the exception of a few that confirm the contents of this invaluable record.

Clearly, the two monuments underwent little damage during the Crusader occupation, and since the Christians used them for religious purposes, they had to keep them in good condition. The Crusader initiatives in the Holy Land call for a study in their own right, devoted entirely to their art and archaeology. I turn briefly, however, to a discussion of a prime edifice, the Church of the Holy Sepulchre. A complete history of the building is beyond the scope of this book; furthermore, the basilica dates back several centuries before the Crusader era.[6] However, during this period it was reconsecrated, an event that inaugurated a key chapter in the history of architecture in Palestine—the exchanges between East and West.

The entrance to the Holy Sepulchre preserves to this day its mid-12th-century plan and style. Its extremely complex façade has been described in a number of studies.[7] The innovation for the period was the decoration framing the double porticos of the main entrance. Here, the wedge-shaped voussoirs gave their name to this new type of cushion arch that would be extensively used in the coming centuries during both the Ayyubid and Mamluk periods.

These cushion arches on the façade of the Holy Sepulchre in the 12th century were copied directly from the Fatimid architecture of Cairo. A typical feature of Muslim architecture, this arch constitutes part of the ornamentation of the great gates of the walls of Cairo.[8] It first made its appearance in 1087, and was the inspiration for the Christian architects in Palestine. This motif was

later used in locations far from the Orient, and these cushion arches can be seen on a good number of medieval monuments, particularly in Italy.[9]

As regards mosaics, reciprocal East-West influences are less clear-cut and remains are rare.[10] The opposite is true for ceramic ware, where the traditions and techniques of pottery were widely disseminated. One of the major problems, however, is the difficulty of clearly differentiating Crusader objects from Islamic ones. This is the case in particular for Ayyubid pottery, where it is hard to distinguish contemporary from post-Crusader work because the Crusader presence in Palestine ended at different times in different provinces.[11] Second, it is not always easy to distinguish pottery made locally by the Crusaders from pieces they imported, in particular from Syria.[12] However, the abundant production and the widespread distribution of ceramics at that time led to its impact being felt as far away as Greece,[13] Italy,[14] France, and probably even Spain.[15]

Two types of pottery were extremely popular at the time. The first was underglazed painted pottery, fairly simple ceramic ware covered with slip with rudimentary designs where the painting was in the form of splashes of color. The second type of pottery was similar to the sgraffito technique, where the decoration is incised into a layer of slip, and the whole piece is then generally covered with monochrome transparent glaze. This type of pottery was originally found in the Muslim Orient, in Iran and Mesopotamia, where it appeared as early as the ninth century. Its enormous popularity in Crusader Palestine and its transmission to the West are a good illustration of the role of Palestine in the development of new techniques in art. This applies especially to 12th-century ceramics. The Crusader period in the Holy Land thus forms a key link in the transmission of a number of artistic techniques whose sources lie in the Orient and which passed through Palestine before reaching the Christian West.

THE AYYUBID PERIOD: DYNAMISM AND NEW INTEGRATION OF WESTERN INFLUENCES

Although historically speaking this period was extremely short, since it only lasted from 1187 to 1250, it was nevertheless the impetus for many art forms whose impact can be seen to this day. Almost all the Ayyubid edifices are

located in Jerusalem, with two key exceptions: Ramla, with the renovation of the White Mosque, and Yokneam, where excavations have revealed important finds, particularly with respect to pottery.

The dynamism of this period is striking, despite its relative brevity. For instance, in Jerusalem, there are vestiges of religious (*khanqahs*, *zawiyas*, etc.) and military architecture (fortification of the walls of the city), as well as many other artworks like mosaics and polychrome wood, discussed below. In addition, a major change took place during the Ayyubid dynasty—namely, the adoption of cursive Arabic writing. Even though the forerunners have been found, and in other centers,[16] at this particular time, monumental and other inscriptions demarcated themselves from the older form. This feature is even more striking in that it was accompanied by a proliferation of inscriptions engraved on wood or stone, sculpted in stone, stamped on coins, painted on wood, molded in pottery, or even formed of glass tesserae, as in the wall murals of the al-Aqsa Mosque and the Dome of the Rock.

The dual battle waged by the Ayyubids first against the "unbelievers" (the Crusaders) and second against the Shi'ite Muslims, represented by the Fatimids, resulted in the construction of numerous madrasas.[17] One of the earliest to be inaugurated in Jerusalem was the Salahiya. But it was in fact purely the transformation of the superb church of St. Anne, built by the Crusaders, into a madrasa.[18] The building is thus not Ayyubid architecture, since the original edifice remained intact. If decoration was indeed added, it has now completely vanished.[19] The Muslims simply appropriated the Crusader building.

Jerusalem

St. Anne thus illustrates the integration of Western influences into Muslim art. However, there was another form of integration that physically incorporated Crusader-period material, and which can be seen in a number of buildings and other architectural works.

This was the case for various materials taken from Crusader buildings, such as small capitals or other fragments of sculpture, which were reused. There are several small units containing these reused materials inside the al-Aqsa Mosque and in the Dome of the Rock. In the Haram al-Sharif there are a number of small monuments where reused sculptural material from the Crusader period can be seen—for instance in the Summer Mosque (also known as the Minbar

of Cadi Burhan al-Din), the Mi'raj chapel, and many others. Similarly, the dome located in front of the Gate of the Chain (*bab al-Silsila*), at the entrance to the Street of the Chain (*tariq bab al-Silsila*), which leads to the Haram al-Sharif, also incorporates reused fragments taken from Frankish sculptures.[20] But the most striking example is clearly the façade of the al-Aqsa Mosque. Here, during restoration work in the 1940s, materials from the Crusader period were found, in particular stones used by al-Malik al-Mu'azzam 'Isa (614/1217–1218) to build the central arch of a new portico.[21] These were true components of pre-Ayyubid sculpture, integrated into this impressive façade.[22]

To cover all the Ayyubid antiquities in Jerusalem, we should begin with the mihrab of the al-Aqsa Mosque, on which is inscribed both the name of Saladin (or Salah al-din), the founder of the Ayyubid dynasty and conqueror of Jerusalem and the initiator of this monument, and the date of the work, 1187–1188. This mosaic inscription was made in *naskhi* script—as is the case for all those in the al-Aqsa Mosque and the Dome of the Rock which date to this period— and is made of gilded glass cubes on a green background.

At the same time that Saladin renovated this mihrab, he had brought to Jerusalem the superb Zengid minbar that had been commissioned by Nur al-din ibn Zengi.[23] This masterpiece of wood sculpture of the 12th century was placed to the right of the mihrab, but, as mentioned earlier, it was destroyed in a fire in 1969, caused by arson.

Next come certain religious institutions, such as the khanqah Salahiya or the zawiya Khantaniya, but only a few scattered vestiges remain.[24]

On the upper platform of the Haram al-Sharif, to the right of the southern staircase, is a small monument topped by a dome, and open on three sides. This monument, known as *qubbat* Yusuf, or the Dome of Joseph, was renovated several times, and thus dating it is difficult. Although its southern wall bears an Ayyubid inscription dated 587/1191, this plaque, which is not in situ, refers not to the monument where it is located but to the construction, by General Sayf al-din 'Ali ibn Ahmad, of a wall over a moat. The inscription thus refers to the extensive plans to reconstruct the walls of the city to repair the partial destruction caused by the siege of 583/1187.

Recent excavations have provided three supplementary pieces of evidence concerning this military architectural project,[25] in particular regarding the building of a tower. But the most striking feature is doubtless the inscription

found by Magen Broshi on the western part of the wall. Dated 599/1202, it mentions the name of al-Malik al-Mu'azzam 'Isa and comes from one of the gates belonging to the part of the walls built by this Ayyubid sultan. Furthermore, this first archaeological discovery was followed by another that confirms a historical fact mentioned in the sources. This discovery is two halves of a monumental inscription bearing the name of the same sovereign and dated 609/1212: It attests to the new destruction of the wall of Jerusalem[26] by the same sultan who had ordered its building 10 years earlier.

This is probably one of the strangest chapters in the history of Palestine from the perspective of military strategy. As we saw earlier concerning Ashkelon, Saladin decided to dismantle all the fortifications of the coastal cities of the country in order to dissuade the Crusaders from attempting to reconquer them.[27] This policy was maintained under the Ayyubids and continued until the end of the Mamluk period. The destruction of the walls turned it into an "open," unfortified city. Jerusalem was not fortified again until the arrival of the Ottomans.

Several fragments of inscriptions from monuments, such as fountains, colonnades, etc. (most of which have disappeared), provide us with an idea of the variety of building activities taking place in Ayyubid Jerusalem.[28]

Apparently no coins were minted in Jerusalem. Even in the rest of the country only a few rare examples have been found, including a coin minted in Ramla, one in Filastin, and three in Gaza.[29]

By contrast, two beautiful examples of woodwork can be found in Jerusalem. The enclosure surrounding the "rock" in the Dome of the Rock provides one of the first illustrations of *mushrabiyya* art, and certain sections were even engraved. It bears the name of al-Malik al-Aziz Abu Fath 'Uthman ibn al-Malik al-Nasir, son of Saladin, who ruled from 1196 to 1199.[30] The second example is a series of wooden beams that were discovered in 1940 during the major restoration of the al-Aqsa Mosque. These beams provide evidence for a type of wood craftsmanship that had been unknown up to then: painted beams. Although similar examples were known from North Africa,[31] in Palestine only sculpted ornamentation or relief had been found. The painted decoration, featuring typical floral or geometric motifs, can still be admired on the beams. Positive dating could be made to the 12th century because of a historical account that mentions repairs carried out in the al-Aqsa Mosque during

that century, and through paleographic data from the several inscriptions on these beams.[32]

Finally, it is worth noting that a highly interesting wall mosaic located at the base of the drum of the Dome of the Rock should probably be attributed to Saladin.[33] The inscription, which is not dated, includes the first verses of the Surat Taha in finely wrought *naskhi* lettering. The Ayyubid period in Jerusalem, which did not appear to hold much promise, reveals itself in fact to be of very great interest.

Ramla

Nasir-i Khusraw, who visited Ramla around 1047, mentions the destruction of most of its defensive walls in the earthquake of 1033. He writes that Ramla had become much smaller, and hence a very weakened city faced the Crusader assault. In terms of topography, as different archaeological surveys have shown, the Umayyad city extended in the Middle Ages toward the northeast. When the Crusaders built a cathedral in what today is Old Ramla, this accelerated the shift of the city center and the great Umayyad mosque—the White Mosque—found itself on the fringes.

It is impossible to estimate the extent of the damage to the White Mosque caused by the earthquake, or later by the Crusader occupation. The historical sources only indicate that after having recaptured Ramla in 1187, Saladin had the great mosque rebuilt. What we see today are the vestiges of this Ayyubid phase.

The strong square pilasters still show the traces of arches. They form two rows: The first corresponded to the façade of the covered part of the prayer hall, and the second, which is parallel to it, was the intermediary between the first row and the qibla wall. These bays were clearly pointed arches. A delicate molding follows the line of the arches. Today the advanced state of ruin reveals the mosque's finely fitted building stones as well as the layers of gravel filler. The Umayyad mihrab, however, which protrudes from the outside wall, still stands.

Yokneam

The Yokneam site is located at the crossroads of the road to Acre and the road to the Jezreel Valley, on the royal road, or *Wadi Milk*. Excavations carried out

onsite have uncovered objects ranging from the Bronze Age to the Mamluk period, including the Crusader period.[34] Walls have been unearthed dating to the beginning of the Arab conquest, which are oriented in a very different way from the preceding period. This phase appears to have been brief, from the end of the 9th century to the beginning of the 11th. It should be noted, however, that the excavations have dealt with only a small portion of the mound, and that we cannot draw valid conclusions for the site as a whole.

The pottery found on the site is consistent with the general typology and presents no unique characteristics. Because it fits into well-defined categories, it confirms theories concerning the different categories of ceramics in the early centuries of Islam.

A large quantity of unglazed pottery sherds from cooking vessels and pots has been found.[35] Only a few rare sherds belonging to the family of unglazed pottery with molded,[36] stamped,[37] or kerbschnitt[38] decoration have been found. The glazed pottery provides examples of the classic families of the 9th and 11th centuries: the dot, splash, and drip ware. Polychrome ceramics with sgraffito decoration are also present in large quantities. One piece of metal lusterware pottery deserves special mention, and is clearly from the Fatimid era.[39]

Among the pieces of unglazed pottery there are also numerous fragments of Mamluk handmade pottery, with simple, dark, monochrome geometric decoration.[40]

In Yokneam, the whole classic range of almond-shaped oil lamps has been found: many examples of the molded variety typical of the Umayyad period, but also the round lamps typical of the Mamluk period. Less common are clay pipes, a large number of which have been found, which date to the 18th and 19th centuries.[41]

The glass fragments correspond to what has been found on other sites dating to the same period, for instance, in Bet Shean or Tiberias. A less typical find was a set of glass beads from a necklace attributed to the Ottoman period[42] that was found in a tomb. Muslims typically avoid placing jewelry or other offerings in graves.

Another grave in Yokneam contained several pieces of bronze jewelry.[43] Excavations of this site yielded rare evidence for the Islamic period, which enabled a study of the type of bones and their identification.[44]

THE MAMLUK PERIOD

In the Mamluk period in Palestine, there was finally true political stability and the country experienced no external threats. The calm that reigned from 1260 to 1517 made it possible to set up stable social structures in both the cities and the rural areas. With the exception of two brief Mongol incursions in 1299–1300, nothing interrupted this continuity. However, during the Mamluk period Palestine was not an independent entity. As an appendage of sorts of the Syrian region, it was ruled by Cairo, the seat of the Mamluk sultan. This prolonged the situation that had existed since the ninth century under the Tulunids.

The new Mamluk administrative centers in Palestine no longer corresponded to the divisions set up over the preceding centuries. Safed, near Syria, with its qal'a, or citadel, became the front-line fortress of the northern region. Its governor took orders directly from the sultan.[45] In the center of the country, Ramla, Yibne, Jerusalem, and Hebron were the most important localities, and in the south, Gaza. These cities dotted the Damascus-Cairo axis, and crossed the Lydda bridge, which will be discussed later.

In terms of archaeology, one of the most difficult problems is distinguishing between the various families of ceramics. As pointed out earlier, it is not always easy to differentiate Crusader pottery from that of the Ayyubids. The same is true of certain Ayyubid and Mamluk pieces, in particular the sgraffito family, glazed pottery with decoration incised through the underglaze, and polychrome ceramics. Dating is not always possible except through the history of the excavated sites and comparison with other archaeological evidence.

Ramla

As discussed earlier, the Umayyad mosque was rebuilt under the Ayyubids, apparently leaving the original plan unchanged. The Mamluks added a dome in front of the mihrab in the 13th century, during the reign of the Sultan Baybars,[46] but nothing remains of it since the entire roof structure of the prayer hall has disappeared. The most impressive feature still standing is doubtless the minaret, a strong square tower that dominates the surrounding plain and whose fine architecture contrasts starkly with the ruins of the mosque. On a square base measuring about 7 meters per side, this tower is 30 meters high.

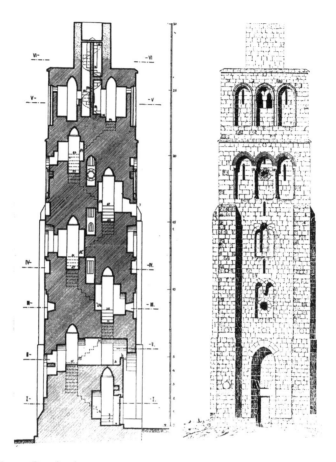

Fig. 14. Ramla, the minaret, cross section. *After L. A. Mayer, Pinkerfeld.*

The upper part, which today forms the top of the minaret, was built recently, making it impossible to know what the top of the tower looked like in the Middle Ages. The structure is a combination of religious and military architecture. Although after a certain date a minaret was an integral part of any mosque, here the buttresses and a few other structural particularities are features of military architecture. On the first floor, there is a protected passageway, which makes it possible to get to either side of the minaret quickly and safely (fig. 14). There are also loopholes all along one side of the building, whose impressive proportions exude a sense of strength (plate 15).

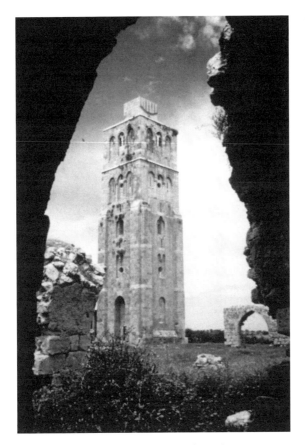

Plate 15. The minaret of Ramla.

Artistically speaking, the tower is a well-chosen and attractive combination of Mamluk architectural features. The tower entrance, for instance, which is clearly recessed in the Mamluk tradition, is in the middle of the northern façade, creating a deep niche framed by two stone benches, which is also typical of Mamluk entrances. On the lintel above the entrance and on the side are two inscriptions providing the dates for the building of the minaret and the name of the sultan: al-Malik al-Nasir Muhammad ibn Qala'un.[47]

The subtle interplay of building materials—white stone and pink and white marble—adheres to the Mamluk tradition of *ablaq,* or alternating courses of light and dark masonry. The reinforcement of certain foundations with column

shafts set horizontally at various intervals also emphasizes the feeling of architectural solidity. Furthermore, the varied use of niches and decorative arches makes the building stand out. For instance, on the first floor, two double arches end with a returned molding—an architectural touch that only appeared after the Crusader period. On the floor above it, a large three-lobed arch is clearly reminiscent of Crusader art.[48] This same influence can be found on the upper floor, where there is a group of three cushion arches. As we have seen, this type of ornamentation was originally used for the Fatimid gates of Cairo and was introduced by the Crusaders in the Church of the Holy Sepulchre; the Mamluks adopted it and used it profusely both in Jerusalem and throughout Palestine. Another element of the Crusader legacy can be seen in the small rose that figures in the center of the minaret and in the frieze around the three arches on the last floor. Here we have a harmonious assimilation by the Mamluks of a borrowed architectural tradition.

Lydda

Lydda provides an excellent illustration of the work of the Mamluk Sultan Baybars, whose touch can still be seen throughout the country (in Ramla, Safed, and Jerusalem). This monument is purely utilitarian, simultaneously highlighting this sovereign's concern for the well-being of his citizens and his vision as a statesman anxious to develop a network of roads in his kingdom. This monument, one of the most typical of the time, remains to this day a work of art.

The Lydda bridge (in Arabic, *Ludd*), built in 1273, is the only ancient bridge to have survived in Palestine. To fully appreciate the role it played in this region, we need to recall Saladin's policy of dismantling the coastal cities,[49] which was continued by the Ayyubids and even by the Mamluks. Thus, the country's interior road network alone ensured all vital traffic, and the bridge of Lydda, or *Jisr Jindas*, played a crucial role in the regulation of the north-south axis between Damascus and Cairo. This road was used for commerce as well as for the passage of troops, including those heading for El Karak in Jordan. This same road was used for the postal services, the barid. Even today, continuing its task undeterred, the Lydda bridge shows no signs of fatigue. It is 30 meters long, 13 meters wide, and is supported by three arches; the central one is 6.5 meters high,and and the two others are 5 meters.

These pointed arches intrigued archaeologists for many years. At the end of the 19th century, Clermont-Ganneau argued that the joining of the two stones at the point of the arch was inconsistent with methods of traditional Islamic architecture. In his opinion, there should have been one keystone;[50] this prompted him to claim that the arches of the bridge were in fact a reuse of the portico of the cathedral of Lydda built by the Crusaders a century earlier and demolished on the orders of Saladin (plate 16). This theory has been abandoned today primarily because numerous Mamluk monuments, in particular in Jerusalem, use both systems of arches, often for the same monument. This type of arch is no longer considered to be the exclusive realm of the Crusaders, but often provides proof of their influence on Mamluk architecture. Clermont-Ganneau's idea that there was a physical transfer of material from a Crusader monument no longer seems convincing.

The bridge is decorated in an identical fashion on both sides. A slab above the midpoint contains an inscription—five lines on one side of the bridge, six on the other. In addition to the traditional religious invocations, it mentions

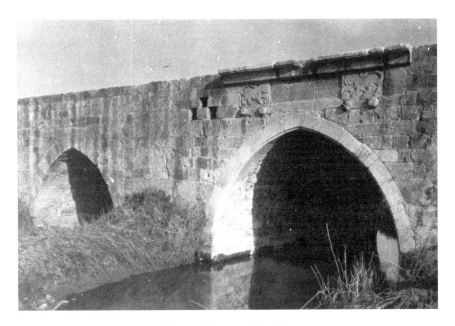

Plate 16. The Lydda bridge.

the name Baybars, his titles, the name of his son, the name of the builder of the bridge, and the date. On either side of the inscription are bas-reliefs with a panther, the coat of arms of Baybars. The panthers are moving toward each other and stepping on a small, indistinct, four-legged animal (perhaps a mouse). According to a somewhat disputed interpretation, the panther symbolizes Baybars crushing Hugues de Lusignan, the king of Jerusalem.

The use of the Baybars panther on bas-reliefs is found on various other monuments, which will be discussed later. Here it is worth mentioning a recent discovery, in the Qal'at Nimrud fortress in the north of the country, of a superb bas-relief of the Baybars panther measuring 70 centimeters by 150 centimeters, which probably comes from one of the defensive towers. Another bridge built by Baybars at the same time, not far from Cairo, has a frieze on one side containing a row of 33 panthers.

Finally, one last architectural detail specific to the Mamluks should be mentioned. Under each of these bas-reliefs there are two outcroppings. These are the remains of shafts of marble columns used initially as reinforcement, in accordance with an ancient principle that can be seen in the Roman port of Caesarea. The Mamluk architects continued to use this technique but here turned it into one of their decorative signatures, one that also decorates the Ramla minaret.

Abu Gosh

From the Mamluk period on, Abu Gosh gradually regained its Muslim identity and the khan entered into its second Islamic phase, which according to the excavators, ranged from the beginning of the 14th century to the end of the 15th.[51]

The architectural complex underwent several renovations. In general this involved minor features resulting from transformations made by the Crusaders. Walls were reinforced and enclosures modified; the layout of the apartments in the northern gallery was changed. Among other things, late clay pipes were found, as in Yokneam. But the real transformation concerns the mosque. The one described during the first phase was apparently no longer used and was replaced by a new building in the eastern part of the complex.

There were many khans in the Middle Ages, but these were gradually abandoned as modes of transportation modernized. Most are in ruins and have yet

to be studied. One of these—the al-Tujjar khan in the Lower Galilee on the Damascus-to-Cairo road—has been surveyed several times. It was apparently in use as of the first Islamic period but played a more major role during the Mamluk period, in the 14th and 15th centuries. It apparently also had an Otto-man period, in the 19th century.[52]

Jerusalem

The Mamluk era is the period in which the walled city of Jerusalem took shape. To a certain extent, today's visitor to the Old City experiences the Mamluk city as it expanded between the 13th century and 1517, when the city fell to the Ottomans. Many "living" examples of this architecturally rich period are still in existence and constitute a gold mine of information. Naturally, some monuments have disappeared;[53] others are partially in ruins;[54] but those that have survived form a true panorama of Mamluk art in Jerusalem.[55]

The relative calm that reigned during this period in terms of foreign relations did not prevent internal conflicts, the inevitable outcome of the Mamluk system of government. The vagaries of this system are reflected in the architectural activities of the era. Yet despite the political conflicts and other vicissitudes of Mamluk rule, the main centers of the regime were clearly linked. Buildings in Palestine are closely connected to those in Cairo and Syria.[56] The strong points may vary locally, and it is obvious that the status of the different centers, as well as the identity of the different Mamluk leaders, had an impact on the architecture. Nevertheless, the monuments of this era as a whole, whether in Palestine, Syria, or Egypt, share numerous common features, and their analysis forms one of the most original chapters in the history of Islamic art. Whether in Cairo, the capital of the empire, Damascus, the stronghold of government, or Jerusalem, the imposed residence of the exiles,[57] all were part of the new Mamluk style. More in-depth studies can reveal local particularities, but the global traits of this style are easily identifiable.

The abundance of monuments greatly facilitates our understanding of this period. Studies of the numerous buildings built in Jerusalem between the 13th and 16th centuries still standing today can draw on the vast collection of original written sources. Many historians have analyzed these sources, and their contributions to investigations of this period are invaluable.[58] Many of these monuments still have their *waqfiya*, or religious institution certificates,

making it possible to identify their function as well as the name of the donor who built them.

About 20 years ago, documents of this type were discovered that are of prime importance for understanding buildings and life in Mamluk Jerusalem;[59] in particular, they confirm other written sources related to architecture. In terms of archaeology, our knowledge is enhanced by the fact that most buildings have inscriptions, almost always positioned above the entrance or inside the building. These help identify the monument, the date of its construction, and the name of the founder; they may also indicate the name of those involved in the building and in some cases the name of the architect.[60]

The fact that the Mamluk system prohibited hereditary rule probably explains the astonishing proliferation of architectural output.[61] This was characteristic of the entire Mamluk empire, and Jerusalem was no exception.[62] More than 100 buildings still standing today, covering a period of three centuries, have been indexed.[63] Yet to really grasp the extent of architectural activity in Mamluk Jerusalem, the list must include known buildings that have disappeared, as well as those we can only presume to have existed.

The location of Mamluk buildings in Jerusalem is striking because of their concentration in certain specific areas: to the north and east of the city, near the Temple Mount, along the main streets, but also in certain streets adjacent to them. There are also buildings within the Haram al-Sharif, along the northern and western walls, since the western part of the Haram al-Sharif becomes the eastern part of the Old City. There are several other isolated Mamluk buildings, but in the sectors just mentioned there are remarkable numbers of them. Did the fact that the walls of the city were broken down under the Mamluks and provided but little protection influence the choice of preferred quarters? This may be the case, but in fact most Mamluk buildings were religious institutions of varying sorts, and this most likely explains why they were built near the Haram al-Sharif.

The dynamism of Mamluk construction in Jerusalem is also found in other types of projects, such as public utilitarian or military buildings. Jerusalem remained on the sidelines of major events in the Muslim world and during these centuries was content to embellish itself with a lovely architectural array. These projects are striking because of their human scale, differentiating them from the massive and somewhat outsized monuments built in Cairo at the

same time. The proliferation of religious institutions was a mirror of changes in lifestyle, a response to the needs generated by transformations and innovations heralded by this new era.

This was also the golden age of pilgrimages to Jerusalem for Jews and Christians as well as Muslims. The latter were obviously the most numerous and the *Fada'il* literature, or the praise of the merits of Jerusalem, was at its height. This probably explains the number of zawiyas, khanqahs, and ribats that doubtless facilitated their stay. The al-Mansuri ribat served as an inn. It was part of a whole range of hostels connected to a network of religious institutions. It differed from the khans, which catered to a very different clientele; the caravansaries were designed for merchants and travelers, whereas the hostels were primarily for those on religious pilgrimages.

Another type of religious edifice was the *turbes*, or mausoleums, built in the center of the city, half a dozen of which still stand today. But Mamluk architecture made its mark primarily for its madrasas, 20 or so of which still exist. These institutions for religious teaching were introduced by the Ayyubids, but grew rapidly during the Mamluk period, which explains the impressive concentration of clergy attested to in Jerusalem at the time. In addition, the madrasas fostered contacts with religious centers outside Jerusalem, encouraging the movement of scholars and students from one center to another.

Analysis of the madrasas shows the extent to which Mamluks considered themselves the defenders of Islamic faith, and the ways in which these monuments so spectacularly testify to this role.[64] But the madrasas, like other religious institutions, played another role in Mamluk culture: They enabled the emirs to provide for the future of their progeny, thus skirting the strict rules of a system that prohibited the hereditary transmission of power. The religious devotion of the Mamluks enabled its leaders to guarantee the transmission of the true faith to their descendants while ensuring their own futures by making large endowments to various religious institutions.[65]

Two people appear to have been the prime movers of Mamluk construction in Jerusalem. The first was Tankiz, the governor of Damascus under Sultan al-Malik al-Nasir Muhammad ibn Qala'un, during the first part of the 14th century. The second was Sultan Qayt Bey, who governed the region during the second half of the 15th century.

Mamluk buildings are characterized by many easily identifiable features.[66] During the first centuries of the Islamic period, the entrance to mosques, which faced the prayer hall, was the prime focus. In the Mamluk era, the façade was the overpowering feature, dominated by stone embellishments. In this sense, Mamluk buildings create a true architectural landscape in the streets of the Old City of Jerusalem. These façades, which are discussed below, contrast strikingly with the buildings themselves, and are made up of a large open portal set into a recessed arch. This arch is framed by a rectangle, and at each of its feet is a stone bench, a seat of prestige for the house guards or a comfortable place to wait. We have already seen the same design used several centuries earlier at the Umayyad castle of Khirbat al-Mafjar, proof that it is a tradition in regional urbanism.

The large vault created by the main arch was decorated with stalactite-shaped or honeycomb molding—the *muqarnas*—which range widely in variety and whose complexity at times creates three-dimensional geometric compositions, forming shapes like small domes; in certain cases, these "stalactites" end in true rosettes.[67] The vault forms an imposing space, at the back of which is the entrance, built on a human scale. This impressive ornamentation is further emphasized by the chromatic effects so closely associated with Mamluk style. Using a subtle combination of red marble, white stone, or at times gray and black stone, the architect outlined the contours of the windows and doors, the door frames and lintels, the line of the façade, and the inside walls.

The simplest pattern is the contrast in the layers, with two alternating colors, but in places there are polychrome combinations—such as the arch over the entrance to the Cotton Merchants' Market, on the side facing the Temple Mount. The decorative sophistication of these chromatic features often goes so far as cutting the supporting arches, creating an interplay between positives and negatives, and alternating the color of the stones of the voussoirs. This technique covers highly varied patterns and attains the virtuosity of inlaid marble in the astonishing complexity of polychrome façades.

Epigraphy is one of the most unique decorative features in the Mamluk repertoire to attest to the Islamic identity of this art. Inscriptions are generally found on large plaques set into the façade or panels above the entrance. The use of repetitive geometric or floral compositions also dates to the Mamluk period. These compositions are set in medallions or arranged inside polygonal

stars continuing on to infinity in all directions. The patterns are also comple-mented by incisions and relief. The decorative surfaces that cover most of the façades further accentuate the interplay of light and shadow.

Another typical feature of Mamluk decoration is the use of heraldic emblems. Integrated into architecture as well as into other more minor arts, they are one of the characteristics of this period.[68]

Many buildings have been identified by their inscriptions, their waqfiya, or through other historical references, which often show they went through sev-eral phases in construction and ornamentation. Some windows have even pre-served their original grillwork, which consists of longitudinal iron bars slipped into the hollow balls of the perpendicular bars.[69]

One of the main Mamluk edifices is the tomb of Bereke Khan. It is a real archaeological puzzle,[70] because it has a cushion arch, which originated in Crusader architecture, along with a zigzag arch, which was later copied in the ribat al-Mansuri, among other places.[71]

Other interesting buildings go back to Governor Tankiz. During his administration from 1312 to 1340, Jerusalem enjoyed a lengthy period of calm. He not only endowed the city with the best preserved madrasa, the Tankiziya, but also built a whole series of public facilities, which enhance the urban design to this day.

The façade of the Tankiziya is one of the most attractive and classic in Mamluk Jerusalem. The band on the façade contains historical information on Tankiz, the master of this house, and a goblet, his coat of arms, in triplicate. In architectural terms, this madrasa has the most complete cruciform plan in Jerusalem.[72] Dated 1328–1329, the central hall is surrounded by four iwans. This is a variation on the covered courtyard with polygonal bays in the central dome. The building is three stories high; on the eastern side, it encroaches into the façade of the Gate of the Chain (bab al-Silsila), mentioned earlier, which opens onto the Haram.[73]

The mihrab of the Tankiziya, located in the southern iwan, is ornately decorated. The niche is covered in longitudinal parallel marble stripes in alternating black and white, and also has an inscription. The arch is crowned by an ornate marble inlay in a style that originally came from Anatolia, as we have already seen concerning the mihrab of the Dome of the Chain.[74] But the most striking feature is clearly the cupola of the niche of this mihrab,

which is entirely decorated with glass mosaics.[75] This is a remarkable specimen of wall mosaic art, which apparently had a brief renaissance in Jerusalem. M. H. Burgoyne believes that this mosaic was the work of artists from Damascus, although his arguments are not entirely convincing.[76] A final component of the elegant madrasa has recently been rediscovered: the central basin, whose bottom is beautifully decorated in polychrome mosaics with geometric patterns.[77] The contour is polygonal and reflects the bay above it.

In 1330, Tankiz built the ribat al-Nisa, a hospice for women, which faces the Tankiziya in the Street of the Chain (tariq bab al-Silsila). In 1336–1337, he built the Cotton Merchants' Market (*suq al-Qattanin*), which is a striking complex of public architecture.[78] Adhering to the classic design for markets in the medieval Orient, it opens westward and extends a little less than 100 meters to end at the Haram al-Sharif (plate 17). This is a covered market, which has about 30 shops with two floors, on both sides of a main alley. Openings along the main artery provide lighting for this long market.

Two public baths, or *hammams*, are connected to this market, the hammam al-'Ayn, near the western entrance, and the hammam al-Shifa, in the middle of the market.[79] This complex also includes a khan, another of Tankiz's initiatives. Aside from its excellent state of preservation, the market can be proud of its monumental entrance on the side of the Haram al-Sharif. It is a spectacular portico, with highly decorative red, black, and white polychrome, and extraordinarily complex muqarnas. The double doors still have, on the bronze plaques, the inscription of their founding by Tankiz.[80] This market may have been rebuilt and enlarged on the ruins of an earlier market set up by the Crusaders.[81]

Tankiz was also responsible for the water adduction system designed to respond to Jerusalem's needs. It was fed by Solomon's pool, an enormous reservoir located between Bethlehem and Hebron. The new system of pipes, which replaced the water system dating back to the Hasmoneans and improved by the Romans, brought water to the Jaffa Gate, then, going under the Street of the Chain, ended at the Haram al-Sharif. This network brought water to the Kas, the large fountain built by Tankiz in front of the al-Aqsa Mosque designed to enable the faithful to purify themselves before prayer. The modern-day fountain is apparently not the original built by Tankiz.[82]

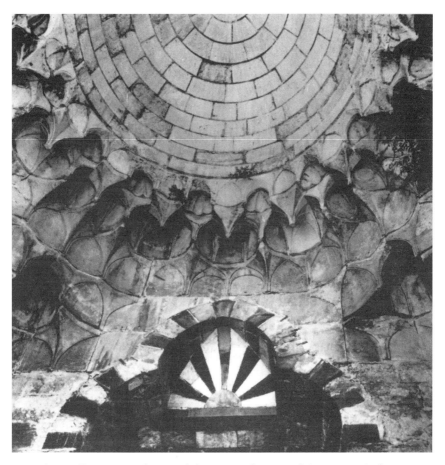

Plate 17. Entrance to the suq al-Qattanin. *Photo, Israel Antiquities Authority.*

At the beginning of the Street of the Chain, there is a completely different type of building. This is the khan al-Sultan, a two-story caravansary. The lovely consoles still remain, their architecture reminiscent of Crusader style and in fact identified as such by C. Enlart.[83] Max Van Berchem's theory that the khan was built by Sultan Barquq, based on an inscription dating to 1386–1387 but which today has disappeared, is probably wrong: The building is more likely a restoration of a Crusader-era caravansary. In fact, the inscription uses the term *"juddida,"* meaning "was renovated, restored."

This brief presentation of Mamluk Jerusalem ends with the two last monuments built in the city at this time. They are attributed to Sultan al-Malik al-Ashraf Sayf al-din Abu Nasr Qayt Bey al-Mahmundi al-Zahiri, to use his full title. The first is the madrasa al-Ashrafiya, built in 1482 and located to the left of the Gate of the Chain at the entrance to the Haram al-Sharif, and the other is the *sabil* of Qayt Bey, the fountain that was built the same year inside the Haram, facing the madrasa, and which bears the name of its donor.

The plan for madrasa Ashrafiya has two floors and a large meeting hall. The historian Mujir al-din states that toward the end of the building process, a Coptic architect and a team of craftsmen were brought from Cairo.[84] The entrance, which is located in the Haram, is clearly one of the most harmonious Mamluk madrasas of Jerusalem. It combines all the typical features, in remarkable equilibrium: the recessed portal, stone benches on either side of the entrance, ablaq, muqarnas, inscriptions, geometric patterns, a three-lobed arch, voussoirs with ornamental carvings, and, in addition, polychrome ceramic encrustations. It is not surprising that this façade is considered to best illustrate this style.[85]

The Qayt Bey sabil, in its sophistication, captures the quintessence of Mamluk style. Here the polychrome plays on delicate pastel tones of pale gray and soft yellow. Built on a square plan five meters on each side, the fountain is crowned by a pointed dome completely decorated with a highly elaborate floral composition creating a tapestry of ornamentation. It is the only dome of its type in Jerusalem.[86] The four colonnades that support it have elegant decorative stripes. The lower part of the sabil, the drinking trough, is made of stone that Max Van Berchem identified as being a sarcophagus from the Lower Empire.[87] A more recent study has confirmed this dating by comparison with a frieze from the same period.[88]

Finally, half a dozen minarets erected in Jerusalem during the Mamluk period were built using a square model, prolonging the Syro-Palestinian tradition. The only exception is the bab al-Asbat minaret, which is cylindrical.

This chapter devoted to the impressive history of life in Mamluk Jerusalem cannot close without discussing the changes made to the citadel of the city. This grandiose military architectural complex, whose history is a genuine puzzle, contains two elements today that date back to this period (fig. 15). The first is the monumental entrance located inside the Old City, on the eastern

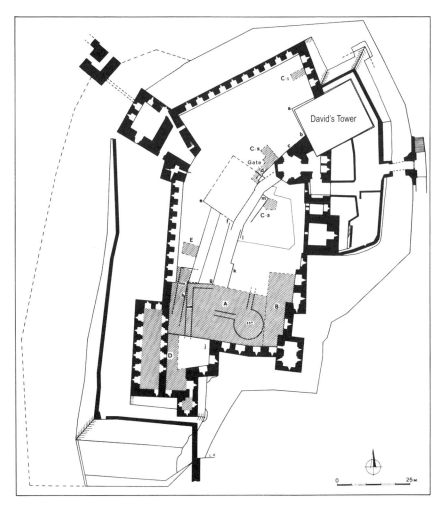

Fig. 15. The Mamluk Citadel, Jerusalem. *After H. Geva.*

side, above the moat and in the octagonal tower; the second is the mosque whose dating is far from clear but which presents many indisputably Mamluk elements[89] (plate 18).

A building that provides an admirable illustration of the archaeological complexity of monuments in Jerusalem is the minbar of qadi Burhan al-din, also known as the Summer Mosque. Built in 790/1338, it incorporates through reuse sculpted pieces from Crusader buildings, and today also has later Ottoman elements. The minbar sculpted in marble to the right of the mihrab is located on the upper platform of the Temple Mount (plate 19).

Hebron

In Arabic, Hebron is known as *al-Khalil*, but some texts also call this city *Masjid Ibrahim*, because of the Tomb of the Patriarchs that is located there. Hebron is the second holiest city after Jerusalem.

The Tomb of the Patriarchs is basically a Herodian building, but many features were added to it during the Islamic Middle Age. During the Mamluk era, more extensive work was carried out, including the marble overlay commissioned by Sultan al-Malik al-Nasir Muhammad (1293–1340).[90] The mihrab in the great hall that serves as the mosque is typically Mamluk in style and is also worthy of note. It is covered with parallel stripes of alternating black and white marble. Its niche is conch-shaped and lined with glass cube mosaics and a mother-of-pearl star encrusted in its center. The mosaic is very similar to the one that decorates the main mihrab of the al-Aqsa Mosque. This close tie between Hebron and Jerusalem is underscored by the fact that the Hebron mihrab is crowned by a rectangle of geometric intertwined ablaq, which is reminiscent of the decoration of the mihrab of the Tankiziya madrasa, which probably dates to the same period.[91] This artwork, from the end of the Middle Ages, provides an example of very late wall mosaic artwork in Palestine.

In the Hebron mosque, to the right of the mihrab, is one of the pinnacles of Muslim art: the Fatimid-era wooden minbar mentioned earlier, which was originally destined for the Ashkelon mosque and which ended up in Hebron. A whole chapter is devoted to this minbar in Vincent, Mackay, and Abel's monograph on Hebron.[92]

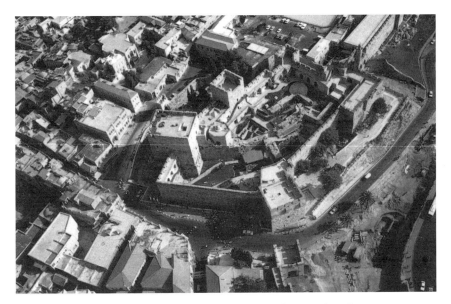

Plate 18. The Citadel of Jerusalem. *Photo, Dubi Tal.*

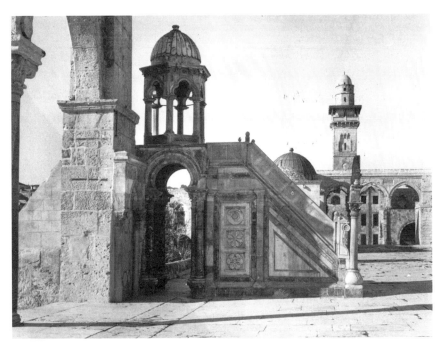

Plate 19. Minbar of qadi Burhan al-din. *Photo, Israel Antiquities Authority.*

The Tomb of the Patriarchs has always been a focal point for pilgrimages. An account written in the 11th century by Nasir-i Khusraw mentions 500 visitors per day at that time.

A whole series of Arabic inscriptions has been found on the site, and they testify to the importance of this monument for the faithful.[93] The minaret, located in one of the four corners of the sanctuary, follows the principle of square minarets characteristic of Palestine, of which many examples are found in Jerusalem.

Wall Mosaics

This section deals with a rarely studied art form, wall mosaics, which experienced a surge of popularity during the Mamluk period. The main phases of the history of wall mosaics are presented below.

Excavations in the Umayyad castles have revealed large quantities of small glass cubes, evidence of the use of mosaics in the architectural decoration of these buildings. In the Umayyad period this art form made an impressive leap forward. The masterpiece was the Dome of the Rock in Jerusalem, whose exterior was originally entirely covered by a sumptuous mosaic. This exceptional piece of artwork has unfortunately disappeared, but inside the monument we can still enjoy the beautiful remains of ornamentation, which enable us to admire the quality and virtuosity of the technique used. Historical and archaeological sources indicate that both the al-Aqsa Mosque and the Dome of the Chain were decorated with wall mosaics of the same type. In addition, as we have seen, Umayyad mosaics were also discovered recently in Bet Shean, as decoration for a market.

The use of this type of ornamentation is attested to at several points during the Fatimid era. Interesting fragments have been identified on the walls of the Dome of the Rock and in the al-Aqsa Mosque, which are notable for being dated. In the drum of the Dome of the Rock, a mosaic inscription gives the date 418/1027–1028. In the upper part of the framing on the great arch that supports the dome in the al-Aqsa Mosque, an inscription indicates 426/1035. There is no doubt, however, that other monuments contained wall mosaics during the Fatimid period, but no trace of them remains today.[94]

The artisans of the Ayyubid period apparently maintained a great interest in wall mosaics. It is thus no surprise that traces of their work can be found in

the two main monuments of the Haram al-Sharif. The first is the mihrab of the al-Aqsa Mosque, which contains an inscription mentioned earlier in this chapter. The shell of the niche of the mihrab is entirely lined with a mosaic whose delicate tracery made of gold cubes forms small medallions embellished with floral decor. A star encrusted in marble, and possibly mother-of-pearl, is located in the center. As we will see later, this design was used once again in Palestine. Let us stop for a moment to examine one idiosyncrasy of this mural decoration: namely, the spandrels located between the rectangle containing the inscription and the arch of the mihrab. They present particularly fine artwork, which in contrast to most wall mosaics—which use glass tesserae—is made of minuscule pieces of colored stone and marble. It is more than likely, as Max Van Berchem has suggested, that this is a technique that originated in southern Italy and was introduced to Palestine by the Crusaders.[95]

In the Dome of the Rock there is also an Ayyubid inscription that is attributed to Saladin, as well as a small mihrab that has attracted scant attention up to now. Located, obviously, in the southern wall of this monument, it is decorated with five lines of concentric mosaics, taken from Surat 29 and dating most likely to the Mamluk period.

Another mihrab located in Hebron is attributed to Tankiz, who undertook major restorations in the city. Here again, the inside of the niche is lined with a mosaic that bears great similarities to the one in the al-Aqsa mihrab. The floral trellis is similar, covering the whole surface, and the same star is found in the center of the conch.

The most impressive wall mosaic masterpiece from the second half of the Middle Ages, from the Mamluk period, is the Tankiziya, the madrasa built in Jerusalem by Tankiz. The mihrab is covered with a highly sophisticated floral mosaic, clearly akin to certain features of Umayyad wall mosaics in the Dome of the Rock, in particular with the encrustation of mother-of-pearl. It seems reasonable to assume that this late-emerging art takes its inspiration from the seventh century in Jerusalem, from the mosaics of the Dome of the Rock (plate 20).

Historical sources also stress that restorations of the wall mosaics were carried out during the Mamluk period in both the Dome of the Rock and the Dome of the Chain. Although it is true that Syria and Egypt both have several examples of wall mosaics of this type, Jerusalem was apparently the home of

Plate 20. Mosaic from the mihrab of the Tankiziya.

a genuine "Palestinian" school that lasted for centuries. The best proof is provided by the artisans of the Medina mosaic, created between 786 and 800, who in signing their masterpiece indicated they were from Jerusalem.[96]

Safed

Located in the north of the country, Safed began to play a key role after the Muslims retook the city from the Crusaders. Baybars, who visited the city in 665/1266–1267, ordered its restoration and made it one of the two capitals of the country (the other being Gaza, in the south). Safed's powerful citadel dominated the region, but little remains of it today. The city also flourished architecturally, with military, religious, and public buildings. In the 15th century it was a major city, and a few vestiges of this golden age can still be seen today in Safed's Old City.

The Banat Hamad zawiya dates back to this time. It is made up of a large square hall topped by an exquisite dome and framed by two iwans, to the east and the west; inscriptions from later periods have been found on them. The harmony of the proportions enhances the specifically Mamluk architectural features. For instance, the monumental entrance is recessed, creating a large overhang with ornamentation in very pure lines, made of contrasting dark and light masonry in the ablaq tradition. The ornamentation is accentuated on the western side by the large bay that frames the two windows. There are also two parallel black basalt plinths running along the entire length of wall, a typical feature of the architecture of country's northern regions.

The ruins of two other monuments from this Mamluk city are the two mosques known as *jami' al-Akhmar* (plate 21) and *jami' al-Jukandar*, located near the zawiya described above. Vestiges of the original stalactite vault can still be seen decorating the main entrance of the former. The prayer hall is supported by four central columns that divide the space into nine areas, the center of which is decorated by a starred dome. The dome is built on the area right in front of the mihrab. The minbar, which is located to the right as it should be, is built of stone and is topped by a pyramidal dome. However, this may have been a recent transformation.[97]

The jami' al-Jukandar is a fairly small monument, but it is unusual in that it has two mihrabs, each opposite an entrance.

Gaza and Khan Yunus

Outside the main centers, the country had a series of khans along the main roads. Whereas the caravansaries in cities were primarily warehouses, the ones located on the roadsides were also relay stations for the mounted postal service.[98] Most of these relays have completely disappeared, and only a few of the remaining ones have preserved any of their architecture.[99]

One of these is the Khan Yunus, near Gaza in the south of the country. In the 14th century, Gaza was the capital of the south and a prime location because of its administrative and commercial role on the road to Damascus and Cairo. It also benefited from being on the pilgrim route (*darb al-hajj*). Its administrative center was the Seraya, and has preserved a good part of its façade where all the features of the Mamluk architectural style can be seen: the use of ablaq with dark stripes alternating with light ones, geometrical patterns

Plate 21. Al-Jami' al-Akhmar mosque, in Safed. *Photo, Israel Antiquities Authority.*

inserted into the panels, and floral decoration. But the most striking are the stalactites, or muqarnas, that decorate the upper entablature of this façade.

Built in 1389 by the Mamluk emir Yunus al-Dawadar, the khan that bears his name originally incorporated a mosque. Built according to the classic design described earlier for Abu Gosh, it had a vaulted monumental entrance, which led to a large open-air courtyard. This inner courtyard was surrounded on all four sides by rooms for travelers. A polygonal minaret that stands to the right of the entrance added another typically Mamluk touch.

Yunus, who was the imperial secretary (*dawadar*) of the sultan Barquq, is cited on either side of the entrance by a double inscription where his name and his heraldic emblem appear: an inkwell and a feather penholder. The heavy door topped by battlements and lancets along the façades present the complex as a fortification, and provide a good example of military architecture of the time.[100]

Sidna ʿAli

Numerous tombs of saints and their adjacent shrines were built in Palestine in the Middle Ages.[101] An inventory would be lengthy, and the subject is beyond the scope of this book since their architectural value is primarily typological.

These tombs can, in most cases, be classified into two groups: small monuments, often topped by a dome but unadorned, and buildings made of four pillars, open on three or four sides and also topped by a dome. The latter are by far the most frequent, and found both in the cities and along easily accessible roads.

A small number of shrines nevertheless stand out: Originally the modest tombs of saints, they have become true pilgrimage centers and have taken on impressive proportions. One of the best preserved, the Haram Sidna ʿAli,[102] is located on the Mediterranean coast, 15 kilometers north of Tel Aviv (fig. 16).

Mujir al-din, the famous Muslim historian often quoted in this volume and who lived in Palestine at the end of the Middle Ages, showers great praise on this tomb. He considers it to be one of the most famous pilgrimage sites of the Palestinian coast, and rightly so since the architectural complex is one of the most impressive in terms of size and the preservation of the initial layout—namely, an enclosure that acts as a devotional site and an inn, next to the famous tomb. After the death of Sayyid ʿAli ibn ʿAlil in 474/1081, his tomb was

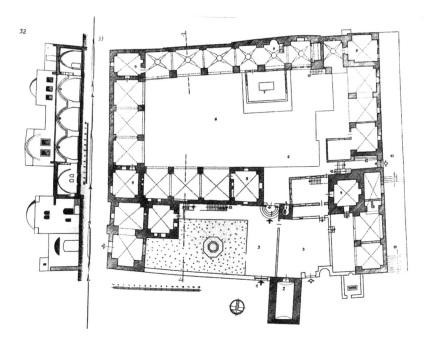

Fig. 16. Sidna 'Ali, plan and cross section. *After L. A. Mayer, Pinkerfeld.*

visited by so many faithful that a seasonal pilgrimage was decreed, the moussem (*mawsim*). He was apparently also revered by Christians, who showed him such respect that they bowed in his direction when their ships passed by the shrine.

The original tomb was made of wood, and later was overlaid in marble. At the end of the Mamluk period, the impressive complex, which can still be seen today, included the funerary architecture (the tomb), religious architecture (the mosque), and military architecture. This is because Sidna 'Ali is a true ribat, a seaside fortress, a rallying point, a pilgrimage site, and the starting point for the jihad. The complex dates to 1481, and the minaret was completed in 1485. The oldest part is probably located near the northern wall where the main gate stands. It has two successive courtyards, forming an irregular rectangle. The second courtyard is surrounded by a monumental arcade. The interplay of the vaults that vary depending on the bays is particularly remarkable.

Another pilgrimage site of this type is the extensive ruins of Nabi Musa, located south of Jericho in the Jordan valley.[103] The structure is larger but the layout is less coherent.

Shipwrecked Vessels

Underwater archaeology has taken on growing importance in recent years, making the treasures of the Mediterranean potentially available to the researcher. In Palestine, several sunken ships have been located; the study of their contents has provided precious information that not only enhances our knowledge and but also corroborates data we already possess.

One of these ships sank near Haifa during the Mamluk period, between the start of the 14th century and the start of the 15th, and the wreck has provided a wealth of information. It is believed that the ship came from Syria and was heading for Egypt.[104] All the objects recovered are bronze, the most commonly used metal at the time. This set of objects provides a vast panorama of typical Mamluk goods. There are vases and pitchers, in the typical shapes of the period, monumental candelabra (chamadan), and candlesticks. There is also a set of mortars with their pestles, in the classic polygonal style.

In addition, a number of panels and decorative bands have been found, for use in decorating doors and boxes. Some of these items were cast, others hammered, and still others done in openwork. Engraved or incised decorations have also been found, as have the remains of inlays of precious metals, in particular silver. But the most astonishing find is a series of clumps of coins, in good condition. These thousands of coins come mostly from the Mamluk period; the most recent was minted in 1404, in the name of the Ottoman sultan Bayazid the First. It is believed that this cargo was a payment of taxes from Syria and destined for the government in Cairo, or perhaps a payment of salaries sent by ship.

Pottery

The pottery of the Ayyubid and Mamluk periods is as rich as it is varied. It is quite homogeneous, and it is also often difficult to differentiate families of pottery from this period from earlier pottery, in particular that of the Crusaders.

Objects found in a wide variety of sites have features that are so similar that it is impossible to find characteristics that distinguish one site from another.

The unglazed pottery plates are deeper than in the preceding period—that is, the period ranging from the first centuries of Islam to the Crusader period. They are characterized by the foot on which each plate is set. Furthermore, the unglazed pitchers have narrow necks and their spout differs from the preceding period; in addition a new feature appears: stamped decorations on the neck. Some pans and pots have a layer of glaze on the inside.

In Abu Gosh, there are no complete unglazed objects. The largest fragments are the spouts of jugs, some of which are stamped. The numerous glazed fragments are decorated in a wide range of greens and browns placed on fine pottery, which is almost always pink.

The Palestinian pottery typical of the Crusader and Mamluk periods found in Abu Gosh is made of red clay decorated with white slip in geometrical patterns under transparent glaze. The shape of the plates differs from the preceding period: They are carinated, the rims curved inward, and the base is annular. This same pottery is found on other contemporary sites such as Athlit, Tiberias, Yokneam, and Jerusalem.

But the dominant Mamluk group is made up of unglazed pottery, with painted, entirely geometric designs. The range of objects is quite varied: bowls, jars, jugs, and pitchers. This pottery was made not on a wheel but by hand. In some places, one can even see finger marks or the imprint of the jute on which the item was made. The pink clay is covered with slip, from the same diluted clay, and the decoration is painted in red, brown, or black. The patterns, basically geometric, are quite varied. This type of pottery has been found on most Palestinian sites with a Mamluk layer (Afula, Yokneam).[105] However, large quantities have been found beyond the borders, in Hama (Syria)[106] and as far away as Afghanistan. Two types of oil lamps are found: the almond-shaped variety, which is molded and often decorated with naskhi inscriptions, and the rounded lamp made on a wheel.

The Abu Gosh pottery is particularly important for dating purposes, even though the dates put forward by archaeologists should be revised, particularly for the first phase. The Mamluk phase can easily be differentiated from the first because of the cutoff point of the Crusader era.

There are several families of glazed pottery. Yellow or green monochrome pieces are found in abundance. The pottery is brownish, covered with slip, and well fired. Two families can be defined: one where the decoration is painted

with underglaze, and the other where the decoration is incised under the glaze (the sgraffito technique). There is also one special family of pottery whose primarily epigraphic decoration is molded and then covered with glaze; some of these items appear to have been made in Jerusalem.[107] Fragments have also been found—and even complete objects—of pottery imported from neighboring countries such as Egypt, Syria, or Iran. These are primarily objects in faience, but there are also a few fragments of lusterware or imitations of celadon. In general, glazed pottery forms one of the well-defined families of pottery produced locally in Palestine.

Glass

Discoveries made in several sites throughout the country all suggest that although pottery was clearly one of the important industries in Islamic-era Palestine, glassmaking was equally important. There is evidence for a local industry in Palestine during the Islamic era, which has been strengthened in particular by a recent and especially important discovery. In Bet Eliezar, in the Hadera area (in the center of the country), a group of large kilns have been identified in which glass blocks destined for glassmaking have been found, thus demonstrating the existence of a local industry. The excavation makes it possible to date these finds to the seventh and eighth centuries. The attested tradition of glassmaking in the country hence goes as far back as the beginnings of the Islamic era.

Much evidence of glassmaking has been found at Bet Shean.[108] Although a large quantity of glass from the first centuries of Islam had already been found, there was a revival at the end of the Islamic Middle Age, and in particular during the Mamluk period. This primarily involved blown glass, which was made into various sizes of bottles, as well as goblets, bowls, and jugs. These objects, which are generally made in colorless glass, are frequently decorated with glass threads, applied when hot. In some cases the threads are blue and stand out on the colorless glass. The large amount of glass found appears to suggest that the people of the time decided it was more convenient to manufacture these objects on-site rather than transport this fragile commodity. They were thus renewing an ancient tradition in Palestine that goes back thousands of years, to the Phoenicians.

But the most interesting discovery has been made in Jerusalem. Excavations conducted in the Old City have uncovered a set of glass fragments as well as a whole object.[109] This is a family of glass that is rarely found in digs: The colored glass is encrusted with white glass threads, or *marvelled*. On the basis of the fragments found, a variety of objects could be reconstructed, including bowls, cups, handles, perfume flagons, zoomorphic containers, game pieces, and even beads. What is particularly remarkable about this site is the presence of glass blocks as well as rejects, extremely rare finds that confirm the nearby existence of a glassmaking workshop, which, unfortunately, could not be found. One characteristic of this group of objects is the use of glass of different colors: semitransparent or opaque purple, semitransparent blue, or opaque red.[110] These glass items are decorated with glass threads, generally white but sometimes green, which were encrusted while hot and form an integral part of the glass object.

Many finds have demonstrated that glassmaking was already present in Jerusalem in the first century BCE, and this craft appears to have continued until the Middle Ages, but not beyond the Mamluk period. Hebron took over as of the 17th century, and its workshops continued to manufacture glass until very recently, making a wide variety of objects primarily in blown glass tinted blue, green, and amber.[111]

The Ottoman Period:
An Art Turned Toward Istanbul

T HE OTTOMAN ERA covers exactly four centuries, from 1517 to 1917. It was a time of relative calm in Palestine, with no external events disturbing life in the country. In the preceding chapters, we have seen that each era articulates around a different political and cultural hub. This chapter also corresponds to a change in orientation. The splendor of the Ottoman court radiated as far as Palestine, and it is no surprise that the art of this province reflected the tastes and trends set in Istanbul, the capital of the empire. This resulted in a very different style than those that preceded it, and gave rise to the birth of the Ottoman style in Palestine.

Overall, however, the country lost its dynamism, to such an extent that it was plunged into virtual economic torpor. New monuments were built only intermittently, and no new architectural complexes were undertaken. Two new mosques were built in Tiberias, each of a different type, but both within Ottoman tradition. The coastal region exhibited slightly more activity, in particular around Jaffa. There, the remains of several mosques can be seen, which were faithful to the provincial Ottoman style, characterized in particular by small spherical domes. The minarets are often polygonal, like the mosque of Caesarea, which was built in the 19th century by a Cherkess contingent stationed there and which overlooks the coastal plain.

As for Ottoman ceramics, excavations have yet to compile a complete picture of the span of this era.

In contrast, underwater archaeology can be proud of a highly unusual discovery: Near Tantura, a cannon belonging to Napoleon's army has been recovered.[1]

But two special cases deserve greater attention: Jerusalem and Acre.

JERUSALEM

The central government of the Ottoman Empire took little interest in the major city of Palestine. Life in Jerusalem was declining, in sharp contrast to what it was like under the Mamluks. Apart from several private residences, which were fairly small and with no artistic pretensions, there was no construction worthy of interest in the 18th and 19th centuries. However, three very different projects call for comment, all of which were undertaken during the reign of Sultan Suleiman the Magnificent, at the beginning of the Ottoman era.

The first is the renovation of the Dome of the Rock. Although no changes were made to the original plan, Suleiman completely transformed the exterior, giving it an unmistakable Ottoman style. As we saw earlier, the Dome of the Rock was built at the end of the seventh century and was decorated, both inside and out, with wall mosaics, a legacy of the famed Byzantine tradition. Many of these mosaics have been preserved in the interior, some in their original state, and others have been restored over the centuries. The case is quite different for the exterior. Despite restorations carried out during the Middle Ages, the tiny mosaic cubes of glass suffered from exposure to the elements, prompting Mujir al-din, the well-known geographer of the 15th century, to comment: "The 'fusayfisa' [mosaics, the Arabic term is borrowed from the Greek] are in a sorry state."

During the Ottoman era, the art of wall mosaics was lost and replaced by that of ceramic tiling. This was the material used by Suleiman to resurface the exterior of the Dome of the Rock. These glazed polychrome tiles were primarily decorated with floral patterns in various dominating blue and turquoise hues. Although originally the windows had marble lattices, doubtless similar to the ones in the great Umayyad mosque in Damascus, Suleiman installed

double-walled windows. Inside, the windows have a single pane of glass, but the outer window is flush with the openwork tiles whose centers were pierced into floral shapes to let the light through the outer set of windows. Facing the inside of the monument is another set of windows cast in openwork stucco, into which are set colored glass. This same technique was used for the most recent restoration of the Dome, carried out in the 1960s by King Hussein of Jordan.

It is also known that during the Mamluk period the dome inside the monument was decorated in painted stucco with verses from the Koran and other religious texts.[2] Other inscriptions were added during the Ottoman era.[3] This was the final touch, so to speak, on a building with a highly complex history.

The Dome of the Chain, the small monument to the east of the Dome of the Rock, was remodeled each time restoration was undertaken on the Dome of the Rock. The Ottoman ceramicists covered its arcades with tiles in the same style, and with the same patterns, as those on the Dome of the Rock. Despite the similarities, one difference nevertheless stands out. Shielded on its western façade by the mass of the Dome of the Rock, the small Dome of the Chain was less exposed to the weather and has preserved, up to this day, its original Ottoman tiles, which have disappeared from the larger monument; the deep shades of the 16th century contrast sharply with the brand-new tiles of the Dome of the Rock.

The second project that testifies to the Ottoman presence in Jerusalem was also carried out under Suleiman. This involved the building of half a dozen sabils throughout the city during the 16th century. These public fountains were placed along main thoroughfares and constitute an original contribution of the Ottoman era to urban architecture. As we will see, they have specific features, setting them apart as a highly cohesive family. In addition, their function and layout suggest they were a new type of architecture, and not the revival of a preexisting phase.[4]

All six sabils were built within the space of a year, from June 29, 1536, to February 13, 1537, several months apart from each other. Their construction was part of a vast campaign to restructure water distribution in Jerusalem, an enterprise described abundantly in the historical sources.[5]

These fountains are all built along the same architectural lines. They are rectangular, framing an arch that opens onto a niche; in the lower part, a

pipe—which today no longer functions—served as a drain. Despite their architectural similarities, each differs in terms of size and decorative details. All of these sabils, with the exception of the one on the Via Dolorosa, have preserved their original plaques indicating the date they were built. Chronologically speaking, the first was located on the road from Jerusalem to Hebron: recall that Solomon's pool, the gigantic reservoir that formed Jerusalem's water supply, was located near Hebron. Because the level of the road was later raised, the effect of this fountain has been somewhat attenuated.

Several components of these sabils, such as columns, capitals, and rosettes, are reused pieces, apparently coming from the Crusader period or, as Max Van Berchem terms it, the era of the "Latins."[6] Their style is a blend of local pre-Ottoman features, such as the Mamluk muqarnas, zigzag arches, or various reused Crusader materials, and forms a local Ottoman style that is one of the characteristics of the era in Jerusalem. This style differs from the public fountains built in Jerusalem by the Ayyubids or the Mamluks, as well as from those built during the same period in Syria, Egypt, or Turkey. These Ottoman sabils hence constitute an original contribution to Jerusalem architecture (plate 22).

The third Ottoman architectural project in Jerusalem was an extraordinary enterprise in military architecture—namely, the construction of a coherent system of strong defensive walls with fortified gates. This project dates from the beginning of the Ottoman period and was also commissioned by Suleiman the Magnificent. Begun in 944/1537, the walls were finished in 947/1541. Thus, though the plan of the Old City of Jerusalem was drawn up during the Mamluk period, the Ottoman period permanently established its contours (fig. 17).

Some sections of this large complex of fortifications probably date to preceding periods—the Fatimid period, the Crusaders, the Ayyubids, and perhaps even the Mamluks—and the Ottoman wall may have closely followed the demarcation of earlier fortifications.[7] However, under the Mamluks, Jerusalem seems to have been an "open city" and the wall was not continuous. It was only in the 16th century that this city had a continuous system of defenses, a classic example of which are the walls and gates.

Of all the Ottoman undertakings in the field of military architecture, it is the only one to remain intact to this day. It is true that several modern mutilations detract somewhat from this impressive complex. First of all, the Jaffa

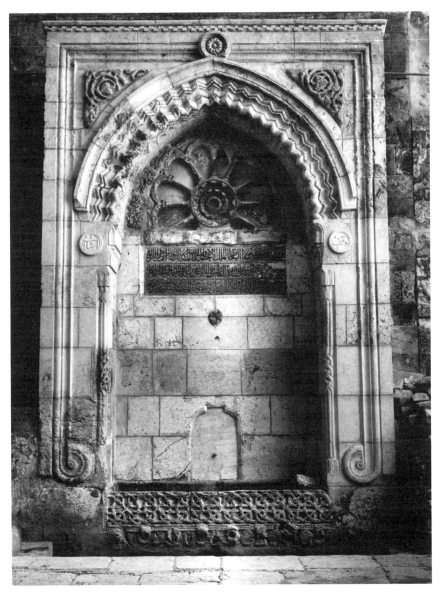

Plate 22. Ottoman sabil. *Photo, Z. Radovan.*

Fig. 17. The walls of Jerusalem.

Gate was transformed in 1898 for the visit of the German emperor Wilhelm II; second, a new gate—the New Gate—was constructed in 1887 by the Ottoman sultan 'Abd al-Hamid opposite the Notre Dame de France hospice; and the Lions' Gate was transformed in the 1960s. These changes did not really detract from this great enterprise as a whole.

Most of the gates have an L-shape: The entranceway forms a 90-degree angle, slowing down any attempt to penetrate the city and facilitating defense. The additional features of machicolations, a rampart walk, and crenels make it an exemplary military complex.

The Damascus Gate, known in Arabic as *bab al-'Amud* or Gate of the [Byzantine] Column, is the only one to have a double-L entrance. The need

for greater fortification can be explained by the fact that it is located in the north, the sector most vulnerable to invasions because of the topography of the city. During archaeological excavations carried out in this sector, parts of the first Roman gate, dating to the time of Hadrian, were found below it, as well as the remains of a Crusader-era church. These historical features revealed through archeaology show that not only was the line of the wall followed over the centuries but that even the location of the gates was carefully preserved (plate 23).

The Lions' Gate, also known as St. Steven's Gate, presents another type of archaeological curiosity. The two pairs of "lions" that embellish each side are in fact panthers, the heraldic emblem of the Mamluk sultan Baybars. They most likely belonged to a Mamluk monument in the vicinity, perhaps a khan, which today has vanished, and were reused by the Ottoman architects during the building of the gate.[8]

Some parts of this fortified wall are decorated with raised roundels with floral and geometrical designs that contrast nicely with the austerity of the walls. This set of gates and walls was restored about 20 years ago, and it is now pos-

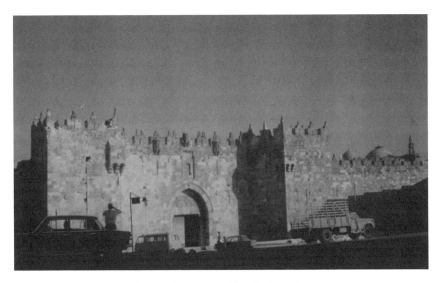

Plate 23. Damascus Gate in Jerusalem.

sible to walk almost entirely around the Old City—a distance of almost four kilometers—along the rampart walk.

TIBERIAS

After several centuries of eclipse, Tiberias experienced a period of renewed growth during the Ottoman era. Two mosques testify to this renaissance. The first, the Great Mosque (*al-jami' al-kabir*), is a typical example of 18th-century Ottoman architecture. Made up of a large prayer hall crowned by a dome and dated 1743, it is located in the center of the Old City.[9]

A small mosque called the Lake (or Fisherman's) Mosque (*al-jami' al-bahri*), located on the shore of the Sea of Galilee, holds particular interest because of its harmonious, atypical architecture. The most interesting feature is the prayer hall located at the rear of the vestibule. The hall has a square plan, measuring eight meters on each side. Its four pointed arches spring from the single central pillar, and support the axial domes. This reused central Roman Ionic column, although anachronistic, nevertheless contributes to the harmony of the site. The cylindrical minaret is located at the western end of the mosque. The decoration is striking by its sobriety, which is only broken by molding setting off the rectangular mihrab and its niche.

ACRE

With the fall of the Crusader kingdom in 1291, Saint Jean d'Acre experienced four centuries of decline. It was only at the end of the 18th century that this port city once again came to life. In recent years, the Israel Antiquities Authority has begun a major project to unearth the remains of the past, thus making an important contribution to the study of the history of this city. A vast program of archaeological excavations has led to the discovery of an unknown chapter in the medieval past of Acre: A large part of the Crusader city has been uncovered over a vast area underground,[10] but this discovery goes beyond the scope of this book (fig. 18).

The revival of Acre during the Ottoman period was the work of its governor, Zahir al-'Omar, who began his career as a minor Bedouin chief but who succeeded in gaining the favor of the Ottoman authorities. He extended his

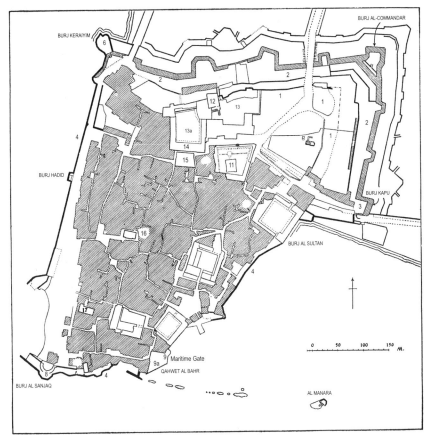

Fig. 18. Plan and ancient monuments in Acre. *After Makhouli.*

1. First wall
2. Second wall
3. Burj Kapu
4. Maritime wall
5. Burj al-Commandar
6. Burj Keraiyim
7. Burj Hadid
8. Burj al-Sandaq
9. Maritime Gate
10. Suq al-Abiyad
11. Jazzar Pacha Mosque
12. Citadel
13. Hamman
14. Khan al-'Umdan
15. Khan al-Shawarda

influence over the entire north of the country, making Acre a small Ottoman capital vested with all the trappings of power.

Thus the city grew in terms of civil architecture as well as religious, military, and public works, all of which were constructed with a high degree of stylistic coherency. All these buildings, built within a fairly short period of time, bore the mark of the Ottoman model that inspired them. The new Islamic urban center at the end of the 18th century was constructed according to a plan comprising mosques, hammams, suqs, khans, fortifications, a citadel, and an aqueduct. The existence of this "urban core" encouraged economic growth throughout the entire region, while remaining its center. However, the drawback to this growth was a weakening of central rule.

The first monument of interest is the very attractive mosque dedicated to Ahmad Jazzar Pacha, an Albanian who was the successor to Zahir al-'Omar and under whose government the city began to flourish. This mosque was built in 1781, in the finest tradition of Ottoman architecture of the 18th century. It has a vast square central prayer hall with no intermediate arches, and is topped by a large dome that covers it entirely and rests on strong buttresses set at each angle (plate 24). The interior is lit mainly by large bay windows. The decoration consists primarily of geometric designs made of polychrome marble inlaid on the inside walls and on the façade. These inlays with geometric designs are also found in Jerusalem, on certain places on the façade of the Dome of the Rock, and testify to restorations carried out on this monument in the 18th century.

The mihrab of the Jazzar Pacha mosque is particularly colorful, through the use of polychrome marble and bright colors on the stone. To the right of the mihrab is a decorated minbar, also made of polychrome marble.

The open-air courtyard that leads to the prayer hall is flanked by vaulted arcades forming many cubicles covered by small domes, in the Ottoman tradition. Each of these cubicles creates a space onto which open small rooms reserved for maintenance or the lodging of students and staff. Each detail of this monument, both in terms of architecture and ornamentation, is characteristic of 18th-century Ottoman style and hence is highly representative of this period in Palestine.

The ceramic tiles, exterior decoration, and minaret are all models of their type. The minaret is cylindrical, slender, and topped by a conical pointed

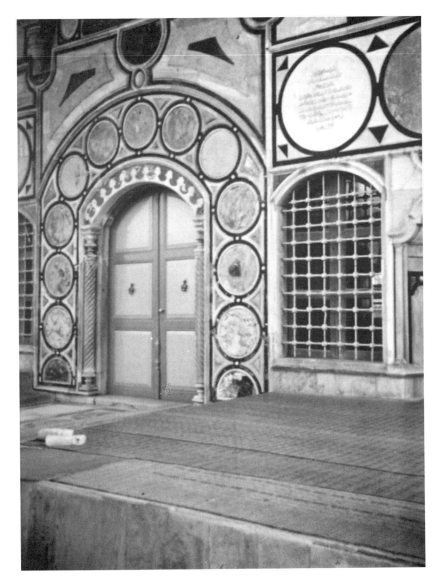

Plate 24. Jazzar Pacha mosque in Acre.

dome, in the best tradition of Ottoman style of the time, as was seen then throughout the regions of the empire.

A lovely rococo sabil that appears to have been imported directly from Istanbul is installed at the entrance to the mosque, almost abutting one of its walls. It adds the final touch to the Ottoman architectural complex of Acre and forms the heart of the urban center to which the other monuments described below are linked. It should be noted that this sabil is unrelated to the ritual ablution basin that is located in the open part of the mosque.

Two or three other small mosques were also built during the Ottoman period at some distance from the Jazzar mosque, but today they are closed and in ruins, and are of little interest.

Not far from the Jazzar Pacha mosque is the White Market (*al-suq al-Abyad*). It probably dates back to the time of Zahir al-'Omar but was rebuilt following a fire in 1818, according to the original plan. It shows that the tradition of oriental bazaars that originated in the Middle Ages continued throughout the centuries. The suq al-Abyad is a covered market made up of a central vaulted passage bordered by two series of parallel stalls, also vaulted and set at regular intervals from each other. A series of openings in the vaults gives light and air.

Recent excavations have revealed a second covered market, the Persian market (*suq farsi*), which was located below the Jazzar mosque but had direct access to it. It was clearly part of the architectural ensemble.

In terms of public works, the most interesting monument is the Pacha hammam (*hammam al-Basha*), a public bathhouse located not far from the Jazzar mosque. It was also built by Jazzar Pacha, and its layout is similar to public baths in Istanbul and Cairo.

Inside the baths there is a main vaulted room with a pool in the center. This was the reception room and where visitors undressed. The layout follows a plan already in use in Roman times, and then adopted by the Umayyads and the Mamluks. Thus this tradition was preserved for centuries, and adopted again in Ottoman architecture. The functional part of the bathhouse is composed of three successive rooms, for the cold bath (frigidarium), the warm bath (tepidarium), and the hot bath (caldarium). Private rooms were reserved for those who had the wherewithal. The building is entirely in keeping with

the style of the time. The walls of this hammam were covered with tiles, some of which remain to this day.

Other public works consisted of a large number of urban khans or caravansaries; some are fairly well preserved. Their layout adheres closely to ancient tradition that goes back to the ninth century, to the beginning of the Islamic period. One of the oldest, in Abu Gosh, was described earlier.

A spacious courtyard is surrounded on all four sides by a series of apartments with a private entrance. In Acre, these khans are large; the khan al-'Umdan, or the Column Khan, even has two stories, in a harmonious layout. The large granite columns that support the gallery around the courtyard apparently come from Tyre or Caesarea and give the building its name, 'umdan, meaning columns. This khan, one of the best preserved and one of the most attractive, was also built under Jazzar Pacha. It is interesting to note that all the khans in Acre were built around the seaport near the customs offices. The size of these caravansaries and their topological arrangement clearly reflects the booming maritime trade. Pilgrims, travelers, European merchants, and Muslims crowded into the city, and this entire infrastructure was built to respond to the needs of the hour.

To the north of the al-'Umdan khan is the al-Firanj khan, or Frankish khan. It has undergone several restorations but one can still see the remains of the most ancient caravansary of Acre, which in the 17th century may have provided lodging for travelers from Europe. Sources mention that Zahir al-'Omar also built a palace surrounded by gardens, but no traces remain.

The most striking feature of Acre is its sea and land fortifications. One can still see today, especially in the north and eastern parts of the city, the remains of three walls. The first wall of the city was built under Zahir al-'Omar, the second by Jazzar Pacha, and the third by his successor, Suleiman Pacha. Using the classic "spolia" method, Zahir al-'Omar constructed his wall by simply demolishing part of the Crusader castle of Atlit and transporting the stones to Acre by sea. An inscription on the Land Gate of the city is now in the Israel Antiquities Authority. It names Zahir al-'Omar and serves to date the first wall, of which only the northern part remains; the eastern part has completely disappeared.

The second wall closely mirrors the first, and was built outside it. Each is protected by a moat. A third moat was even begun by Ibrahim Pacha, the son of Mehemet Ali, but was never finished. The sea wall is attributed to Zahir

al-'Omar, but it is built on a foundation that could date back to Crusader times. Its ramparts are impressive, and two sloping ramps lead up to the lookouts overlooking the wall.

The major feature of this large military architectural complex is the citadel. It is located north of the Jazzar Pacha mosque and has undergone numerous transformations and restorations. It is likely that initially it was the home of Jazzar Pacha and was modified several times by his successors. The arsenal is located nearby. This complex also has a square courtyard surrounded by vaulted arcades that served as lodging for the garrison.

Jazzar Pacha finished his works by constructing an aqueduct to provide a water supply to the city. Starting from the al-Fawar spring, near the village of Kabri to the north, it was intended to reach Acre but was never completed; only portions of it remain today. It was not until the 19th century that Suleiman Pacha built a new aqueduct, which can still be seen today (plate 25). It was a beautiful work of art, one of the loveliest remaining in Palestine, and starts three kilometers to the north of the city. Most of the aqueduct, parts of which are underground, has two levels, made up by the superposition of

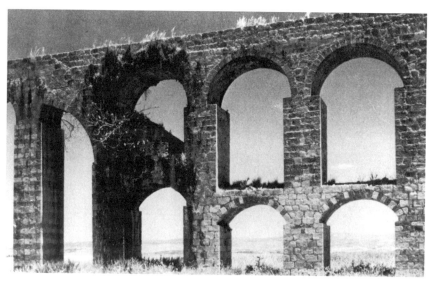

Plate 25. The Acre aqueduct.

a series of arches supported by massive pillars. Five water towers are found along the aqueduct; the masonry is of high quality.

In recent years, enormous efforts have been made to renovate the old neighborhoods of the city. These focused on the Ottoman residential sector dating from the 19th and 20th centuries. Several formerly elegant residences with two or three stories have been renovated. The rooms are generally laid out around a large living area, adhering to secular tradition. They were often decorated with wall paintings that gave them a special charm. These paintings were done on wooden panels, and were placed high on the walls and on the ceilings, as was the fashion at the time; the style was also found in bourgeois residences in other cities in Palestine, especially in Nazareth, Jaffa, and Jerusalem.[11] This was an example of European influence on Ottoman art at the end of the 19th century. An excellent example can also be found in the American Colony Hotel in Jerusalem, which was a family home at that time. The beautiful ceiling in painted wood in the reception room on the first floor is worth admiring. In a style that at times is naïve, it captures the local interpretation of European artistic influence.

Chapter Six

The Post-Ottoman Era: Armenian Ceramics

O NE OF THE MOST original chapters in contemporary Islamic art was written in Jerusalem. This art form is apparently only found in Jerusalem, and it would be difficult to find another example of this highly specific type of craftsmanship elsewhere in Palestine. Despite the influence of Ottoman art on Palestine as a whole from the 16th century onwards, there has been no trend—either in Syria or in Egypt—comparable to the one existing in Jerusalem in the 20th century.

In Jerusalem, many buildings constructed at the turn of the 20th century have polychrome ceramic tile decorations of varying sizes. This art form was inspired by an initiative of the British Mandate authorities, who governed as of 1917 and who undertook to renovate the façade of the Dome of the Rock. It should be recalled that Suleiman the Magnificent, who wanted to restore this façade in the 16th century, was the first to use ceramic tiles to replace the original wall mosaics, which were in an advanced state of disrepair. But, in keeping with the style of the Ottoman mosques of the 16th century, this renovation also deteriorated, and the British authorities called in Armenian potters. A team of specialized craftsmen were brought in from Kütahya, in Turkey, with the express purpose of manufacturing on-site the 26,000 polychrome ceramic tiles needed for the façade of the Dome of the Rock.[1]

This project was never carried out, but the potters nevertheless settled in Jerusalem and laid the groundwork for this new art form, which in both design

and concept adheres to the Muslim artistic tradition. The themes are taken from classic concepts such as the tree of life or other floral motifs inspired by the repertoire of Kütahya ceramics. Inside the American Colony Hotel in Jerusalem, a composition faithfully reproduces a panel that is found in the harem of the Ottoman Topkapi Palace in Istanbul. But, doubtless having been made by craftsmen who were unfamiliar with the original, the two halves of the panel were installed separate from each other.[2] Curiously, there are no examples of ornamentation of this type in the Old City, and with a few rare exceptions are only found in Jerusalem *extra muros* (that is, outside the Old City).

Two categories of buildings were decorated in this way. The first is a series of public buildings constructed under the auspices of the British authorities: the Rockefeller Museum, the residence of the high commissioner, and the YMCA building. The second is composed of buildings constructed by rich proprietors, both Muslim and Christian.[3] The ceramic panels decorate various surfaces and embellish the arches with a whole range of traceries (plate 26). The exteriors of these buildings also often have ceramic medallions. Certain streets in Jerusalem, in particular the main roads, had trilingual ceramic tile street signs at the turn of the century in English, Arabic, and Hebrew, written in ochre on a blue background. Their polychrome decoration was a testimony to 20th-century Muslim art in Jerusalem.

Aside from these monochrome and polychrome ceramics, which often had underglaze painting, another quite unusual technique was used. The inner courtyard of the Rockefeller Museum, including the walls and the vault, was completely covered with a decoration of blue or turquoise stars of different sizes. The technique used is the cuerda seca, another method drawing on an ancient tradition of Islamic pottery.

This chapter cannot be brought to a close without mentioning the most recent example of Muslim ceramics in Jerusalem. As we saw earlier, the renovation of the façade of the Dome of the Rock by Armenian potters failed to materialize, and this façade continued to deteriorate. In the 1960s, King Hussein of Jordan decided to resurface the dome entirely with new ceramics commissioned in Turkey, in the traditional Ottoman spirit, and capable of returning the work of Suleiman the Magnificent in the 16th century to its original splendor. The restoration work was completed in 1965.

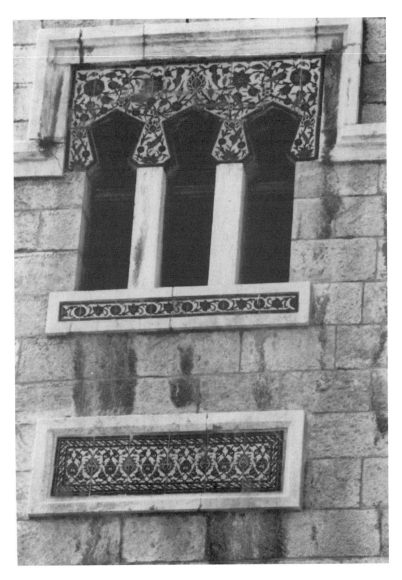

Plate 26. Armenian ceramics in Jerusalem. *Photo, Z. Radovan*

Conclusion

THROUGH THE PRISM of the vicissitudes of the Islamic history of Palestine, this book has aimed at illustrating the impact of convergent artistic influences on the country. Depending on the era, these creative forces originated in Damascus, Cairo, or Istanbul. They flourished in Palestine, and in a sense mirrored the dominant ideas and trends of these often divergent worlds.

Certain objects or art forms can only be explained in terms of the status of Palestine at a given era. For instance, it would be difficult to dissociate the exquisite quality of Fatimid-era jewelry, such as the hoards found in Caesarea or Ashkelon, from jewelry being made in Egypt at the same time. Were these pieces imported, or were they high-quality local craftsmanship? The same question applies to the glassware or the bronzes found in Caesarea and Tiberias. The impressive quantity of objects found, along with other evidence such as the presence of kilns, particularly in Tiberias, appears to suggest that there was local workmanship whose style and quality were comparable with objects made in the capital.

Other art forms, however, arose from purely local traditions. This is most likely the case for mosaics: As of the Umayyad era, Jerusalem craftsmen were highly respected and their work ranks favorably in the sources.[1] This vibrant tradition continued for centuries.[2]

Other local traditions, dating back to the pre-Islamic period in Palestine, continuously enriched Islamic art. These were not only decorative motifs or compositional themes, but rather trends and traditions that should be seen as genuine art forms. Adopted by the new civilization that was taking shape in the country, these art forms continued to develop throughout the Islamic period. In addition to architecture, these include mosaics and wall paintings[3] that echoed earlier achievements in these fields, which were highly reputed during the pre-Islamic period. Palestinian artistic output during the Islamic period is marked by this symbiosis with local traditions that continued to inspire new artists.

The other centers of Muslim civilization also contributed to Palestinian artistic expression, as a function of their proximity and their spheres of influence at different times in its history.

The sites mentioned in this volume clearly do not constitute a complete inventory of the rich archaeological treasures of the region, nor does the book describe all the monuments associated with these sites. A selection was made, with the purpose of highlighting the most significant of these finds. Some of these finds were the starting point or the meeting point, if not the turning point, for Islamic art in Palestine. This is true for the key features of the Dome of the Rock, or the encounter between Crusader and Ottoman art illustrated by the sabils of Jerusalem, to mention just two examples.

However, the enormous variety of artistic output in Palestine has yielded more than one surprise. For instance, in certain cases, an archaeological find complements our understanding of a historical event, as was the case for the Ayyubid inscription in the Dome of the Rock. As for the founding of the city of Ramla, archaeology has provided tangible proof for accounts in written sources. The reverse can also happen, when certain finds have provided evidence of the existence of historical facts that apparently have gone unrecorded. This was the case for the Umayyad architectural complex unearthed to the southwest of the Haram al-Sharif, a find that truly revolutionized our historical understanding of Jerusalem's role during the Umayyad era.

The wealth of material discovered during all these excavations could fill countless studies. The goal of this book was not to index each tessera or each fragment, but rather to highlight, on the basis of the enormous archaeological work accomplished to date, the most significant data and the most unusual

objects so as to provide a global historical overview from the Middle Ages up to the beginning of modern times.

Palestine made a major contribution to Islamic civilization and art. This overview of finds—which themselves have been the subject of studies and analyses—enables us to not only form an overall picture of the different art forms, but also to get a glimpse of daily life in Palestine over the course of time. I have tried to disentangle and pinpoint some major landmarks in this history—for instance, the sudden appearance of a masterpiece like the Dome of the Rock—or certain specific features, such as the typology of pottery or textile manufacture. I have also tried to differentiate certain Islamic monuments that could be confused with non-Muslim ones. These different issues all call for comment. Each chapter in this book could have been an in-depth study in itself, and certain monuments clearly deserve entire monographs. However, from the outset, the scope of this book imposed limitations.

The history of Islamic art and archaeology in Palestine teaches us specific lessons connected to the country's history, and provides concrete reflections of historical events. For instance, one factor is the dominant role played by the south in the development of this new Islamic civilization. Whether we are dealing with the first stages—the infiltration of Arab tribes into the region— or the official establishment of Islam in the country, it is significant that the Negev has yielded much evidence for these different phases of Arab presence. To fully grasp the meaning of this Arab presence in the south, the real impact of the Nabatean civilization on the pre-Islamic era needs to be appreciated for what it was. The south was the area where, several centuries earlier, the Nabatean civilization had flourished in cities such as Sbeita, and maintained an active cultural presence for centuries afterwards. This infrastructure indisputably facilitated the assimilation of the bearers of the new Arab and Islamic culture.

The Sassanid occupation, along with other scourges that ravished Palestine on the eve of Muslim conquest and which destabilized the country, also rendered this domination easier. The south has also revealed other unexpected finds. One was the discovery of papyri in Nessana, a Nabatean city whose history extends through the Byzantine period up to the start of the Islamic era. This invaluable documentary source, particularly rare for the period, provides a wealth of information of all sorts on the life and history

of the south of Palestine during the period that immediately preceded the Muslim invasion. For this same period, unusual installations in the form of enclosures have also been found in the Negev, whose purpose remains unknown. Different pieces of evidence are associated with them, attesting in particular to two key phenomena. First, there are hundreds of graffiti covering the cliffs of the central Negev. Although such inscriptions have been found outside Palestine, their concentration in the Negev covers a period of several centuries, doubtless from the sixth to the ninth. The second phenomenon is more specific to the region: the existence of small open-air mosques located in several areas of the Negev. These are thought to have been indigenous to the south of Palestine during the first centuries of Islam, even though several comparable examples have been found elsewhere and beyond the borders of the country.

The Umayyad era emerges next as one of unquestionable importance for Islamic art in Palestine. As with all formative eras, it was marked by feverish activity in all areas, from architecture to the minor arts, whose importance should not be underestimated. Major architectural undertakings were initiated at this time, as well as the key concepts that would have their impact in the centuries to come. But the great artistic impetus of this era, inherited from the rich classic past of the region, was halted by the fall of the first caliphate dynasty, which also coincided with a severe earthquake. Nevertheless, the masterpiece of Muslim art—the Dome of the Rock, which no other building was ever built to rival—was erected during the Umayyad era. Its superb wall mosaics, which illustrate the symbiosis of artistic trends of the East and the West, were an example up to the Middle Ages, both in Palestine and in neighboring regions. The architectural style used in the al-Aqsa Mosque served as a model for the building of several monuments, known as the Syro-Palestinian type, with one or two rows of pillars parallel to the qibla wall.

It was also during the Umayyad period that the new architectural space that would become the Haram al-Sharif took shape. The study of the buildings associated with it, both on and outside the Haram, confirm that there is nothing accidental in their layout. They were built at locations that mesh perfectly with an overall plan. This helps us understand the relationship of the Dome of the Rock to the al-Aqsa Mosque, as well as its relationship to the Dome of the Chain and the four arcades of the upper platform, and to the

two oldest gates—the Double Gate and the Golden Gate—which illustrate the integration of the earliest elements into Islamic architecture. The group of buildings outside the Haram, to the south and west, are part of a vast project that bears the mark of the visionary 'Abd al-Malik, and illustrate the integration of pre-Islamic ruins into this complex. This was not merely a pragmatic decision, but rather it was prompted by a deeper motivation that, as a political gesture, the new Islamic civilization would appropriate symbols of the past.

In this respect, the role played by archaeologists in the discovery of Umayyad monuments outside the Haram al-Sharif cannot be stressed enough. These monuments considerably affect our knowledge of Umayyad Jerusalem, as they did the architectural vision of the caliphs of the time. In addition, they constitute the urban counterpart to the other Umayyad castles that were built at the same time, primarily in the desert regions. The other castles illustrate the two extremes of an identical phenomenon: on the one hand, Khirbat al-Minya, with the sober and compact features of its initial phase, and at the other extreme, the flamboyant or baroque style used at Khirbat al-Mafjar. Nevertheless, despite the difference in scale, these examples are all related in terms of style and ornamentation, which through their richness and skill make them remarkable constructions. Local traditions as well as the direct influence of the artistic past of pre-Islamic Palestine may have contributed to the characteristics of these works of art.

During the Umayyad era, the city of Ramla was founded. Its contribution to the history of architecture is substantial, both through the systematic use of the pointed arch and by the originality of the construction of the underground cisterns of the Umayyad mosque, whose dating still poses a problem. But it was also during the Umayyad period that various institutions were set up that enable us, through archaeology, to reconstruct the rich and complex picture of the history of the country. The beginning of the period was still under Byzantine influence, as is shown by coins or the inscription in Greek found at Hammat Gader. But the contributions made by the new Muslim civilization were on the rise. This can be seen in the building of a suq in Bet Shean by Caliph Hisham, or the repair of the country's roadways, as demonstrated by the discovery of milestones. Archaeology has also helped unearth a whole irrigation network, as well as fragments of cloth that prove the existence of a flourishing textile industry. The great numismatic reform undertaken by 'Abd al-Malik

was not restricted to the region but extended to the whole empire. It is thus no surprise that the coins minted in Palestine provide proof of their links to this new monetary system.

This great Umayyad era clearly promoted artistic creativity in Palestine that drew culturally on the dominance of Damascus because of its geographical proximity and the fact that it was the seat of the caliphate. The direct effects of the local classic inheritance shared by Palestine and Damascus should not be overlooked.

With the fall of the Umayyads, the seat of power was transferred to Baghdad, weakening the ties between the distant caliphate and Palestine. Very few projects were undertaken by the central authorities at that time. Two initiatives are nevertheless important: the construction of underground reservoirs in Ramla, which an inscription attributes to the Abbasid caliph Harun al-Rashid, and the port of Acre, nothing of which remains today except for the detailed description by the geographer al-'Muqaddasi. In the meantime, Palestine was annexed to Egypt in the ninth century and would remain politically a vassal until the end of the Middle Ages.

Although it is true that we have scant proof of intervention from the central government in Palestine during the Fatimid period, numerous archaeological finds provide evidence of an unmatched blossoming of artistic creation. The numerous masterpieces of Fatimid art that have found their way into museums were for the most part acquisitions from the two previous centuries. The archaeology of Palestine alone has yielded an amazing number of rare pieces. These impressive harvests come from four main sites: Caesarea, Tiberias, Ashkelon, and Jerusalem. In addition to the jewelry from each of these centers, whose quality is comparable to the most beautiful specimens of the other Fatimid arts, the abundance of finds in the area of metalwork, also of fine quality, is also surprising.

In addition, archaeology has revealed types of activity that were previously unknown. This is the case for utilitarian buildings for sugar manufacturing, including the remains of equipment and utensils that have been found throughout the country. Studies in Ashkelon and Caesarea, among other places, have also revealed remarkable collections of bone objects that are unusual in that they have openwork decorations, like lace made out of bone.

I have only touched upon the Crusader period, which deserves a study in its own right. The works it left behind are not related to Muslim art, and the period was mentioned only to the extent that it testifies to the impact of a new Western entity that clearly influenced subsequent Islamic artwork in Palestine. By contrast, the Ayyubid period that followed it was of major importance despite its brevity, which encompassed a 15-year hiatus following an agreement signed in 1229 between al-Malik al-Kamil and Emperor Frederich II. This era was characterized by striking innovations in terms of art, whose influence was only grasped much later on.

During the period of relative calm that immediately followed the Ayyubid era, Palestine prospered. It continued to maintain close ties with both Cairo and Damascus, as was reflected in local art. The monuments and minor arts remained stylistically linked to the models in the two capitals. For instance, the Tankiziya madrasa in Jerusalem closely resembles the Tankiziya madrasa in Damascus. One artistic technique used at that time that deserves attention is wall mosaics. It further embellished monuments, and prolonged a tradition that reaches back to the beginnings of Islamic art in Palestine, namely, the Umayyad period.

Cities such as Ramla, Jerusalem, and Hebron continued to grow and serve as the centers of numerous activities. New centers also developed, such as Safed, whose Mamluk citadel became a major military outpost, or Gaza, which was the capital of the south.

Jerusalem provides us with an overview of the major works of Mamluk architecture, presenting all the various types of buildings of that era. Dozens of monuments are indicative of the style and trends that dominated at that time. For instance, the particularities of Mamluk style, such as can be seen in the early monuments of the period, were still present at the close of the era. This did not hinder the development of increased ornamental complexity over the years, associated with certain novelties. It is highly interesting in this respect to compare the Tankiziya madrasa mentioned earlier and which dates from the first half of the 14th century with the Ashrafiya madrasa built in the second half of the 15th century.

The pottery finds from every era have helped characterize Palestinian pottery, better explain its history, and trace its development over the course of the centuries. Although certain families of ceramics are part of an industry that

extends beyond the geographical limits of this study, other families are specific to the region and show proof of great originality. Pottery has been found in almost all the archaeological sites, although the quantities vary considerably from one site to another, and the material is not always coherent with the stratigraphy. Among the centers that have yielded significant material for the study of ceramics, Ramla, Khirbat al-Mafjar, Jerusalem, Abu Gosh, Yokneam, and Tiberias are the most important.

The pottery found on these sites has yielded a typology that constitutes a key tool for archaeology, a topic that goes beyond the scope of this study. The major characteristics serve to define the common denominators of Palestinian pottery as a whole, and are illustrative of its great homogeneity. In the early Islamic period, unglazed ceramics played a major role. The shapes were initially a prolongation of pre-Islamic traditions, but rapidly distanced itself from them. Although the raw materials were ordinary, the use of certain techniques—including molded ceramics—resulted in the creation of unglazed pieces of extremely high quality. Glazed ceramics gradually made their appearance during the eighth century. By the ninth century, it was already the dominant mode throughout the country and different decorative procedures were being used. Monochrome or polychrome glazing, ornamented with incisions or molded decoration, was one of the most typical styles of the Mamluk period. It was also closely linked to Egyptian ceramic ware of the same period, attesting to the artistic ties between Egypt and Palestine under the Mamluks, which were also expressed in all the other arts. Finally, in many sites that were still active in the Middle Ages there was substantial production of a fairly unusual family of plain monochrome unglazed pottery, made by hand with geometric designs.

One of the biggest surprises archaeology had in store for us is doubtless the discovery in Palestine of a considerable glass industry during the Islamic period. As was the case for pottery, the glass fragments found throughout the country are highly homogeneous. For instance, the glass finds from Caesarea, Tiberias, Yokneam, and even Bet Shean are all evidence of local production. However, Palestinian glass has no inherent originality but rather is part of the general history of Muslim glassmaking in the Middle Ages.

Extending over four centuries, the Ottoman period led Muslim art to the threshold of modern times. Nevertheless, it was not marked in Palestine by

any major event; the cultural fabric was loosening, and hence this artistic production was somewhat irregular. Jerusalem, for instance, benefited from major contributions made in the 16th century under the rule of Suleiman the Magnificent. These are imperial works, designed to mirror the greatness of this individual, and numerous inscriptions attest to his involvement. His building campaigns played a major role in defining the current landscape of Jerusalem, and can be seen to this day.

Unfortunately the same cannot be said for the rest of the country. The provincial cities remained on the fringes of artistic endeavor, and it is almost impossible to find traces today of this period. A certain number of mosques were indeed built, but they are unremarkable. These mosques are indicative, however, of the presence of Islam throughout the country, in a region that was to open up to the outside world, and above all to the West, where visitors, pilgrims, travelers, and merchants of all types came in growing numbers to journey or to settle. This explains the proliferation of pilgrimage sites, shrines, and mosques such as the ones in Jaffa, Lydda, or Ramla, or the small Cherkess mosque in Caesarea. A few rare sabils were built, as can still be seen in Jaffa.[4]

In Tiberias, one can still see two examples of truly significant mosques. The first is small in size, as would suit a provincial mosque. The other, the main mosque, is one of a series of imposing monuments with a large central dome. These two buildings clearly illustrate the impact of Ottoman inspiration in two parallel forms. However, the city center of Acre is clearly the most grandiose Ottoman achievement in Palestine. Created in the 18th century on a site exposed to centuries of neglect, this Ottoman city owes nothing to the central government in Istanbul. Rather, it reflects the vision of a political leader in conflict with his superiors and desirous to affirm his independence and his authority. Indeed, the model he chose for his "mini-capital" was that of a large city. He closely monitored the building of the city facilities in the most faithful tradition of Ottoman Empire. Both the style of the monuments and their decoration are all linked to 18th-century Ottoman trends.

The impact of the Ottoman era was so strong that it continued to affect art after the era came to an end in Palestine. Ceramic art, which made a special contribution to the landscape and the aesthetics of Jerusalem in the 20th century, was clearly inspired by Ottoman themes, and used techniques that

are the direct extensions of the skills honed by the Ottoman Empire over the centuries.

This overview of the history of Islamic art and archaeology in Palestine shows that the main chapters in the history of Muslim art all found their place. Palestine, a country whose geography has scarcely changed, has experienced throughout the centuries a remarkably high level of artistic expression. At the same time, it can be said that despite an often irregular trajectory, its art has never ceased to show proof of dynamism and originality as compared to the arts of the neighboring regions. This contribution should clearly be seen as a microcosm in the macrocosm of Islamic art.

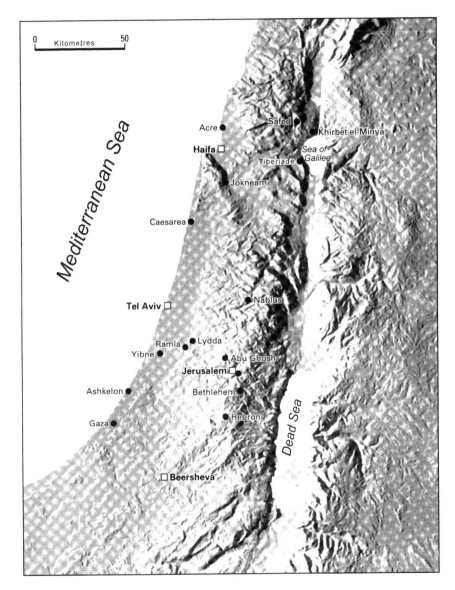

Map 1. Principal sites.

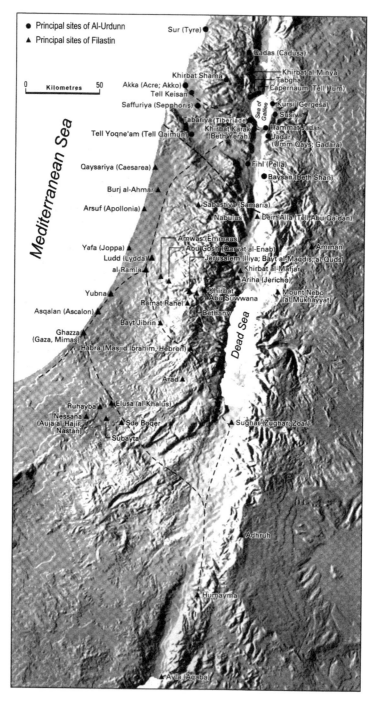

● Principal sites of Al-Urdunn
▲ Principal sites of Filastin

0 Kilometres 50

Mediterranean Sea

Dead Sea

Sea of Galilee

Sur (Tyre) ●

Qadas (Cadusa) ●

Khirbat Shama ▲
Khirbat al-Minya
Tabgha
Akka (Acre; Akko) ● Capernaum (Tell Hum)
Tell Keisan ●
Saffuriya (Sepphoris) ● Kursi (Gergesa) ●
Susiya ●
Tabariya (Tiberias) ● Hammat Jadar ●
Khirbat Karak ● Jadar ●
Tell Yoqne'am (Tell Qaimun) ● (Beth Yerah) (Umm Qays; Gadara) ●

Qaysariya (Caesarea) ▲ Fihl (Pella) ●

Baysan (Beth Shan) ●

Burj al-Ahmar ▲

Arsuf (Apollonia) ▲ Sabastiya (Samaria) ●

Nabulus Deir 'Alla (Tell Abu Qa'dan) ▲

Amwas (Emmaus)
Yafa (Joppa) ▲ Abu Gosh (Qaryat al-Enab) Amman ▲
Ludd (Lydda) ▲ Jerusalem (Iliya; Bayt al-Maqdis; al-Quds)
al-Ramla ▲ Khirbat al-Mafjar ▲
Ariha (Jericho) ▲
Yubna ▲ Khirbat Mount Nebo ▲
Abu Suwwana (al-Mukhayyat)
Ramat Rahel ▲
Asqalan (Ascalon) ▲ Bethany
Bayt Jibrin ▲
Ghazza
(Gaza, Mimas) ▲
Habra (Masjid Ibrahim, Hebron) ▲

Arad ▲

Ruhayba ▲ Elusa (al-Khalus) ▲
Nessana ▲
(Auja al-Hajir, Sde Boqer ▲ Sughar (Zughar; Zoar) ▲
Nastan)
Subayta ▲

Adhruh ▲

Humayma ▲

Ayla (Aqaba) ▲

Map 2. Location of excavation sites and main monuments.

Map 3. Location of excavation sites in Tiberias (related to the Islamic period).

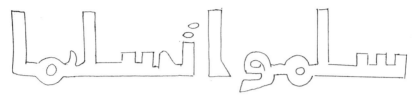

1. Umayyad—Dome of the Rock, 72/691–692 (wall mosaic).

2. Abbasid—Ramla cistern, 172/789 (painted on plaster).

3. Fatimid—Wood beam from the Dome of the Rock, 413/1022.

4. Ayyubid—al-Aqsa Mosque, 587/1187 (wall mosaic).

5. Mamluk—al-Aqsa Mosque (inscribed slab).

6. Ottoman—Dome of the Rock (polychrome glazed tile).

Fig. 19. Samples of epigraphy at different periods

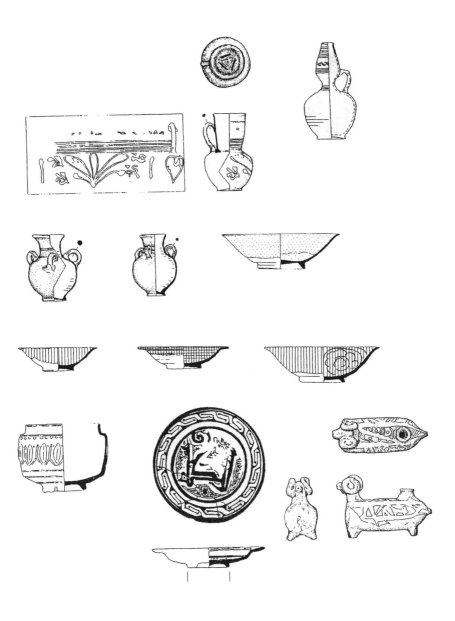

Fig. 20. Partial typology (first centuries) of ceramics from Caesarea.
After A. Lester et al.

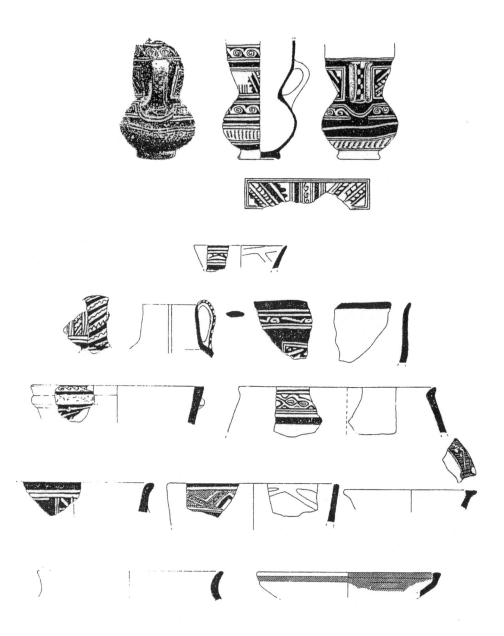

Fig. 21. Partial typology of post-Crusader ceramics from Hammat Gader.
After A. Boas.

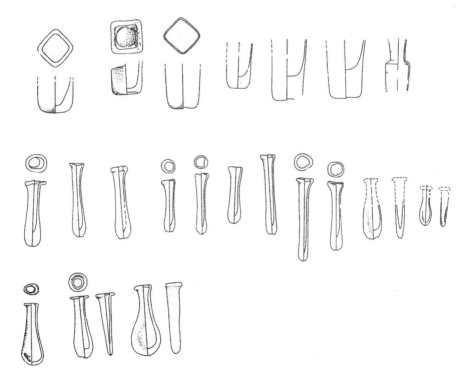

Fig. 22. Partial glass typology (Tiberias). *After A. Lester.*

Dates	Arabia	Palestine	Egypt	Mesopotamia
622	Hegira			
632	Death of Mohammed			
634				Muslim conquest
638		Arabic-Islamic conquest		
641			Muslim conquest	
661		Beginning of Umayyad caliphate		
685	Ibn Zubayr revolt			
750		End of Umayyad caliphate and beginning of Abbasid caliphate		
762				Founding of Baghdad
833				Founding of Samarra
868		Palestine annexed by the Tulunids	Establishment of Tulunid independence 868–905	
935			Ikhshidid caliphate	
945				Buyid emirs 945–1055
969		Palestine under Fatimid rule	Fatimid conquest	
1038		Turkish invasions in Palestine		Rise of Seljuk Turks 1038–1137
1099		Crusaders occupy Palestine		
1169			Ayyubids rule Egypt and Syria	
1187		Battle of Hattin; Palestine under Ayyubid rule 1187–1260		
1250			Mamluk sultanate 1250–1517	
1258				Mongols occupy Baghdad 1258–1338
1260		Mamluk victory at Ayn Jalut and rule 1260–1516		
1517			Ottoman rule 1517–1917	
1917		Arrival of British forces		

Fig. 23. Table of dates.

Notes

Introduction

1. B. Lewis, "Palestine."

2. For a more recent discussion of the geographical borders of Jund al-Urdunn and its fluctuations, see A. Elad, "The Southern Golan," in particular page 67. The topic of "Palestina Tertia" is beyond the scope of this book.

3. D. Whitcomb, *Ayla*; *Aqaba*.

4. J. Sauvaget, "Châteaux umayyades de Syrie."

5. M. Rosen-Ayalon, "Three Perspectives on Jerusalem."

Chapter 1

1. I. Eph'al, *The Ancient Arabs*.

2. P. Mayerson, "The First Muslim Attacks," p. 181.

3. A. A. Vasiliev, "Notes on some Episodes."

4. M. A. Meyer, *History of the City of Gaza*, p. 74.

5. G. Avni, *Archaeological Survey of Israel*; D. Nachlieli, I. Israel, and I. Ben Michael, "Nahal Laana," pp. 67–78 (Hebrew); Y. D. Nevo, "Sede Boker and the Central Negev,"; see also M. Rosen-Ayalon, "Récentes découvertes d'archéologie islamique," pp. 207–210.

6. G. Avni, "Les mosquées anciennes sur le mont du Néguev," p.78

7. F. Day, "Early Islamic and Christian Lamps."

8. Y. D. Nevo, Z. Cohen, and D. Heftmann, *Ancient Arabic Inscriptions from the Negev.*

9. A. Grohman, *Arabic Inscriptions*; H. Field, *Camel Brands.*

10. D. H. Kallner-Amiran, "A Revised Earthquake Catalogue of Palestine"; D. H. Kallner-Amiran, E. Arieh, and T. Turcotte, "Earthquakes in Israel and Adjacent Areas."

11. L. I. Conrad, "Historical Evidence and the Archaeology of Early Islam," p. 269.

12. R. de Vaux and A. M. Stève, *Fouilles à Qaryet el-'Enab Abu Gosh*, p. 93.

13. L. H. Vincent and F. M. Abel, *La Jérusalem nouvelle*, p. 927.

14. A. M. Maeir, "Sassanica Varia Palaestiniensia."

15. C. Coüasnon, *The Church of the Holy Sepulchre*, p. 27.

16. M. Sharon, "The Birth of Islam in the Holy Land."

17. P. Mayerson, "The First Muslim Attacks."

18. A. Negev, "Nabatean Inscriptions from 'Avdat (Oboda)," pp. 123–124.

19. K. A. C. Creswell, *Early Muslim Architecture*, vol. 1, pp. 445–448; M. Rosen-Ayalon, "The Contribution of Local Elements to Umayyad Art," pp. 194–199.

20. P. Crone and M. Cook, *Hagarism.*

21. L. I. Conrad, "Historical Evidence and the Archaeology of Early Islam," p. 268.

22. G. Avni, *Nomads, Farmers and Town-Dwellers*; D. Nachlieli, I. Israel, and I. Ben Michael, "Nahal Laana"; Y. D. Nevo, *Pagans and Herders.*

23. Y. D. Nevo, Z. Cohen, and D. Heftmann, *Ancient Arabic Inscriptions.*

24. C. J. Kraemer, *Excavations at Nessana.*

Chapter 2

1. An abundant bibliography, as well as researchers' theories on this topic, can be found in O. Grabar, *The Formation of Islamic Art*; E. Kühnel, *Islamic Art and Architecture*; D. and J. Sourdel, *La civilisation de l'Islam classique*, to cite only some of the most easily available sources.

2. R. Grafman and M. Rosen-Ayalon, "The Two Great Syrian Umayyad Mosques," pp. 1–2.

3. According to D. Schlumberger's definition, *l'Orient hellénisé.*

4. J. Strzygowski, "Die islamische Kunst als Problem," pp. 7–9.

5. R. Avner, "Elat-Elot: An Early Islamic Village."

6. L. Kolska-Horwitz, "Animal Exploitation During the Early Islamic Period in the Negev."

7. O. Lernau, "Fish Remains at Elat-Elot."

8. M. Haiman, "An Early Islamic Period Farm," pp. 1–13.

9. Y. Hirschfeld, *The Roman Baths of Hammat Gader*, p. 1.

10. R. Ben-Arieh, "The Roman, Byzantine and Umayyad Pottery."

11. Ibid, pp. 379–380 and p. XV/14–19.

12. T. Coen Uzzielli, "The Oil Lamps."

13. E. Cohen, "Roman, Byzantine and Umayyad Glass"; A. Lester, "Islamic Glass Finds."

14. N. Amitai-Preiss and A. Berman, "Muslim Coins."

15. N. Amitai-Preiss, "Arabic Inscriptions, Graffiti and Games."

16. L. Di Segni, "The Greek Inscriptions of Hammat Gader."

17. Ibid.

18. A. J. Boas, in Hirschfeld, *Hammat Gader*, pp. 387–394. For a more detailed presentation of late ceramics at Hammat Gader, see A. J. Boas, "Late Ceramic Typology."

19. The architectural data were studied primarily by K. A. C. Cresswell, *Early Muslim Architecture*, vol. 1, part 1, pp. 65–129, which also includes a detailed bibliography. On the meaning of the monument as well as its associated bibliography, see M. Rosen-Ayalon, *Early Islamic Monuments*, pp. 12–24, 46–69. An overview of the issues raised by the Dome of the Rock can be found in O. Grabar, *The Shape of the Holy*.

20. Al-Muqaddasi, *Ahsan al-taqasim*, p. 173, 1.3; see also M. Rosen-Ayalon, *Early Islamic Monuments*, pp. 6–7.

21. R. Grafman and M. Rosen-Ayalon, "The Two Great Syrian Umayyad Mosques."

22. R. W. Hamilton, *The Structural History of the Aqsa Mosque*, with reservations concerning the first phases of construction, on which see article quoted in note 21. For the subsequent periods, the different stages are entirely satisfactory.

23. K. A. C. Cresswell, *Early Muslim Art*, vol. 1, part 2, p. 378.

24. M. Rosen-Ayalon, "Remnants of a Piece of Wood-Carving from Khirbat al-Mafjar."

25. The author is currently preparing a repertory of all the architectural features of the whole complex.

26. See M. Rosen-Ayalon, *Early Islamic Monuments*, pp. 30–32, where a 10th-century source is quoted which already mentions the existence of six staircases.

27. J. Wilkinson, *Column Capitals in the Haram al-Sharif*, pp. 17–18, 127, 171–172, 186–189.

28. M. Rosen-Ayalon, *Early Islamic Monuments*, p. 27.

29. Ibid, p. 39.

30. H. Busse, "The Sanctity of Jerusalem in Islam," p. 451, and "The Church of the Holy Sepulchre," p. 285, as well as M. Rosen-Ayalon, *Early Islamic Monuments*, p. 39.

31. U. Monneret de Villard, *Introduzione allo studio dell' archeologica Islamica*, pp. 209–215.

32. M. Rosen-Ayalon, *Early Islamic Monuments*, p. 41, as well as "The Façade of the Holy Sepulcher," pp. 289–296.

33. J. Sauvaget, *La mosquée omeyyade de Médine*, pp. 137–138.

34. J. Sauvaget, "Châteaux umayyades de Syrie," for a discussion of the issue, pp. 5–21.

35. Some of these issues were taken up again and reanalyzed by L. I. Conrad, "Historical Evidence and the Archaeology of Early Islam."

36. O. Grabar, J. Perrot, B. Ravani, and M. Rosen, "Sondages à Khirbet al-Minyeh."

37. For a discussion of the common denominators of these "Umayyad castles," see H. Stern, "Note sur l'architecture des châteaux omeyyades."

38. R. W. Hamilton, "Who Built Khirbat al-Mafjar," pp. 61–67.

39. A detailed report of these excavations can be found in R. W. Hamilton, *Khirbat al-Mafjer*.

40. M. Rosen-Ayalon, "Further Considerations Pertaining to Umayyad Art."

41. R. Ettinghausen, *From Byzantium to Sasanian Iran and the Islamic World*, pp. 21–24 (III, "The Throne and Banquet Hall").

42. For a discussion of the baths complex, see J. Sourdel and O. Sourdel, *La civilisation de l'Islam classique*, pp. 352–355.

43. R. Ettinghausen, *From Byzantium to Sasanian Iran*.

44. R. W. Hamilton, *Walid and His Friends*.

45. M. Rosen-Ayalon, "Remnants of a Piece of Wood-Carving."

46. D. Sourdel, "La fondation umayyade d'al-Ramla en Palestine."

47. J. Kaplan, "Excavations at the White Mosque in Ramla."

48. M. Rosen-Ayalon and A. Eitan, *Ramla Excavations*.

49. D. C. Baramki, "The Pottery from Khirbet el-Mafjer," pp. 98–99, plates XX 1–2; for revising of Baramki's dating, see also D. Whitcomb, "Khirbet el-Mafjer Reconsidered."

50. This is the case, for example, of a small Byzantine site that continued to be occupied through the beginning of the Islamic era: E. Eisenbert and R. Ovadiah, "A Byzantine Monastery at Mevo Modi'in," p. 13.

51. M. Rosen-Ayalon, "The First Mosaic Discovered in Ramla."

52. M. Rosen-Ayalon, "The First Century of Ramla," p. 259.

53. Y. Tsafrir and G. Foerster, "Urbanism at Scythopolis-Bet-Shean in the Fourth to Seventh Centuries."

54. E. Khamis, "Two Wall-Mosaic Inscriptions from Umayyad Bet-Shean."

55. G. Avni, "Les mosquées anciennes sur le mont du Néguev."

56. Ibid.

57. C. Baly, "Sbaita."

58. D. Sourdel, "Barîd."

59. M. van Berchem, *Jérusalem ville*, pp. 17–29; R. de Vaux and A. M. Stève, *Fouilles à Qaryet el-'Enab Abu Gosh*, p. 81.

60. A. Elad, "The Southern Golan in the Early Islamic Period."

61. Ibid, pp. 78–79.

62. M. van Berchem, *Jérusalem ville*, p. 31.

63. A. Elad, "Caliph Abu al-'Abbas al-Saffah," and "An Epitaph of the Slave Girl of the Grandson of the Abassid Caliph al-Ma'mun," which are only two of many examples.

64. A forthcoming series of publications on Arabic inscriptions in Palestine will complete this collection of inscriptions.

65. R. Milstein, "A Hoard of Early Arab Figurative Coins."

66. D. Barag, "The Islamic Candlestick Coins of Jerusalem."

67. J. Porath, "Qanats in the Arava."

68. Ibid, p. 258.

69. A complete list of textile remnants from the Islamic period, with their places of origin, can be found in Z. Amar, "The Revolution in Textiles in Eretz Israel and Syria in the Middle Ages." See also the series of studies on this topic cited in the bibliography.

70. S. D. Goitein, *A Mediterranean Society*, p. 417.

71. N. Porath and S. Ilani, *From Colors to the Origins of Minerals*, pp. 33–36.

72. al-Balâduri, *Kitab futuh al-buldan*, p. 143.

73. "Trésors fatimides du Caire," p. 204.

74. J. David-Weill, "Fragments de nattes provenant d'Egypte."

Chapter 3

1. Works by Goitein on the Geniza provide abundant confirmatory information. S. D. Goitein, *A Mediterranean Society*.

2. M. de Vogüe, "La citerne de Ramleh et le tracé des arcs brisés."

3. H. Mitchell and S. Levi, "A Hoard from Ramla."

4. R. de Vaux and A.-M. Stève, *Fouilles à Qaryet el-'Enab Abu Gosh.*

5. Ibid, pp. 71–72.

6. P. Deschamps, *Terre sainte romane*, pp. 222–226.

7. See R. de Vaux and A.-M. Stève, *Fouilles à Qaryet el-'Enab Abu Gosh*, p. 130.

8. Al-Muqaddasi, *Ahsan al-taqâsim fi ma'rifat al-aqâlim*, p. 163.

9. E. J. Stern, "Evidence of Early Islamic Pottery Production in Acre."

10. A. Raban, *The Richness of Islamic Caesarea*, pp. 5–6.

11. Ibid, p. 13.

12. An initial presentation of these metal objects appeared in I. Ziffer, *Islamic Metalwork*, pp. 51–57.

13. I. Ziffer, *Islamic Metalwork*, contains references to pottery and glass as well as the pieces of metal unearthed during these excavations.

14. M. Rosen-Ayalon, "A Silver Ring from Medieval Islamic Times."

15. See "Khatt," in *Encyclopédie de l'Islam.*

16. The style of this beautiful goldsmith's work is attested elsewhere for the Fatimid era. This is the case for certain silver bracelets discovered during excavations in Jerusalem; see M. Ben-Dov, *The Dig at the Temple Mount*, p. 332.

17. Y. Porat, "The Gardens of Caesarea."

18. This piece is currently being studied by the author.

19. E. Oren, "Early Islamic Material from Ganei-Hamat (Tiberias)."

20. D. Stacy, PhD dissertation, forthcoming.

21. E. J. Stern, "An Early Islamic Kiln in Tiberias."

22. G. Lehrer-Yakobson, "Un verre de Tsur-Nathan peint en lustre métallique."

23. Y. Hirschfeld and O. Gutfeld, "Discovery of a Fatimid Period Vessel Hoard."

24. E. Khamis and R. Amir, "The Fatimid Period Bronze Vessel Hoard."

25. A. Onn, "Tiberias."

26. N. Brosh, "Two Jewelry Hoards from Tiberias."

27. R. Hasson, *Early Islamic Jewelry*, pp. 57–91.

28. D. J. Wasserstein, "The Coins in the Golden Hoard from Tiberias."

29. D. J. Wasserstein, "The Silver Coins in the Mixed Hoard from Tiberias."

30. Ibid, p. 17.

31. See "'Askalân," in *Encyclopédie de l'Islam.*

32. See D. Goitein, *A Mediterranean Society*, as well as M. Gil, *A History of Palestine.*

33. M. Rosen-Ayalon, "The Islamic Jewelry from Ashkelon."

34. E. Dvorzeski, "Tsrifa Shebe Ashkelon."

35. M. Sharon, "A New Fatimid Inscription from Ascalon and Its Historical Setting."

36. S. Kedar, "Les monnaies d'Ashkelon sous l'Islam."

37. D. Ayalon, *Le phénomène mamelouk dans l'Orient islamique*, pp. 117–124 (the Mamluk policy concerning ports and coastline defense).

38. H. Geva, "Excavations at the Citadel of Jerusalem."

39. Ibid, p. 166.

40. The episodes relating to this period are found in the respective chapters dealing with these two monuments.

41. M. de Vogüe, *Le temple de Jérusalem*, p. 93, plate XXXVII.

42. M. van Berchem, *Jérusalem ville*, pp. 39–73.

43. M. de Vogüe, *Le temple de Jérusalem*.

44. A. Peled, "The Local Sugar Industry Under the Latin Kingdom."

45. J. Seligman, "Excavations in the Crusader Fortress of Beth Shean," p. 141.

46. M. Kervran, "Une sucrerie d'époque islamique sur la rive droite du Chaour à Suse."

47. R. Abu Dalu, "The Technology of Sugar Mills in the Jordan Valley During the Islamic Periods."

48. E. J. Stern, "The Sugar Industry in Palestine During the Crusader, Ayyubid and Mameluk Periods in Light of Archaeological Finds."

49. M. L. von Wartburg, "Design and Technology of the Medieval Cane Sugar Refineries in Cyprus," pp. 81–116.

50. E. Ayalon and C. Sorek, *Ancient Artifacts from Animal Bones*, p. 56 for the worked fragments and p. 63 for the figurines.

51. D. Whitcomb, *Ayla*.

52. "Ayn Djarr," in *Encyclopédie de l'Islam*.

53. K. A. C. Creswell and J. Allan, *A Short Account of Early Muslim Architecture*, pp. 148–151.

54. Concerning the Seljuk attacks on Jerusalem and the restoration of the walls of the city under the Fatimids, see M. Gil, "The Political History of Jerusalem."

55. See the commentary concerning the "three walls" mentioned by Rabbi Benjamin of Tudela, in M. Rosen-Ayalon, "Three Perspectives on Jerusalem," p. 339.

56. D. Bahat, *Carta's Great Historical Atlas of Jerusalem*, pp. 87, 91, 93–97.

57. J. Prawer, "Ashkelon et la bande d'Ashkelon dans la politique des Croisés."

58. Ibid.

59. H. Geva, "Excavations at the Citadel of Jerusalem."

60. This excavation has not yet been published.

Chapter 4

1. J. Prawer, *Histoire du Royaume latin de Jérusalem.*

2. P. Deschamps, *Terre sainte romane.*

3. A. J. Boas, *Crusader Arcaheology,* pp. 143–150.

4. S. de Sandoli, *Corpus Inscriptionum Crucesignatorum Terrae Sanctae,* pp. 105–112.

5. Al-Hawari, *Guide des lieux de pèlinerage,* pp. 62–69.

6. C. Coüasnon, *The Church of the Holy Sepulchre.*

7. N. Kenaan, "Local Christian Art in Twelfth-Century Jerusalem," as well as M. Rosen-Ayalon, "The Façade of the Holy Sepulchre."

8. See discussion on the origins and the ramifications in Palestine in K. A. C. Creswell, *The Muslim Architecture of Egypt,* pp. 212–213.

9. See, among others, F. Gabrieli and U. Cerrato, *Gli Arabi in Italia,* and in particular pp. 16, 105, 128 and 129.

10. F. Gabrieli and U. Cerrato, *Gli Arabi in Italia,* pp. 30, 35–37; see below, on this topic, the mihrab of the al-Aqsa Mosque (during the Ayyubid period).

11. For a timeline of events in Palestine during the Crusader period, see S. Rosenberg, *Knights of the Holy Land,* pp. 14–15.

12. A. Lane, "Medieval Finds at al-Mina in Northern Syria."

13. E. J. Stern, "Ceramic Ware from the Crusader Period in the Holy Land."

14. Ibid.

15. Ibid, p. 265.

16. "Khatt," in *Encyclopédie de l'Islam.*

17. "Madrasa," in *Encyclopédie de l'Islam.*

18. M. van Berchem, *Jérusalem ville,* pp. 90–95.

19. The preserved inscription gives the name of Saladin, as well as the date 588/1192.

20. M. Rosen-Ayalon, "Art and Architecture in Ayyubid Jerusalem."

21. R. W. Hamilton, *The Structural History of the Aqsa Mosque,* p. 44, plate XXV, 4–5. For a more in-depth study of the pieces of Crusader sculpture reused in Muslim art, see H. Buschhausen, *Die Süditalienische Bauplastik im Königreich Jerusalem.*

22. Ibid.

23. M. van Berchem, *Jerusalem Haram,* pp. 393–402.

24. See the list of Ayubbid monuments of Jerusalem in M. Rosen-Ayalon, "Art and Architecture in Ayyubid Jerusalem."

25. M. H. Burgoyne and A. Abul-Hajj, "Twenty-Four Medieval Arabic Inscriptions from Jerusalem."

26. M. Broshi, "New Excavations Along the Walls of Jerusalem," p. 78.

27. D. Ayalon, *Le phénomène mamélouk dans l'Orient islamique*, pp. 117–124 (Mamluk policy concerning ports and coastal defense).

28. M. Rosen-Ayalon, "Art and Architecture in Jerusalem During the Ayyubid Jerusalem."

29. P. Balog, *The Coinage of the Ayyubids*, p. 315.

30. M. van Berchem, *Jérusalem Haram*, pp. 301–302.

31. *De Carthage à Kairouan, 2000 ans d'art et d'histoire*, p. 207.

32. R. W. Hamilton, *The Structural History of the Aqsa Mosque*, pp. 74–82, plates 39–43.

33. M. Rosen-Ayalon, "Jewish Substratum, Christian History and Muslim Symbolism."

34. A. Ben-Tor, M. Avissar, and Y. Portugali, *Yokneam I*, p. 13.

35. Ibid, p. 141.

36. Ibid, p. 159.

37. Ibid.

38. Ibid, color plate facing p. 89.

39. Ibid, pp. 170–198 and color plate facing p. 88.

40. Ibid, pp. 86–87.

41. Ibid, pp. 198–201.

42. Ibid, p. 216.

43. Ibid, p. 227.

44. Ibid, pp. 246–247.

45. Al-Qalqashandi, *Subh al-A'sha fi Kitâbat al-insha'*.

46. Mujir al-din, *Al-uns aljalil bi-ta'rikh al-Quds wa-l-Halil*, p. 418.

47. Ibid.

48. Here is it worth drawing attention to the portico of the *maristân* of al-Nasir Muhammad b. Qala'un in Cairo, which exemplifies this type of trilobed arch. In fact, it is thought to be a portal that was part of the Church of St. Andrew, built by the Crusaders in Acre and sent to Cairo by the Mamluks as "spoils of war."

49. See above, note 27.

50. C. Clermont-Ganneau, "Le pont de Baibars à Lydda."

51. R. de Vaux and A. M. Stève, *Fouilles à Qaryet el-'Enab Abu Gosh*, p. 110.

52. A. Mukari and Z. Gal, "Investigations at Khan et-Tujjar."

53. For example, a khan built by Baybarss: M. van Berchem, *Jérusalem ville*, pp. 445–446.

54. Ibid.

55. It is obviously impossible to mention all the Mamluk monuments in Jerusalem. See the detailed inventory by M. Burgoyne, *Mamluk Jerusalem*, as well as the overview by M. van Berchem, *Jérusalem ville*.

56. M. Meinecke, *Die Mamelukische Architektur in Agypten und Syrien*.

57. D. Ayalon, "Discharges from Service," pp. 25–50.

58. A list of the documents that provides a glimpse of wealth of these writings can be found in the bibliography by R. Amitai-Preiss, *Mongols and Mamluks*.

59. D. P. Little, *A Catalogue of the Islamic Documents from al-Haram al-Sharif in Jerusalem*.

60. The set of inscriptions described in M. van Berchem, *Matériaux pour un Corpus inscriptionum Arabicarum, Syrie du Sud: Jérusalem ville*, provide ample information on this topic.

61. D. Ayalon, *Le phénomène mamélouk dans l'Orient islamique*.

62. Ibid.

63. M. H. Burgoyne, *Mamluk Jerusalem*, provides an impressive list.

64. It should be noted, however, that this catalogue only includes existing monuments and not those that have disappeared.

65. D. Ayalon, *Le phénomène mamélouk dans l'Orient islamique*, p. 26.

66. One of the first to have attempted to define this style was M. A. Briggs, *Muhammadan Architecture in Egypt and Palestine*, pp. 89–131.

67. M. H. Burgoyne, *Mamluk Jerusalem*, plate 18.8, as well as "Some Mameluke Doorways," pp. 1–30.

68. L. A. Mayer, *Saracenic Heraldry*, as well as the more recent study by M. Meinecke, "Zur mamlukischen Heraldik."

69. M. van Berchem, *Jérusalem ville*, p. 294.

70. M. H. Burgoyne, *Mamluk Jerusalem*, pp. 109–116.

71. Ibid, p. 133.

72. M. van Berchem, *Jérusalem ville*, p. 252, as well as M. H. Burgoyne, *Mamluk Jerusalem*, pp. 223–239.

73. M. H. Burgoyne, *Mamluk Jerusalem*, p. 230, plate 18.5.

74. E. Herzfeld, "Damascus: Studies in Architecture."

75. M. Rosen-Ayalon, "A Neglected Group of Mihrabs in Palestine," figure 5, plate VI.

76. M. H. Burgoyne, *Mamluk Jerusalem*, p. 237.

77. M. Rosen-Ayalon, "A Mamluk Basin Rediscovered."

78. M. H. Burgoyne, *Mamluk Jerusalem*, pp. 273–298.

79. For further details on hammams, see M. Dow, *The Islamic Baths of Palestine*.

80. O. Grabar, "A New Inscription from the Haram al-Sharif in Jerusalem."

81. M. H. Burgoyne, *Mamluk Jerusalem*, p. 273.

82. M. van Berchem, *Jérusalem ville*, p. 244, note 4.

83. C. Enlart, *Les monuments des Croisés dans le Royaume de Jérusalem*, pp. 265–266.

84. Mujir al-din, *Al-uns aljalil bi-ta'rikh al-Quds wa-l-Halil*, pp. 326–327; Max van Berchem had already alluded to this, see M. van Berchem, *Jérusalem ville*, p. 362, note 6.

85. M. A. Briggs, *Muhammadan Architecture in Egypt and Palestine*, figure 175.

86. C. Kessler, *The Carved Masonry Domes of Medieval Cairo*, in which decorated domes are studied.

87. M. van Berchem, *Jérusalem Haram*, pp. 159–162.

88. R. Jacoby, "The Stone at the Foot of Qaitbai's Sabil," pp. 115–116.

89. M. van Berchem, *Jérusalem ville*, pp. 129–168, describing the complexity of this monument.

90. L. H. Vincent, E. J. H. Mackay, and F. M. Abel, *Hébron, le Haram al-Khalil*, pp. 194–195.

91. See E. Herzfeld, "Damascus," as well as M. Rosen-Ayalon, "A Neglected Group of Mihrabs in Palestine."

92. Vincent, Mackay, and Abel, *Hébron*, p. 252.

93. Ibid, pp. 200–250.

94. M. Rosen-Ayalon, "Une mosaïque médiévale au Saint-Sepulcre," pp. 248–251.

95. M. van Berchem, *Jérusalem Haram*, p. 413.

96. *RCEA*, vol. XVIII.

97. L. A. Mayer, J. Pinkerfeld, and J. W. Hirschberg, *Some Principal Muslim Religious Buildings in Israel*, pp. 44–46.

98. "Barid," in *Encyclopédie de l'Islam*.

99. Ms. Katya Citryn-Silverman is currently writing a Ph.D. on khans in Palestine.

100. M. S. Briggs, *Muhammadan Architecture*, figure 107.

101. T. Canaan, "Mohammadan Saints and Sanctuaries in Palestine."

102. L. A. Mayer, J. Pinkerfeld, and J. W. Hirschberg, *Some Principal Muslim Religious Buildings in Israel*, pp. 36–39.

103. S. Tamari, "Makam Nabi Musa près de Jéricho."

104. *From the Depths of the Sea*.

105. M. Dothan, "The Excavations at Afula," pp. 48–49.

106. P. J. Riis and V. Poulsen, *Hama*, pp. 270–276.

107. N. Avigad, *The Upper City of Jerusalem*, p. 255, figure 302.

108. S. Haddad has just finished a Ph.D. on glass found in Bet Shean, which will be published shortly.

109. R. Hasson, "Islamic Glass."

110. Ibid, p. 109.

111. G. Lehrer, *Hebron, City of Glassmaking*.

Chapter 5

1. S. Wachsman and K. Raveh, "The Guns of Tantura."

2. M. van Berchem, *Jérusalem Haram*, pp. 368–371.

3. Ibid.

4. M. Rosen-Ayalon, "On Suleiman's Sabils in Jersualem."

5. A. Cohen, "Local Trade, International Trade and Government Involvement in Jerusalem During the Early Ottoman Period."

6. M. van Berchem, *Jérusalem Haram*, pp. 424–425.

7. See the discovery of Ayyubid towers during excavations by M. Broshi, "New Excavations along the Walls of Jerusalem," and Avigad: These were connected to sections of wall which were part of the line of Ottoman walls.

8. M. van Berchem, *Jérusalem Haram*, pp. 445–446.

9. Mayer, L. A., J. Pinkerfeld, and J. W. Hirschberg, *Some Principal Muslim Religious Buildings in Israel*, p. 49.

10. A good number of references to the various monuments can be found in the guide by M. Makhouly and C. M. Johns, *Guide to Acre*.

11. A recent study features some illustrations of these wall paintings: R. Fuchs, "The Palestinian Arab House Reconsidered."

Chapter 6

1. Y. Olenik, *The Armenian Pottery of Jerusalem*.

2. M. Rosen-Ayalon, "Later Islamic Art in Jerusalem."

3. Ibid.

Conclusion

1. Marguerite van Berchem, in K. A. C. Creswell, *Early Muslim Architecture*, vol. 1, part 1 (1969), quotes a series of texts concerning mosaic art related to the Dome of the Rock.

2. M. Rosen-Ayalon, "A Neglected Group of Mihrabs in Palestine."

3. M. Rosen-Ayalon, "The Contributions of Local Elements to Umayyad Art," pp. 194–199. The field of sculpture also provides interesting comparisons by supplying a good number of examples of forerunners, in particular announcing themes found later at Khirbat al-Mafjar. See E. Russo, *Acta ad Archaeologiam et Artium Historiam Pertinentia.*

4. Unfortunately, the most recent study on Ottoman archaeology is very limited in scope: U. Baram and L. Carroll, eds. *A Historical Archaeology of the Ottoman Empire.*

Bibliography

Abu Dalu, R. "The Technology of Sugar Mills in the Jordan Valley during the Islamic Periods." In *Studies in the History and Archaeology of Jordan V*, 37–48. Amman: Dept. of Antiquities, 1975 (Arabic).

Albright, W. P. *The Archaeology of Palestine.* Harmondsworth: Penguin, 1960.

Amar, Z. "The Revolution in Textiles in Eretz Israel and Syria in the Middle Ages." *Cathedra* 87 (April 1998): 51–53 (Hebrew).

Amitai-Preiss, Nitzan. "Arabic Inscriptions, Graffiti and Games." In *The Roman Baths of Hammat Gader*, edited by Yizhar Hirschfeld, 267–272. Jerusalem: Israel Exploration Society, 1997.

Amitai-Preiss, Nitzan, and Berman Ariel. "Muslim Coins." In *The Roman Baths of Hammat Gader*, edited by Yizhar Hirschfeld, 301–318. Jerusalem: Israel Exploration Society, 1997.

Amitai-Preiss, Reuven. "Mongol Raids into Palestine (A.D. 1260 and 1300)." *Journal of the Royal Asiatic Society* (1987): 234–255.

———. *Mongols and Mamluks.* Cambridge: Cambridge University Press, 1995.

Arnon, Y. "The Commercial Activity of Caesarea During the Early Islamic and Crusader Periods (640–1265) According to the Ceramic Evidence." In *Caesarea: A Mercantile City by the Sea*, Exhibition Catalogue 12, Haifa, Reuben and Edith Hecht Museum, 1995, pp. 26–29 (Hebrew).

Avigad, Nahman. *The Upper City of Jerusalem.* Jerusalem, 1980.

———. *Discovering Jerusalem*. Jerusalem: T. Nelson, 1983.

Avi-Yonah, M. "Oriental Elements in the Art of Palestine in the Roman and Byzantine Periods." *Quarterly of the Department of Antiquities of Palestine* 1 (1942): 105–151.

Avner, Rina. "Elat-Elot: An Early Islamic Village." *'Atiqot* 36 (1998): 21–39, 124–125.

Avni, Gideon. *Archaeological Survey of Israel. La carte du Mont Sagi*. Jerusalem, 1992.

———. "Ancient Mosques on the Negev Mount." *'Atiqot* 21 (1992) (Hebrew).

———. "Early Mosques in the Negev Highlands: New Archaeological Evidence on Islamic Penetration of Southern Palestine." *Bulletin of the American Schools of Oriental Research* 294 (1994): 83–100.

———. *Nomads, Farmers and Town-Dwellers: Pastoralist-Sedentist Interaction in the Negev Highlands, 6th–8th Centuries* C.E. Jerusalem: Archaeological Survey of Israel, 1996.

Ayalon, David. "The Mamluks and Naval Power: A Phase of the Struggle between Islam and Christian Europe." *Proceedings of the Israel Academy of Sciences and Humanities* 1, no. 8 (1967): 1–12.

———. "Discharges from Service: Banishments and Imprisonments in Mamluk Society." *Israel Oriental Studies* 3 (1972): 25–50.

———. *Le phénomène mamelouk dans l'Orient islamique*. Paris: PUF, 1996.

Ayalon, E., and C. Sorek. *Ancient Artifacts from Animal Bones*. Tel Aviv: Eretz Israel Museum, 1999.

Bacharach, J. "Palestine in the Policies of Tulunid and Ikhshidid Governors of Egypt (A.H. 254–358/868–969 A.D.)." In *Egypt and Palestine: A Millennium of Association (868–948)*, edited by A. Cohen and G. Baer, 51–65. Jerusalem: Ben Zvi Institute, 1984.

Baginski, A., and O. Shamir. "Early Islamic Textiles, Basketry and Cordage from Nahal Omer." *'Atiqot* 26 (1995): 21–42.

Bahat, D. *Carta's Great Historical Atlas of Jerusalem*. Jerusalem, 1989.

al-Baladuri. *Kitab futuh al-buldan*. Edited by M. J. de Goeje. Leiden: Brill, 1866.

Balog, Paul. *The Coinage of the Ayyubids*. London: Royal Numismatic Society, 1990.

Baly, C. "Sbaita." *Palestine Exploration Fund Quarterly Statement* 62 (1935): 171–181.

Barag, Dan. "The Islamic Candlestick Coins of Jerusalem." *Israel Numismatic Journal* 10 (1988–1989): 40–48.

Baram, Uzi, and Lynda Caroll, eds. *A Historical Archaeology of the Ottoman Empire: Breaking New Ground*. New York: Springer, 2000.

Baramki, D. C. "The Pottery from Khirbet al-Mafjer." *Quarterly of the Department of Antiquities of Palestine* 10 (1942): 65–103.

Ben-Arieh, Roni. "The Roman, Byzantine and Umayyad Pottery." In *The Roman Baths of Hammat Gader*, edited by Yizhar Hirschfeld, 375–381. Jerusalem: Israel Exploration Society, 1997.

Ben-Dov, M., *The Dig at the Temple Mount*. Jerusalem: Keter, 1982.

Ben-Tor, A., M. Avissar, and Y. Portugali. *Yokneam I: The Later Periods*. Qedem Reports, vol. 3. Jerusalem: Israel Exploration Society, 1996.

Blau, J. "The Transcription of Arabic Words and Names in the Inscription of Mu'awiya from Hammat Gader." *Israel Exploration Journal* 32 (1982).

Boas, Adrian J. "Late Ceramic Typology." In *The Roman Baths of Hammat Gader*, edited by Yizhar Hirschfeld, 382–395. Jerusalem: Israel Exploration Society, 1997.

———. *Crusader Archaeology*. London: Routledge, 1999.

Bonfioli, M. "Syriac-Palestinian Mosaics in Connection with the Decorations of the Mosques at Jerusalem and Damascus." *East and West* 10 (1959): 57–76.

Briggs, M. A. *Muhammadan Architecture in Egypt and Palestine*. Oxford, 1924 (reprint).

Brosh, Naama. "Two Jewelry Hoards from Tiberias." *'Atiqot* 36 (1998): 1–9.

Broshi, Magen. "New Excavations along the Walls of Jerusalem." *Qadmoniot* 9 (1976): 78 (Hebrew).

Burgoyne, M. H. "Some Mameluke Doorways in the Old City of Jerusalem." *Levant* 3 (1971): 1–30.

———. "A Recently Discovered Marwanid Inscription in Jerusalem." *Levant* 14 (1982): 188–121.

———. *Mamluk Jerusalem*. London: A Scorpion Pica production, 1987.

———. "The Gates of the Haram al-Sharif." In *Bayt al-Maqdis*, edited by J. Raby, 105–124. Oxford: Oxford University Press, 1993.

Burgoyne, M. H., and A. Abul-Hajj. "Twenty-Four Medieval Arabic Inscriptions from Jerusalem." *Levant* 11 (1979): 121–123, plates XIVa and XVa–b.

Buschhausen. *Die süditalienische Bauplastik im Königreich Jerusalem*. Vienna: Verlag der Österreichischen Akademie der Wissenschaften, 1978.

Busse, Heribert, "The Sanctity of Jerusalem in Islam." *Judaism* 17 (1972).

————. "The Church of the Holy Sepulchre, the Church of the Agony and the Temple: The Reflection of a Christian Belief in Islamic Tradition." *Journal of Studies in Arabic and Islam* 9 (1987).

Canaan, T. "Mohammadan Saints and Sanctuaries in Palestine." *Journal of the Palestine Oriental Society,* 1927 (reprint Ariel Publishing House, Jerusalem).

————. "The Palestinian Arab House and its Architecture and Folklore." *Journal of the Palestine Oriental Society* 12 (1932): 223–247; 13 (1933): 1–83.

Chen, D. "The Design of the Dome of the Rock in Jerusalem." *Palestine Exploration Quarterly* 112 (1980–1981): 41–50.

Clermont-Ganneau, C. "Le pont de Baibars à Lydda." *Recueil d'archéologie orientale,* vol. 1, 262–279. Paris, 1888.

Coen Uzzielli, Tania. "The Oil Lamps." In *The Roman Baths of Hammat Gader,* edited by Yizhar Hirschfeld, 326–328, plates VII 5–6, VII–X, XI-1, figs. 13–14. Jerusalem: Israel Exploration Society, 1997.

Cohen, Amnon. "Local Trade, International Trade and Government Involvement in Jerusalem During the Early Ottoman Period." *Asian and African Studies* 12 (March 1978): 5–12.

Cohen, Einat. "Roman, Byzantine and Umayyad Glass." In *The Roman Baths of Hammat Gader,* edited by Yizhar Hirschfeld, 426–429. Jerusalem: Israel Exploration Society, 1997.

Colt, H. D. *Excavations at Nessana,* vol. I. London: British School of Archaeology in Jerusalem, 1962.

Combe, E., J. Sauvaget, and G. Wiet. *Répertoire chronologique d'épigraphie arabe,* vol. I. Cairo: Institut Français d'Archéologie Orientale, 1931.

Conrad, Lawrence I. "Historical Evidence and the Archaeology of Early Islam." In *Quest for Understanding, Arabic and Islamic Studies in Memory of Malcolm H. Kerr,* edited by S. Seikaly, R. Baalbaki, and P. Dodd. Beirut: American University of Beirut, 1991.

Coüasnon, C. *The Church of the Holy Sepulchre.* London: Oxford University Press for the British Academy, 1974.

Creswell, K. A. C. *Early Muslim Architecture,* vols. I and II. Oxford: Oxford University Press, 1932, 1940.

————. *The Muslim Architecture of Egypt.* Oxford: Oxford University Press, 1952.

————. *A Short Account of Early Muslim Architecture.* New York: Penguin, 1959.

————. *Early Muslim Architecture,* vol. I, Part II. Oxford: Clarendon Press, 1969.

———. *Early Muslim Architecture*, vol. II. New York: Hacker Art Books, 1970.

Creswell, K. A. C., and J. Allan. *A Short Account of Early Muslim Architecture.* Cairo: The American University in Cairo, 1989.

Crone, P., and M. Cook. *Hagarism: The Making of the Islamic World.* Cambridge: Cambridge University Press, 1977.

David-Weill, J. "Fragments de natte provenant d'Egypte (Xe–XIe siècles)." *La Revue des Arts* 4 (1956): 248–249.

Day, Florence. "Early Islamic and Christian Lamps." *Berytus* 3 (1942): 65–79.

De Carthage à Kairouan: 2000 ans d'art et d'histoire en Tunisie. Paris: Musée du Petit Palais de la Ville de Paris, 1982.

Deschamps, Paul. *Terre sainte romane.* Paris, 1990.

Di Segni, Leah. "The Greek Inscriptions of Hammat Gader." In *The Roman Baths of Hammat Gader,* edited by Yizhar Hirschfeld, 237–240. Jerusalem: Israel Exploration Society, 1997.

Dothan, Moshe. "The Excavations at Afula." *'Atiqot* 1 (1955).

Dow, M. *The Islamic Baths of Palestine.* Oxford: Oxford University Press, 1996.

Dvorzeski, E. "Tsrifa Shebe Ashkelon. The Talmudic Reality in the Art of Goldsmithery in the Land of Israel at the Time of the Mishna and the Talmud." *Tarbitz* 60, no. A (1994): 27–40 (Hebrew).

Eisenbert, E., and R. Ovadiah. "A Byzantine Monastery at Mevo Modi'irn." *'Atiqot* 36 (1998).

Elad, Amikam. "The Coastal Cities of Palestine During the Early Middle Ages." *The Jerusalem Cathedra* 2 (1982): 466–467.

———. "An Epitaph of the Slave Girl of the Grandson of the Abassid Caliph al-Ma'mun." *Le Muséon* III, booklets 1–2 (1988): 227–244.

———. "The History and Topography of Jerusalem during the Early Islamic Period: The Historical Value of Fada'il al-Quds Literature, a Reconsideration." *Journal of Studies in Arabic and Islam* 14 (1991): 41–70.

———. *Medieval Jerusalem and Islamic Worship: Holy Places, Ceremonies, Pilgrimage.* Leiden: Brill, 1995.

———. "Caliph Abu al-'Abbas al-Saffah, the First Abbasid Mahdi. Remarks on an Unknown Inscription from Bet Shean." In *Massat Moshe,* edited by E. Fleischer, M. A. Friedman, and J. Kraemer, 9–55. Jerusalem and Tel Aviv: Mossad Bialik and Tel Aviv University, 1998 (Hebrew).

————."The Southern Golan in the Early Muslim Period, The Significance of Two Newly Discovered Milestones of 'Abd al-Malik." *Der Islam* 76 (1999): 33–88.

Encyclopédie de l'Islam, 2nd ed., Leiden: Brill, 1954.

Enlart, C. *Les monuments des Croisés dans le Royaume de Jérusalem.* Paris, 1925–1927.

Eph'al, Israel. *The Ancient Arabs. Nomads on the Borders of the Fertile Crescent, 9th–5th Century B.C.* Jerusalem: Magnes Press, 1984.

Ettinghausen, Richard. *From Byzantium to Sasanian Iran and the Islamic World. Three Modes of Artistic Influence.* Leiden: Brill, 1972.

Field, Henry. *Camel Brands and Graffiti from Iraq, Syria, Jordan, Iran and Arabia.* Supplement to the *Journal of the American Oriental Society*, 1952.

FitzGerald, G. *Beth Shean Excavations, 1921–1923: The Arab and Byzantine Levels.* Philadelphia: University of Pennsylvania, 1931.

From the Depths of the Sea. Jerusalem: Israel Museum Catalogue , 1985.

Fuchs, Ron. "The Palestinian Arab House Reconsidered. Part 2, Domestic Architecture in the 19th Century." *Cathedra* 90 (December 1998): 53–86 and plates 74–76 (Hebrew).

Gabrieli, F., and U. Cerrato. *Gli Arabi in Italia.* Milan, 1979.

Geva, Hillel. "Excavations at the Citadel of Jerusalem 1976–1980." In *Ancient Jerusalem Revealed*, edited by H. Geva, 164–167. Jerusalem: Israel Exploration Society, 1994.

Gichon, Mordechai. "Fine Byzantine Wares from the South of Israel." *Palestine Exploration Quarterly* 106 (1974): 119–139.

Gichon, Mordechai, and R. Landau. "Muslim Oil Lamps From Emmaus." *Israel Exploration Journal* 34, no. 2–3 (1984): 156–159.

Gil, Moshe. *A History of Palestine, 634–1099.* Cambridge: Cambridge University Press, 1992.

————. "The Political History of Jerusalem." In *The History of Jerusalem: The Early Muslim Period, 638–1099*, edited by J. Prawer and H. Ben-Shammai, 29–35. Jerusalem: Yad Ben Zvi, 1996.

Gilat, A., M. Shirav, R. Bogoch, L. Halicz, U. Avner, and D. Nahlieli. "Significance of Gold Exploitation in the Early Islamic Period, Israel." *Journal of Archaeological Science* 20, no. 4 (1993): 429–437.

Goitein, S. D. *A Mediterranean Society*, 4 vols. Berkeley: University of California Press, 1967.

Grabar, Oleg. "The Umayyad Dome of the Rock in Jerusalem." *Ars Orientalis* 3 (1959): 33–62.

———. "A New Inscription from the Haram al-sharif in Jerusalem. A note on the Medieval Topography of Jerusalem." In *Studies in Islamic Art and Architecture in Honour of Professor K. A. C. Creswell*, 72–83. Cairo: American University of Cairo Press, 1965.

———. *The Formation of Islamic Art*. New Haven: Yale University Press, 1973.

———. *The Shape of the Holy*. Princeton, NJ: Princeton University Press, 1996.

Grabar, O., J. Perrot, B. Ravani, and M. Rosen. "Sondages à Khirbet al-Minyeh." *Israel Exploration Journal* 10 (1960): 226–243.

Grafman, Rafi, and Myriam Rosen-Ayalon. "The Two Great Syrian Umayyad Mosques: Jerusalem and Damascus." *Muqarnas* 16 (1999).

Green, J., and J. Tsafrir. "Greek Inscriptions from Hammat-Gadar. A Poem by the Empress Eudocia and Two Building Inscriptions." *Israel Exploration Journal* 32, no. 2–3 (1982): 97–101.

Griffith, S. *Arabic Christianity in the Monasteries of Ninth-Century Palestine*, Aldershot: Variorum, 1992.

Grohman, Adolf. *Arabic Inscriptions. Expédition Philby-Ryckmans-Lippens en Arabie*. Louvain: University of Louvain, 1962.

———. *Arabic Papyri from Hirbet el-Mird*. Louvain: University of Louvain, 1963.

Haaretz Museum. *Rashaya al-Fukhkhar*. Catalogue. Tel Aviv, 1983 (Hebrew).

Haiman, M. "An Early Islamic Period Farm at Nahal Mitnan in the Negev Highlands." *'Atiqot* 26 (1995).

———. "Agriculture and Nomad-State Relations in the Negev Desert in the Byzantine and Early Islamic Periods." *Bulletin of the American Schools of Oriental Research* 297 (1995): 29–53.

Hamilton, R. W. "Some Capitals from the Aqsa Mosque." *Quarterly of the Department of Antiquities of Palestine* 13 (1948): 103–120.

———. *The Structural History of the Aqsa Mosque*. Oxford: Oxford University Press, 1949.

———. *Khirbet al-Mafjer*. Oxford: Oxford University Press, 1959.

———. "Who Built Khirbat al-Mafjar." *Levant* 1 (1969): 61–67.

———. "Khirbat al-Mafjar: The Bath Hall Reconsidered." *Levant* 10 (1978): 126–138.

————. *Walid and His Friends: An Umayyad Tragedy.* Oxford: Oxford University Press, 1988.

————. "Once Again the Aqsa." In *Bayt al-Maqdis: 'Abd al-Malik's Jerusalem,* edited by J. Raby and J. Johns, 141–144. Oxford: Oxford University, 1992.

al-Harawi, 'Ali. *Guide des lieux de pèlerinage.* Edited by J. Sourdel-Thomine, 24–28. Damascus, 1954. Trans. J. Sourdel-Thomine. Damascus, 1957.

Hasson, I. "Remarques sur l'inscription de l'époque de Mu'awiya à Hammat Gader." *Israel Exploration Journal* 32 (1982): 97–101.

————. "The Muslim View of Jerusalem: The Qur'an and Hadith." In *The History of Jerusalem: The Early Muslim Period 638–1099,* edited by J. Prawer and H. Ben Shammai, 349–385. Jerusalem: Yad Izhak Ben-Zvi, 1996.

Hasson, Rachel. "Islamic Glass from Excavations in Jerusalem." *Journal of Glass Studies* 25 (1983): 109–113.

————. *Early Islamic Jewelry.* Jerusalem: L. A. Mayer Memorial Institute for Islamic Art, 1987.

Herzfeld, E. "Damascus: Studies in Architecture." *Ars Islamica* 9 (1942): 1–53; 10 (1943): 13–70; 11–12 (1946): 1–71; 13–14 (1948): 118–138.

Hirschfeld, Yizhar. *The Roman Baths of Hammat Gader.* Jerusalem: Israel Exploration Society, 1997.

Hirschfeld, Yizhar, and O. Gutfeld. "Discovery of a Fatimid Period Vessel Hoard at Tiberias." *Qadmoniot* 32, no. 2 (1999): 102–107 (Hebrew).

Horwitz, L. K. "Fauna from the Nahal Mitnan Farm." *'Atiqot* 26 (1995): 15–19.

Jacobson, D. M. "The Golden Section and the Design of the Dome of the Rock." *Palestine Exploration Quarterly* 115 (1983): 145–147.

Jacoby, David. "Montmusard, Suburb of Crusader Acre: The First Stage of Its Development." In *Outremer,* edited by B. Z. Kedar, H. E. Mayer, and R. C. Smail, 205–217. Jerusalem: Yad Izhak Ben-Zvi Institute, 1982.

Jacoby, R. "The Stone at the Foot of Qaitbai's Sabil on the Temple Mount Sarcophagus or Late Second Temple Period Frieze." *Qadmoniot* 21, no. 3–4 (1998): 115–116.

Jaussen, J. A. "Inscription arabe du Khan al-Ahmar à Beisan (Palestine)." *Bulletin de l'Inst. fr. d'archéologie orientale* 22 (1922): 99–103.

Kalayan, H. "The Similarity in Planning the Dome of the Rock and the Church of Ascension in Jerusalem." *Annual of the Department of Antiquities (Jordan)* 26 (1982): 405–409.

Kallner-Amiran, D. H. "A Revised Earthquake Catalogue of Palestine." *Israel Exploration Journal* 1 (1950–1951): 223–246.

Kallner-Amiran, D. H., E. Arieh, and T. Turcotte. "Earthquakes in Israel and Adjacent Areas." *Israel Exploration Journal* 44 (1994): 261–305.

Kaplan, J. "Excavations at the White Mosque in Ramla." *'Atiqot* 2 (1957): 96–103 (Hebrew).

Kedar, S. "The Coins of Ashkelon Under Islam." In *Ashkelon: 4000 and 40 More Years*, 183–186. Ashkelon, 1990 (Hebrew).

Kenaan, N. "Local Christian Art in Twelfth-Century Jerusalem." *Israel Exploration Journal* 23 (1973): 167–175, 221–229.

Kervran, M. "Une sucrerie d'époque islamique sur la rive droite du Chaour à Suse." *Cahiers de la DAFI* 10 (1979): 177–237.

Kessler, Christel. *The Carved Masonry Domes of Medieval Cairo*. Cairo: American University in Cairo Press, 1976.

Khamis, E. "Two Wall-Mosaic Inscriptions from Umayyad Bet-Shean." *Cathedra* 85 (1997): 45–64, 188.

Khamis, E., and R. Amir. "The Fatimid Period Bronze Vessel Hoard." *Qadmoniot* 32, no. 2 (1999): 108–114 (Hebrew).

Kolska-Horwitz, L. "Animal Exploitation During the Early Islamic Period in the Negev: The Fauna from Elat-Elot." *'Atiqot* 36 (1998): 27–38.

Kraemer, C. J. *Excavations at Nessana*. Vol. 3: *Non-Literary Papyri*. Princeton, NJ: Princeton University Press, 1958.

Kühnel, E. *Islamic Art and Architecture*. New York: Cornell University Press, 1966.

Lane, Arthur. "Medieval Finds at al-Mina in Northern Syria." *Archaeologia* 87 (1937): 19–78.

Layish, A. "The Sijill of the Jaffa and Nazareth Courts as a Source for the Political and Social History of Ottoman Palestine." In *Studies on Palestine during the Ottoman Period*, edited by M. Ma'oz, 525–532. Jerusalem: The Magnes Press, 1975.

Lecker, Michael. "The Estates of 'Amr b. al-As in Palestine: Notes on a New Negev Arabic Inscription." *Bulletin of the School of Oriental and African Studies* 52 (1989): 24–37.

Lee, M., C. Raso, and R. Hillenbrand. "Mamluk Caravansarais in Galilee." *Levant* 24 (1992).

Lehrer, G. *Hebron, City of Glass Making*. Tel Aviv: Haaretz Museum, 1969.

Lehrer-Yakobson, G. "A Glass from Tsur-Nathan as Painted in Metallic Luster." *Israel—People and Land, Annual of the Eretz Israel Museum (Tel Aviv)* 7–8 (1990–1993): 83–90.

Lenzen, C. "The Byzantine/Islamic Occupation at Caesarea Maritima as Evidenced Through the Pottery." PhD dissertation, Drew University, 1983.

Lernau, Omri. "Fish Remains at Elat-Elot." *'Atiqot* 36 (1998): 41–46, 125–126.

Lester, Ayala. "A Glass Weight From the Times of 'Abd al-Malik b. Yazid." *'Atiqot* 10 (1990): 21 (Hebrew).

———. "Islamic Glass Finds." In *The Roman Baths of Hammat Gader*, edited by Yizhar Hirschfeld, 432–441. Jerusalem: Israel Exploration Society, 1997.

Lester, Ayala, Y. D. Arlion, and R. Polak. "The Fatimid Hoard from Caesarea: A Preliminary Report." In *L'Egypte Fatimide: Son art et son histoire*, 233–246. Paris: Presses de l'Université de Paris, 1999.

Levy, Thomas, ed. *The Archaeology of Society in the Holy Land*. New York: Facts on File, 1995.

Lewis, Bernard. "An Arabic Account of the Province of Safed." *Bulletin of the School of Oriental and African Studies* 11 (1953): 477–488.

———. "Palestine: On the History and Geography of a Name." *The International History Review* 2, no. 1 (January 1980): 1–12.

———. *The Muslim Discovery of Europe*. New York: W. W. Norton, 1982.

———. *Comment Islam a découvert l'Europe*. Paris, 1984.

Little, D. P. *A Catalogue of the Islamic Documents from al-Haram al-Sharif in Jerusalem*. Beirut-Wiesbaden, 1984.

Maeir, A. M. "Sassanica Varia Palaestiniensia. A Sassanian Seal from T. Istabab, Israel and Other Sassanian Objects from the Southern Levant." *Iranica Antiqua* 35 (2000): 159–183.

Magness, J. "Reexamination of the Archaeological Evidence for the Sasanian Persian Destruction of the Tyropoeon Valley." *Bulletin of the American Schools of Oriental Research* 287 (1992): 67–74.

———. "The Byzantine and Islamic Pottery from Area A2 and G." In *Excavations at the City of David 1978–1985*, vol. 3, edited by A. de Groot and D. Ariel, 164–166. Qedem 33. Jerusalem: Hebrew University, 1992.

———. *Jerusalem Ceramic Chronology circa 200–800 CE*. Sheffield: Sheffield Academic Press, 1993.

Makhouly, N., and C. M. Johns. *Guide to Acre*. Jerusalem, 1946.

Marmardji, A. S. *Textes géographiques arabes sur la Palestine.* Paris: Librairie Lecoffre; J. Gabalda, 1951.

Mayer, L. A. "A Medieval Arabic Description of the Haram of Jerusalem." *Quarterly of the Department of Antiquities of Palestine* 1 (1932): 44–51, 74–85.

———. "The Name of Khan el-Ahmar, Beisan." *Quarterly of the Department of Antiquities of Palestine* 1 (1932): 95–96.

———. *Saracenic Heraldry.* Oxford: Clarendon Press, 1933.

———. "As-Sinnabra." *Israel Exploration Journal* 2 (1952): 183–187.

Mayer, L. A., J. Pinkerfeld, and J. W. Hirschberg. *Some Principal Muslim Religious Buildings in Israel.* Jerusalem, 1950.

Mayerson, P. "The First Muslim Attacks on Southern Palestine (A.D. 633–34)." *Transactions and Proceedings of the American Philological Association* 95 (1964): 155–159.

Mazar, Amihai. *Archaeology of the Land of the Bible, 10000–586 B.C.E.* New York: Doubleday, 1992.

Meinecke, M. "Zur mamlukischen Heraldik." *Mitteilungen des Deutschen Archaeologischen Instituts. Abteilung Kairo* 28, no. 2, 1972 (1973): 213–287.

———. *Die Mamelukische Architektur in Agypten und Syrien,* 2 vols. Gluckstadt, 1992.

Meyer, M. A. *History of the City of Gaza, From the Earliest Times to the Present Day.* New York: AMS Press, 1966.

Milstein, Rachel. "A Hoard of Early Arab Figurative Coins." *Israel Numismatic Journal* 10 (1988–1989): 3–26.

Mitchell, H., and S. Levi. "A Hoard from Ramla." *Israel Numismatic Journal* 3 (1965–1966): 37–66.

Monneret de Villard, Ugo. *Introduzione allo studio dell'archeologia Islamica.* Venice and Rome: Istituto per la Collaborazione Culturale, 1968.

Mujir al-din. *Al-uns aljalil bi-ta'rikh al-Quds wa-l-Halil,* 2 vols. Cairo, 1866.

Mukari, A., and Z. Gal. "Investigations at Khan et-Tujjar." *'Atiqot* 36 (1998): 126, 47–55.

al-Muqaddasi. *Ahsan al-taqasim fi ma'rifat al-aqalim.* Edited by de Goeje. Leiden: Brill, 1906.

Nachlieli, D., I. Israel, and I. Ben Michael. "Nahal Laana, a farm from the early Islamic period." *'Atiqot* 30 (1993): 67–78 (Hebrew).

Nasir i Khusraw. *Relation de voyage.* Paris: Editions de Ch. Shefer, 1881.

Negev, A. "Nabatean Inscriptions from 'Avdat (Oboda)." *Israel Exploration Journal* 13 (1963).

Nevo, Yehuda D. "Sede Boker and the Central Negev: 7th–8th Century." In *Third International Colloquium: From Jahiliyya to Islam.* Jerusalem, 1985.

———. *Pagans and Herders: A Re-examination of the Negev Runoff Cultivation Systems in the Byzantine and Early Arab Periods.* Sede Boker: Israel Publication Services, 1991.

Nevo, Yehuda D., Zemira Cohen, and Dalia Heftmann. *Ancient Arabic Inscriptions from the Negev,* vol. 1. Negev: Midreshet Ben-Gurion, 1993.

Olenik, Yael. *The Armenian Pottery of Jerusalem,* Tel-Aviv: Haaretz Museum, 1986.

Onn, A. "Tiberias." *Excavations and Surveys in Israel* 10 (1991): 166–167.

Oren, E. "Early Islamic Material from Ganei-Hamat (Tiberias)." *Archaeology* 24, no. 1 (1971): 274–277.

———. "Ganei-Hamat (Tiberias) Excavations 1970." *Journal of Glass Studies* 13 (1971): 149–150.

Peled, A. "The Local Sugar Industry Under the Latin Kingdom." In *Knights of the Holy Land. The Crusader Kingdom of Jerusalem,* edited by S. Rosenberg, 251–257. Jerusalem: The Israel Museum, 1999.

Porat, Y. "The Gardens of Caesarea." *Qadmoniot* 8 (1975): 90–93 (Hebrew).

Porath, J. "Qanats in the Arava." In *Eilat Studies in Archaeology, History and Geography of Eilat and the Aravah,* edited by J. Aviram, H. Geva, R. Cohen, Z. Meshel, and E. Stern, 243–260. Jerusalem: The Israel Exploration Society, 1995 (Hebrew).

Porath, N., and S. Ilani. "From Colors to the Origins of Minerals." In *Colors from Nature: On Natural Colors in Ancient Times,* edited by H. Sorek and A. Ayalon, 33–36. Tel Aviv, 1993 (Hebrew).

Prawer, J. "Ashkelon and the Ashkelon Strip in the Crusaders' Policy." In *Ashkelon: 4000 and 40 More Years,* 187–198. Ashkelon, 1990.

———. *Histoire du Royaume latin de Jérusalem,* 2 vols., 2nd ed. Paris: Centre national de la recherche scientifique, 1975.

———. "The Jewish Community in Jerusalem in the Crusader Period." In *The History of Jerusalem: Crusaders and Ayyubids (1099–1250),* edited by J. Prawer and H. Ben-Shammai, 194–212. Jerusalem: Yad Ben-Zvi, 1991 (Hebrew).

Prawer, J., and H. Ben-Shammai. *The History of Jerusalem: The Early Muslim Period 638–1099.* Jerusalem: Yad Izhak Ben-Zvi, 1996.

Pringle, D., and P. Leach. *The Red Tower (al-burj al-ahmar): Settlement in the Plain of Sharon at the Time of the Crusaders and Mamluks* A.D. *1099–1516.* London: British School of Archaeology in Jerusalem, 1986.

al-Qalqashandi, *Subh al-A'sha fi Kitabat al-insha'.* Cairo, 1919.

Qedar, S. "The Dated Islamic Coinage of Palestine." *Israel Numismatic Journal* 4 (1980): 63–71.

Raban, A. *The Richness of Islamic Caesarea.* Haifa: Reuben and Edith Hecht Museum, University of Haifa, 1999.

Raby, J., and J. Johns, eds. *Bayt al-Maqdis: 'Abd al-Malik's Jerusalem.* Oxford: Oxford University Press, 1992.

Richards, D. S. "Arabic Inscriptions." In *The Red Tower (al-burj al-ahmar): Settlement in the Plain of Sharon at the Time of the Crusaders and Mamluks* A.D. *1099–1516,* edited by D. Pringle and P. Leach, 78–82. London: British School of Archaeology in Jerusalem, 1986.

Riis, P. J., and V. Poulsen. *Hama: Fouilles et Recherches 1931–1938.* Vol. 4, pt. 2, *Les verreries et poteries médiévales.* Copenhagen: Carlsberg Foundation, 1957.

Ron, Z. "Qanats and Spring Flow Tunnels in the Holy Land." In *Qanat Kariz and Khattara: Traditional Water Systems in the Middle East and North Africa,* edited by P. Beaumont, M. Bonine, and K. McLachlan, 211–236. London: University of London, 1989.

Rosen, S. A., and G. Avni. "The Edge of the Empire: The Archaeology of Pastoral Nomads in the Southern Negev Highlands in Late Antiquity." *Biblical Archaeologist* 56 (1993): 189–199.

Rosen-Ayalon, Myriam. "Further Considerations Pertaining to Umayyad Art." *Israel Exploration Journal* 23 (1973): 92–100.

———. "The Contributions of Local Elements to Umayyad Art." *Eretz-Israel* vol. 12, Jerusalem, 1975.

———. "The First Mosaic Discovered in Ramla." *Israel Exploration Journal* 26 (1976): 104–119.

———. "Une mosaïque médiévale au Saint-Sepulcre." *Revue Biblique* 83 (1976): 237–253.

———. "A Silver Ring from Medieval Islamic Times." In *Studies in Memory of Gaston Wiet,* edited by M. Rosen-Ayalon, 195–201. Jerusalem: Institute of Asian and African Studies, Hebrew University of Jerusalem, 1977.

———. "A Neglected Group of Mihrabs in Palestine." In *Studies in Islamic History and Civilisation in Honour of Professor David Ayalon*, edited by M. Sharon, 559–561. Jerusalem: Brill, 1986.

———. "New Discoveries in Islamic Archaeology in the Holy Land." In *The Holy Land in History and Thought, Johannesburg*, edited by M. Sharon, 257–269. Leiden: Brill, 1986.

———. "The Façade of the Holy Sepulcher." In *Studies in Honour of Ugo Monneret de Villard, II: Islamic Archaeology and Art History*, edited by B. M. Alfieri and U. Scerrato, *Revista degli Studi Orientali*, 59 (1985): 289–296. Rome, 1987.

———. "Islamic Monuments in Jerusalem." In *Jerusalem: City of the Ages*, edited by A. L. Eckard, 81–91. Lanham, MD: University Press of America 1987.

———. "Récentes découvertes d'archéologie islamique." In *Archéologie, Art et Histoire de la Palestine*, edited by E. M. Laperrousaz. Paris: Cerf, 1988.

———. "On Suleiman's Sabils in Jerusalem." In *The Islamic World from Classical to Modern Times: Essays in Honour of Bernard Lewis*, edited by C. E. Bosworth, Charles Issawi, Roger Savory, and A. L. Udovitch, 589–607. Princeton, NJ: Princeton University Press, 1989.

———. *The Early Islamic Monuments of al-Haram al-Sharif: An Iconographic Study*, Qedem 28. Jerusalem: Hebrew University, 1989.

———. "Art and Architecture in Ayyubid Jerusalem." *Israel Exploration Journal* 40 (1990): 305–314.

———. "The Islamic Jewelry from Ashkelon." In *Jewellery and Goldsmithing in the Islamic World*, edited by N. Brosh, 9–20. Jerusalem: Israel Museum, 1991.

———. "Later Islamic Art in Jerusalem." In *The Arabs in Jerusalem Hamizrah Hehadash*, XCXXIV, 1992, pp. 145–150 (Hebrew).

———. "Remnants of a Piece of Wood-Carving from Khirbat al-Mafjar." In *Studies in the Archaeology and History of Ancient Israel*, edited by Michael Heltzer, Arthur Segal, and Daniel Kaufman, 26, 265–269. Haifa: University of Haifa, 1993.

———. "A Mamluk Basin Rediscovered." In *Ancient Jerusalem Revealed*, edited by H. Geva, 321–324. Jerusalem: Israel Exploration Society, 1994.

———. "Art and Architecture in Jerusalem in the Early Islamic Period." In *The History of Jerusalem: The Early Muslim Period 638–1099*, edited by J. Prawer and H. Ben-Shammai, 386–412. Jerusalem: Yad Izhak Ben-Zvi, 1996.

———. "The First Century of Ramla." *Arabica* 43 (1996).

————. "Jewish Substratum, Christian History and Muslim Symbolism: An Archaeological Episode in Jerusalem." *The Real and Ideal Jerusalem in Jewish, Christian and Islamic Art, Jewish Art* 23–24 (1997–1998): 463–466.

————. "Three Perspectives on Jerusalem: Jewish, Christian and Muslim Pilgrims in the Twelfth Century." In *Jerusalem, Its Sanctity and Centrality to Judaism, Christianity and Islam,* edited by Lee I. Levine, 326–346. New York: Continuum, 1999.

Rosen-Ayalon, M., A. Ben Tor, and Y. Nevo. *The Early Arab Period in the Negev.* Jerusalem, 1982.

Rosen-Ayalon, M., and A. Eitan. *Ramla Excavations: Finds From the VIIIth Century* C.E. Jerusalem: Israel Museum, 1969.

Rosenberg, S., ed. *Knights of the Holy Land: The Crusader Kingdom of Jerusalem.* Jerusalem: The Israel Museum, 1999.

Rothenberg, B. "Early Islamic Copper Smelting and Workshop at Beer Ora, Southern Arabah (Israel)." *Institute for Archaeo-Metallurgical Studies* 12 (1990).

Russo, Eugenio. *Acta ad Archaeologiam et Artium Historiam Pertinentia.* Giorgio Bretschneider ed., 1987.

de Sandoli, S. *Corpus Inscriptionum Crucesignatorum Terrae Sanctae.* Jerusalem: Studium Biblicum Franciscanum, 1974.

Sauvaget, Jean. *La poste aux chevaux dans l'empire des Mamelouks.* Paris: Adrien-Maisonneuve, 1941.

————. *La mosquée omeyyade de Médine.* Paris: Vanoest, 1947.

————. "Châteaux umayyades de Syrie, Contribution à l'étude de la colonisation arabe aux Ier et IIe siècles de l'Hégire." In *Revue des Etudes islamiques* 35 (1967): 1–49.

Sauvaire, H. *Histoire de Jérusalem et d'Hébron.* Paris: Leroux, 1876.

Schein, S. "Latin Hospices in Jerusalem in the Late Middle Ages." *Zeitschrift des Deutschen Palästina-Vereins* 101 (1985): 82–92.

Schick, R. "Christian Life in Palestine During the Early Islamic Period." *Biblical Archaeology* 51 (1989): 218–221, 239–240.

Schlumberger, D. *L'Orient hellénisé.* Paris: A. Michel, 1970.

Seligman, J. "Excavations in the Crusader Fortress of Beth Shean." *Qadmoniot* 27, no. 3–4 (1994).

Shamir, O. "Textiles from the Nahal Shahaq Site." *'Atiqot* 26 (1995): 43–48.

———. "Textiles, Basketry and Cordage from Jazirat Fara'un (Coral Island)." *'Atiqot* 36 (1998): 39–92.

Sharon, Moshe. "An Arabic Inscription from the Time of the Caliph 'Abd al-Malik." *Bulletin of the School of Oriental and African Studies* 29 (1966): 367–372.

———. "The Ayyubid Walls of Jerusalem: A New Inscription." In *Studies in Memory of Gaston Wiet*, edited by M. Rosen-Ayalon, 179–193. Jerusalem: Institute of Asian and African Studies, Hebrew University of Jerusalem, 1977.

———. "The Birth of Islam in the Holy Land." In *Pillars of Smoke and Fire, The Holy Land in History and Thought*, edited by M. Sharon, 225–235. Johannesburg: Southern Books, 1988.

———. "Arabic Rock Inscriptions from the Negev." In *Ancient Rock Inscriptions: Supplement to Map of Har Nafha*, 9–35. Jerusalem: Israel Antiquities Authority, 1990 (Hebrew).

———. "Five Arabic Inscriptions from Rehovoth and Sinai." *Israel Exploration Journal* 43 (1993): 50–59, 252.

———. "A New Fatimid Inscription from Ascalon and its Historical Setting." *'Atiqot* 26 (1995): 61–86.

Sivan, E. "The Beginnings of the Fada'il al-Quds literature." *Israel Oriental Studies* 1 (1971): 263–271.

Soucek, Priscilla. "The Temple of Solomon in Islamic Legend and Art." In *The Temple of Solomon: Archaeological Fact and Medieval Tradition in Christian, Islamic and Jewish Art*, edited by J. Gutmann, 73–122. Missoula, MT: Scholars Press for American Academy of Religion, 1976.

———. "Solomon's Throne/Solomon's Bath: Model or Metaphor?" *Ars Orientalis* 1993: 109–134.

Sourdel, Dominique. "Barîd." In *Encyclopédie de l'Islam*, 2nd ed. Leiden: Brill, 1954.

———. "La fondation umayyade d'al-Ramla en Palestine." In *Studien zur Geschichte und Kultur des Vorderen Orients*, edited by Hans R. Roemer and Albrecht Noth, 387–395. Leiden: Brill, 1981.

Sourdel, Dominique, and Janine Sourdel. *La civilisation de l'Islam classique*. Paris: Arthaud, 1968.

Stern, Edna J. "An Early Islamic Kiln in Tiberias." *'Atiqot* 26 (1995): 57–59.

———. "Evidence of Early Islamic Pottery Production in Acre." *'Atiqot* 36 (1998): 23–25.

————. "Ceramic Ware from the Crusader Period in the Holy Land." In *Knights of the Holy Land. The Crusader Kingdom of Jerusalem*, edited by S. Rosenberg, 258–265. Jerusalem: The Israel Museum, 1999.

————. "The Sugar Industry in Palestine during the Crusader, Ayyubid and Mameluk Periods in the Light of Archaeological Finds." Master's thesis, Hebrew University of Jerusalem, 1999 (Hebrew).

Stern, Henri. "Note sur l'architecture des châteaux omeyyades." *Ars Islamica* 11–12 (1946): 72–97.

————. "Recherches sur la mosquée al-Aqsa et sur ses mosaïques." *Ars Orientalis* 5 (1963): 27–47.

Strzygowski, J. "Die islamische Kunst als Problem." *Ars Islamica* 1934: 7–9.

Tamari, S. "Makam Nabi Musa Near Jericho." *Cathedra* 2 (1979): 153–180 (Hebrew).

Toledano, Ehud. "The Sanjak of Jerusalem in the 16th Century: Patterns of Rural Settlement and Demographic Trends." In *Jerusalem in the Early Ottoman Period*, edited by A. Cohen, 61–92. Jerusalem: Yad Izhak Ben-Zvi, 1977 (Hebrew).

Toueg, R. "The Urban Plan of Arab Caesarea as a Result of Commercial Activity (640–1101)." In *Caesarea. A Mercantile City by the Sea*, Exhibition Catalogue, 12, 22–25. Haifa: Reuben and Edith Hecht Museum, 1995 (Hebrew).

"Trésors fatimides du Caire." Exhibit at l'Institut du monde arabe, 1998.

Tsafrir, Yoram, and G. Foerster. "The Dating of the 'Earthquake of the Sabbatical Year' of 749 C.E. in Palestine." *Bulletin of the School of Oriental and African Studies* 55 (1992): 231–235.

————. "From Scythopolis to Baysân. Changing Concepts of Urbanism." In *The Byzantine and Early Islamic Near East II: Land Use and Settlement Patterns*, edited by G. R. D. King and A. Cameron, 95–115. Princeton, NJ: Darwin Press, 1994.

————. "Urbanism at Scythopolis-Bet-Shean in the Fourth to Seventh Centuries." *Dumbarton Oaks Papers* 51 (1997): 85–146.

van Berchem, Max. "La chaire de la mosquée d'Hébron et le martyrion de la tête de Husain à Ascalon." *Festschrift E. Sachau*, 1915, 298–310.

————. *Matériaux pour un Corpus inscriptionum Arabicarum, Syrie du Sud: Jérusalem ville*, vol 43. Cairo: Impr. de l'Institut français d'archéologie orientale, 1922.

————. *Matériaux pour un Corpus inscriptionum Arabicarum, Syrie du Sud: Jérusalem Haram*, vol 44. Cairo: Impr. de l'Institut français d'archéologie orientale, 1927.

————. *Matériaux pour un Corpus inscriptionum Arabicarum, Syrie du Sud: Jérusalem—index et pl.*, vol 45. Cairo: Impr. de l'Institut français d'archéologie orientale, 1949.

van Berchem, Marguerite. "The Mosaics of the Dome of the Rock in Jerusalem and of the Great Mosque in Damascus." In *Early Muslim Architecture*, vol. I, Part II, edited by K. A. C. Creswell. Oxford: Clarendon Press, 1969..

Vasiliev, A. A. "Notes on Some Episodes Concerning the Relations Between the Arabs and the Byzantine Empire from the Fourth to the Sixth Century." *Dumbarton Oaks Papers* 9–10 (1956): 309–310.

de Vaux, R., and A. M. Stève. *Fouilles à Qaryet el-'Enab Abu Gosh*. Paris: Gabalda, 1950.

Vincent, L. H., and F. M. Abel. *La Jérusalem nouvelle*, vol. II. Paris: Gabalda, 1926.

Vincent, L. H., E. J. H. Mackay, and F. M. Abel. *Hébron, le Haram al-Khalil*. Paris, 1923.

de Vogüe [Charles-Jean Melchior], *Le temple de Jérusalem*. Paris: Noblet & Baudry, 1864.

————. "La citerne de Ramleh et le trace des arcs brisés." *Mémoires de l'Academie des inscriptions et belles lettres* 39 (1912): 163–180.

Wachsman, S., and K. Raveh. "The Guns of Tantura, Napoleonic Weaponry from Beneath the Sea." *Israel Land and Nature* 9, no. 2 (Winter 1983–1984): 56–60.

Waddington, H. "A Note on Four Turkish Renaissance Buildings in Ramleh." *Journal of the Palestine Oriental Society* 15 (1935): 1–6.

Walls, A. G. "Ottoman Restorations to the Sabil and to the Madrasa of Qaytbay in Jerusalem." *Muqarnas* 10 (1993): 85–97.

van Wartburg, M. L. "Design and Technology of the Medieval Cane Sugar Refineries in Cyprus. A Case Study in Industrial Archeology." In *Paisajes del Azucar*, edited by A. Malpica, 81–116. Actas del Quinto Seminario Internacional Sobre la Cana del Azucar, 1995.

al-Wasiti, Abu Bakr Muhammad b. Ahmad. *Fada'il al-Bayt al-Muqaddas*. Edited by Y. Hasson. Jerusalem, 1979.

Wasserstein, David J. "The Coins in the Golden Hoard from Tiberias." *'Atiqot* 36 (1998): 10–14.

————. "The Silver Coins in the Mixed Hoard from Tiberias." *'Atiqot* 36 (1998): 15–23.

Whitcomb, Donald. *Aqaba: "Port of Palestine in the China Sea."* Chicago: Oriental Institute, 1988.

———. "Khirbet al-Mafjer Reconsidered. The Ceramic Evidence." *Bulletin of the American Schools of Oriental Research* 271 (1988): 51–67.

———. *Ayla: Art and Industry in the Islamic Port of Aqaba.* Chicago: Oriental Institute 1994.

———. "Islam and the Socio-Cultural Transition of Palestine. Early Islamic Period (638–1099 C.E.)." In *The Archaeology of Society in the Holy Land,* edited by T. Levy, 488–501. London: Leicester University, 1995.

Wilkinson, J. *Jerusalem Pilgrims before the Crusades.* Warminster: Aris and Phillips, 1977.

———. *Column Capitals in al-Haram al-Sharif.* Jerusalem: Adm. of Wakfs and Islamic Affairs, Islamic Museum, 1987.

———. "Column Capitals in the Haram al-Sharif." In *Bayt al-Maqdis,* edited by J. Raby, 125–139. Oxford: Oxford University Press, 1992.

Zeyadeh, A. "Baysan: A City from the Ninth Century A.D." In *Proceedings of the Fifth International Conference for the History of Bilad al-Sham: Bilad al-Sham During the Abbasid Period,* edited by A. Bakhit and R. Schick, 114–134. Amman: University of Jordan, 1991.

———. "Settlement Patterns, An Archaeological Perspective: Case Studies from Northern Palestine and Jordan." In *The Byzantine and Early Islamic Near East: Land Use and Settlement Patterns,* edited by G. R. D. King and A. Cameron, 117–131. Princeton, NJ: Darwin Press, 1994.

Ziffer, I. *Islamic Metalwork.* Tel-Aviv: Eretz Israel Museum, 1996.

Zohar, A. "Written Sources Regarding the Jazirat Fara'un (Coral Island) Textiles." *'Atiqot* 36 (1998): 114–119.

Zvi, C. K. "The Mamluk Period Jazirat Fara'un (Coral Island) Textile Dyeings." *'Atiqot* 36 (1998): 108–113.

Glossary

ablaq: Arabic term, meaning "spotted," and designating the use of colored elements in building; it is one of the distinctive decorative features of Mamluk art.

amsar: Military camps built as the Muslim armies advanced; later they were transformed into cities.

bab: Gate.

badiya: Country home.

barid: Postal system.

bayt: House, specific architectural unit.

betyl: Standing stone with religious significance.

bima (pl. **bimot**): Hebrew term, meaning "raised platform."

cuerda seca: Decorative technique used in Muslim pottery and characterized by applying organic matter such as rope or other material to the surface, to prevent the glazes from blending.

Darb al-Hajj: The pilgrimage route to Mecca.

divan: Term often used for a council room.

jihad: Holy war.

Fada'il: Medieval literary genre, primarily used to praise a city.

filigree: Silversmith's term, referring to the use of gold or silver threads to decorate or make jewelry.

fusayfisa: Greek term meaning "mosaics," used in Arabic.

graffiti: Inscriptions or other designs engraved on stone.

granulation: Age-old technique of jewelry decoration using tiny beads of gold, which are soldered onto the object to be decorated.

hammam: Public bath.

al-Haram al-Sharif: The "Noble Sanctuary" of Jerusalem.

iwan: Term taken from Iranian architecture referring to a vaulted space closed on three sides and entirely open on the fourth.

al-Khalil: Friend, companion (refers to Abraham the patriarch).

khan: Caravansary.

khanqah: Convent, in most cases for Sufis.

Kufic: Arabic calligraphic style with square letters, used primarily during the early centuries of Islam. The name comes from the city of Kufa, one of the first Muslim cities in Mesopotamia.

Jahiliya: The pre-Islamic era of ignorance.

kerbschnitt: Originally a German term, used to describe woodwork and consisting of oblique incisions, often used in the early Islamic period to decorate ceramics.

madrasa: Religious academy of instruction.

Maghreb: The world of western Islam, covering Spain, North Africa, and Sicily.

marvelled: Glassmaking technique, in particular used for colored glass, using encrustations of glass threads, generally white.

Marwanid: The branch of the Umayyads descending from 'Abd al-Malik ibn Marwan.

mashhad: Sanctuary, often pilgrimage site.

mawazin: Broken arcade that crowns the stairs on the Haram al-Sharif leading from the temple esplanade to the upper level.

Meshatta: One of the Umayyad castles in Jordan.

mihrab: Niche located in the qibla wall inside a mosque, indicating the direction of prayer.

minaret: Tower for the call to prayer found in all mosques.

minbar: Pulpit found in all mosques, located to the right of the mihrab.

muqarna: Honeycomb or stalactite, an architectural technique used to decorate vaulted spaces, niches, or pendentives.

moussem: Seasonal pilgrimage.

musharabiya: Type of Islamic woodwork using a system of decorative interlocking wooden bobbins.

naskhi: Arabic script used frequently starting from the 12th century.

qal'a: Citadel.

qanat: Irrigation system.

qibla: Direction of Mecca, the direction Muslims face when praying; the term applies to the inner wall of all mosques oriented toward Mecca.

qubba: Dome.

ribat: Fort originally used to lodge religious military units preparing to leave for the holy war. In the early centuries of Islam, the ribâts were mainly built in the coastal regions but subsequently the term was extended to cover institutions located in cities.

sabîl: Public fountain.

Safaitic: Writing related to southern Arabic (as was Thamudean writing); the name comes from Jebel Safa, in northeastern Haran.

stilt: Earthenware tripod used to keep pieces of pottery stacked in the kiln apart during firing.

saraya: Residence, palace.

Sassanid: Iranian dynasty that ruled from the third to the seventh centuries.

graffito: Decorative ceramic technique consisting of making fine incisions through the layer of slip and under a layer of glaze.

shamadan: Candlestick.

sirdab: Originally a Persian term, meaning "fresh water"; used to designate a room cooled by running water.

stucco: Mixture of lime, marble powder, straw, and other amalgamating materials to make an easy, quick, and cheap wall covering.

Sufi: Muslim mystic.

Sufyanid: The name comes from Abu Sufan, father of Mu'awiya, the founder of the first Muslim dynasty, the Umayyads.

suq: Market.

tariq: Road, street.

Thamudean: Writing related to southern Arabic (like Safaitic writing).

tiraz: Woven bands with Arabic inscriptions.

turbe: Mausoleum.

waqfiya: Certificate of the founding of a religious institution.

zawiya: Sufi teaching center, sometimes associated with a tomb.

Index

Page numbers followed by an *f* refer to figures.

About the Author

MYRIAM ROSEN-AYALON is Mayer Professor of Islamic Art and Archeology at Hebrew University in Jerusalem and one of the leading experts on the archaeology of the Islamic Middle East. She is author or editor of *The Early Islamic Monuments of al-Haram al-Sharif, Jerusalem: An Iconographic Study* (Qedem, 1989), *Ramla Excavations: Finds from the VIIIth Century C.E.* (Israel Museum,1969), *The Early Arab Period in the Negev* (Institute of Archaeology, Hebrew University, 1982), and *In Pursuit of Gender: Worldwide Archaeological Approaches* (AltaMira 2001) among her many other works.